SHOUJO MANGA TECHNIQUES

Techniques

Drawing Basics

Written & Illustrated by
Hirono Tusbasa & Nene Kotobuki

DIGITAL MANGA PUBLISHING
Los Angeles

Content Manga
HIRONO TUSBASA

Sample Manga
NENE KOTOBUKI

Cover Illustration
KAIMU TACHIBANA

English Translating
KIMIKO EASTHAM

Lettering
SNO CONE STUDIOS, LTD.

Graphic Design
ERIC ROSENBERGER

Editing
MARK FUJITA

Editor in Chief
FRED LUI

Japan Relations
JOHN WHALEN

Publisher
HIKARU SASAHARA

SHOUJO MANGA TECHNIQUES
Drawing Basics

English Edition Published by
DIGITAL MANGA PUBLISHING
1123 Dominguez Street, Unit K
Carson, CA 90746
www.dmpbooks.com
tel: (310) 604-9701
fax: (310) 604-1134

Distributed Exclusively in North America by
WATSON-GUPTILL PUBLICATIONS
a division of VNU Business Media
770 Broadway, New York, NY 10003
www.watsonguptill.com

ISBN: 1-56970-971-8
Library of Congress Control Number: 2004105581
First Edition January 2005
1 2 3 4 5 6 7 8 9 10

Printed in China

DRAWING BASICS

THIS MANGA IS FOR "BEGINNERS WHO WANT TO CREATE MANGA"

ONE DAY I DECIDED "I WANT TO CREATE MANGA", SO I READ A BOOK, GOT SOME TOOLS AND I WAS READY! "HERE I GO!" I THOUGHT, BUT WHEN I SAT IN FRONT OF THE PAPER I COULD ONLY THINK, "HMMM? I DON'T KNOW WHERE TO BEGIN." SOUND FAMILIAR?

◎ ARE YOU READING A BORING TEXTBOOK FOR MANGA THAT'S SUPPOSED TO BE FUN?

◎ DO DIFFICULT TECHNIQUES LEAD YOU TO CREATIVE DEAD ENDS?

DRAWING MANGA SHOULD BE EASY AND FUN. USING THE RIGHT TECHNIQUE, YOU TOO CAN CREATE WONDERFUL STORIES JUST LIKE THE PROS. DON'T THINK SO HARD, RELAX AND READ THIS BOOK AS IF IT WERE ONE OF YOUR FAVORITE MANGA TITLES. THROUGH MANGA, WE'LL SHOW YOU THE BASIC DRAWING SKILLS AND THEN THE MORE ADVANCED TECHNIQUES, WHICH ACTUAL PROS ARE USING TODAY. FURTHERMORE, WE'VE INSERTED "ONE POINT ADVICE" SECTIONS TO BREAK DOWN EACH TECHNIQUE, MAKING IT EASIER FOR YOU TO UNDERSTAND. THIS BOOK WILL CONTAIN MANY TIPS TO HELP IMPROVE YOUR MANGA WITHOUT TOO MUCH DIFFICULTY. LET'S HAVE FUN MASTERING HOW TO CREATE MANGA!

CHARACTER INTRODUCTIONS

WHY DON'T YOU CREATE WITH US!?

I'LL SHOW YOU HOW ANYONE CAN CREATE MANGA IF THEY KNOW THE RIGHT TECHNIQUES!

I'M A BEGINNER WHO IS CHALLENGING MYSELF TO DRAW MANGA!

▲KYOKO NAKASATO: ALISA'S TEACHER WHO'S SHOWING HER THE TECHNIQUES OF CREATING MANGA.

▲ ALISA MIZUKI: THIS IS HER FIRST ATTEMPT AT CREATING MANGA.

① Let's-Think-About-the-Foundation, or the "Idea" of Manga

◎ NECESSARY TOOLS: A NOTEBOOK, OR NOTE PAD, PENCIL OR MECHANICAL PENCIL (B–B2) AND AN ERASER.

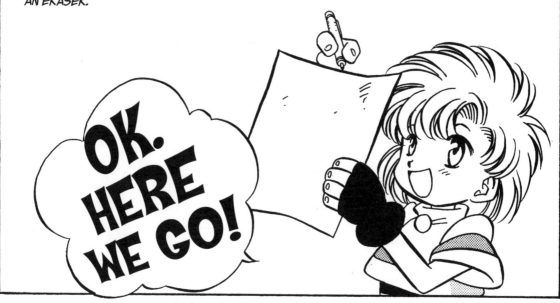

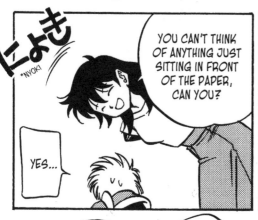

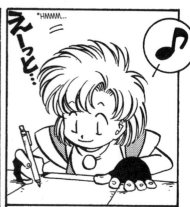

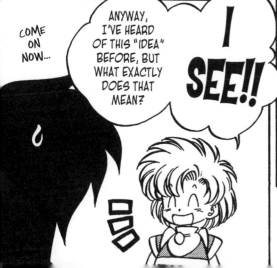

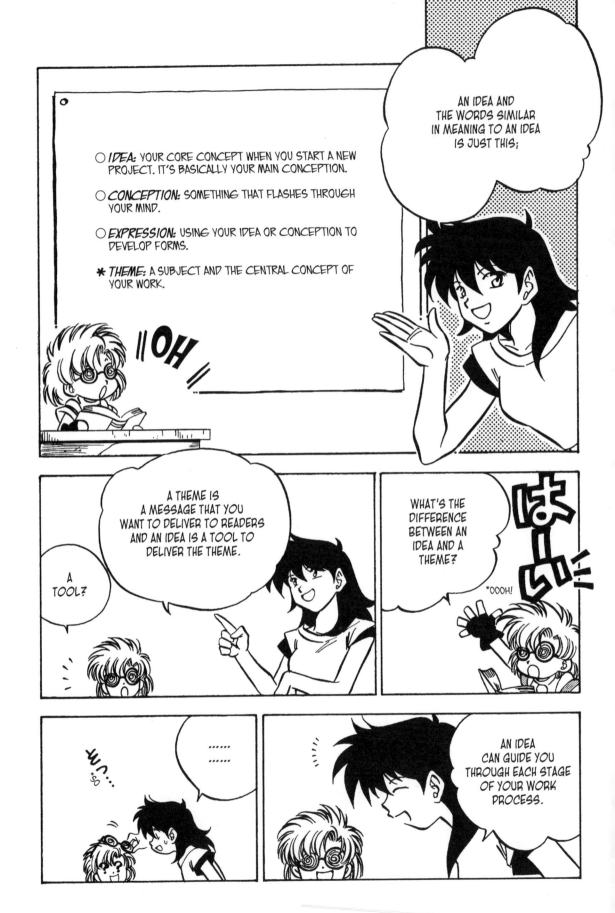

○ **IDEA:** YOUR CORE CONCEPT WHEN YOU START A NEW PROJECT. IT'S BASICALLY YOUR MAIN CONCEPTION.

○ **CONCEPTION:** SOMETHING THAT FLASHES THROUGH YOUR MIND.

○ **EXPRESSION:** USING YOUR IDEA OR CONCEPTION TO DEVELOP FORMS.

✱ **THEME:** A SUBJECT AND THE CENTRAL CONCEPT OF YOUR WORK.

AN IDEA AND THE WORDS SIMILAR IN MEANING TO AN IDEA IS JUST THIS;

OH

A THEME IS A MESSAGE THAT YOU WANT TO DELIVER TO READERS AND AN IDEA IS A TOOL TO DELIVER THE THEME.

A TOOL?

WHAT'S THE DIFFERENCE BETWEEN AN IDEA AND A THEME?

*OOOH!

......
......

*SO...

AN IDEA CAN GUIDE YOU THROUGH EACH STAGE OF YOUR WORK PROCESS.

The Idea Helps To:

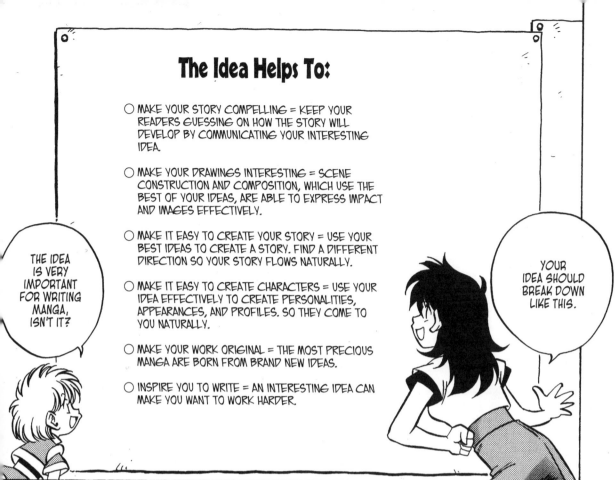

○ MAKE YOUR STORY COMPELLING = KEEP YOUR READERS GUESSING ON HOW THE STORY WILL DEVELOP BY COMMUNICATING YOUR INTERESTING IDEA.

○ MAKE YOUR DRAWINGS INTERESTING = SCENE CONSTRUCTION AND COMPOSITION, WHICH USE THE BEST OF YOUR IDEAS, ARE ABLE TO EXPRESS IMPACT AND IMAGES EFFECTIVELY.

○ MAKE IT EASY TO CREATE YOUR STORY = USE YOUR BEST IDEAS TO CREATE A STORY. FIND A DIFFERENT DIRECTION SO YOUR STORY FLOWS NATURALLY.

○ MAKE IT EASY TO CREATE CHARACTERS = USE YOUR IDEA EFFECTIVELY TO CREATE PERSONALITIES, APPEARANCES, AND PROFILES. SO THEY COME TO YOU NATURALLY.

○ MAKE YOUR WORK ORIGINAL = THE MOST PRECIOUS MANGA ARE BORN FROM BRAND NEW IDEAS.

○ INSPIRE YOU TO WRITE = AN INTERESTING IDEA CAN MAKE YOU WANT TO WORK HARDER.

THE IDEA IS VERY IMPORTANT FOR WRITING MANGA, ISN'T IT?

YOUR IDEA SHOULD BREAK DOWN LIKE THIS.

HAVING AN IDEA MAKES YOUR WORK MORE INTERESTING AND YOU'LL HAVE AN EASIER TIME CREATING NEW MATERIAL.

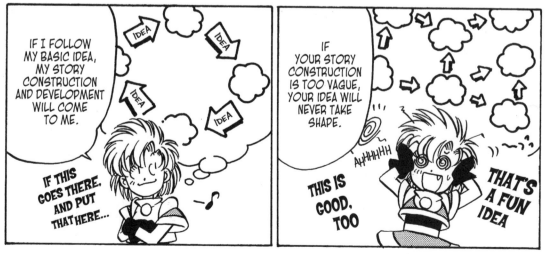

IF I FOLLOW MY BASIC IDEA, MY STORY CONSTRUCTION AND DEVELOPMENT WILL COME TO ME.

IDEA IDEA IDEA IDEA

IF THIS GOES THERE, AND PUT THAT HERE...

IF YOUR STORY CONSTRUCTION IS TOO VAGUE, YOUR IDEA WILL NEVER TAKE SHAPE.

AHHHHH

THIS IS GOOD, TOO

THAT'S A FUN IDEA

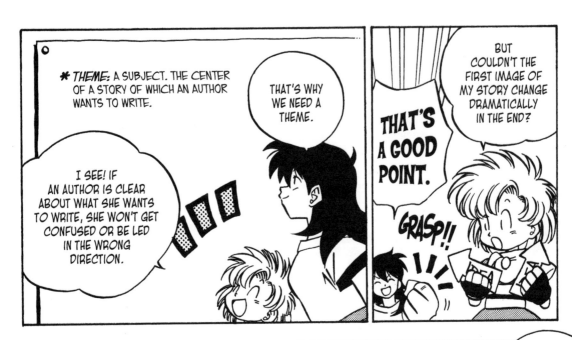

* *THEME:* A SUBJECT. THE CENTER OF A STORY OF WHICH AN AUTHOR WANTS TO WRITE.

THAT'S WHY WE NEED A THEME.

I SEE! IF AN AUTHOR IS CLEAR ABOUT WHAT SHE WANTS TO WRITE, SHE WON'T GET CONFUSED OR BE LED IN THE WRONG DIRECTION.

BUT COULDN'T THE FIRST IMAGE OF MY STORY CHANGE DRAMATICALLY IN THE END?

THAT'S A GOOD POINT.

GRASP!!

I DON'T THINK I CAN COME UP WITH AN INTERESTING STORY IDEA THAT EASILY.

I UNDERSTAND HOW IMPORTANT IDEAS ARE, BUT IT'S PUTTING A LOT OF PRESSURE ON ME.

SCRATCH, SCRATCH

IT'S JUST HARD FOR SOME PEOPLE TO DEVELOP IDEAS OR USE THEM AS GUIDES. THAT'S ALL.

THAT'S NOT TRUE. ANYBODY CAN THINK OF SOME IDEAS.

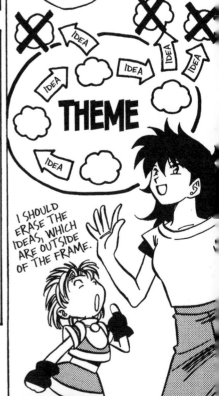

A THEME IS LIKE THE FRAME OF YOUR WORK. YOUR MANY IDEAS ARE IN THE FRAME.

THINK OF IT AS YOUR GUIDE TO CREATE OUR WORK WITHIN.

IDEA IDEA IDEA IDEA IDEA IDEA IDEA

THEME

I SHOULD ERASE THE IDEAS, WHICH ARE OUTSIDE OF THE FRAME.

BUT IT SOUNDS SO HARD. DEVELOPING A STORY...

THAT'S TRUE.... IT'S NOT THAT MOST PEOPLE CAN'T THINK OF IDEAS, THEY JUST CAN'T DEVELOP THEM INTO THEIR STORY. AND THEY GET CONFUSED.

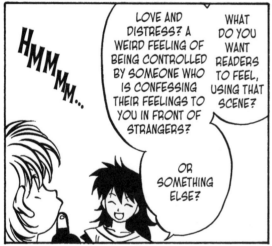

HMMMM...

LOVE AND DISTRESS? A WEIRD FEELING OF BEING CONTROLLED BY SOMEONE WHO IS CONFESSING THEIR FEELINGS TO YOU IN FRONT OF STRANGERS?

WHAT DO YOU WANT READERS TO FEEL, USING THAT SCENE?

OR SOMETHING ELSE?

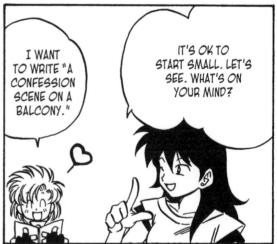

I WANT TO WRITE "A CONFESSION SCENE ON A BALCONY."

IT'S OK TO START SMALL. LET'S SEE. WHAT'S ON YOUR MIND?

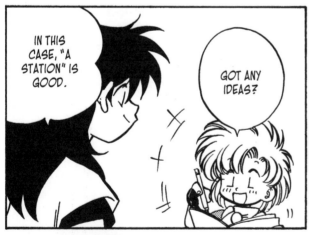

IN THIS CASE, "A STATION" IS GOOD.

GOT ANY IDEAS?

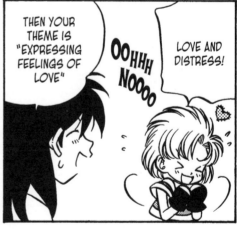

THEN YOUR THEME IS "EXPRESSING FEELINGS OF LOVE"

OOHHH NOOOO

LOVE AND DISTRESS!

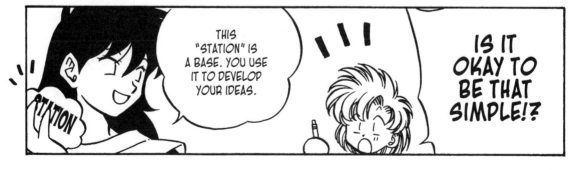

THIS "STATION" IS A BASE. YOU USE IT TO DEVELOP YOUR IDEAS.

IS IT OKAY TO BE THAT SIMPLE!?

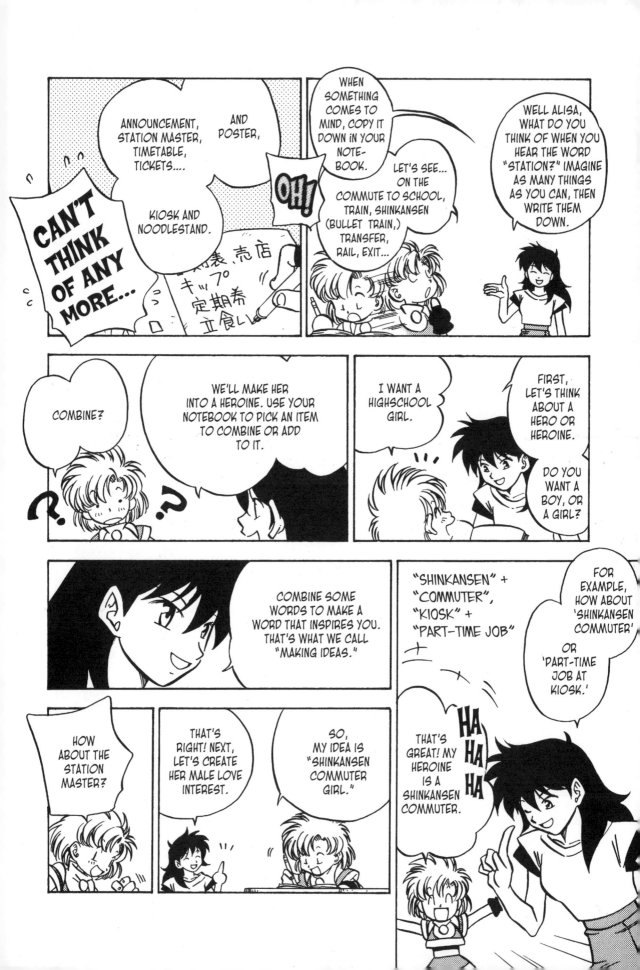

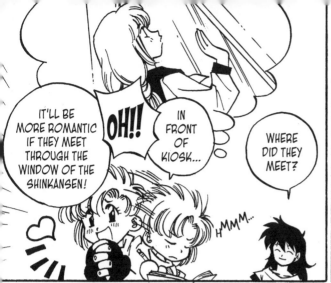

IT'LL BE MORE ROMANTIC IF THEY MEET THROUGH THE WINDOW OF THE SHINKANSEN!

OH!!

IN FRONT OF KIOSK...

WHERE DID THEY MEET?

HMMM...

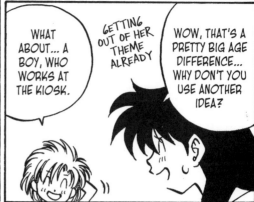

WHAT ABOUT... A BOY, WHO WORKS AT THE KIOSK.

GETTING OUT OF HER THEME ALREADY

WOW, THAT'S A PRETTY BIG AGE DIFFERENCE... WHY DON'T YOU USE ANOTHER IDEA?

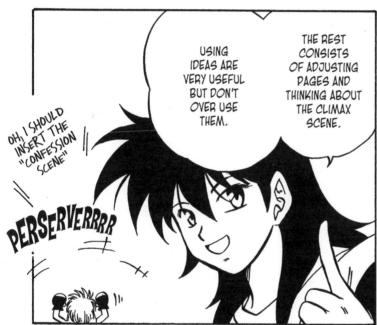

OH, I SHOULD INSERT THE "CONFESSION SCENE"

PERSERVERRRR

USING IDEAS ARE VERY USEFUL BUT DON'T OVER USE THEM.

THE REST CONSISTS OF ADJUSTING PAGES AND THINKING ABOUT THE CLIMAX SCENE.

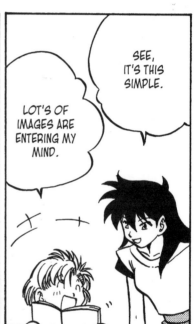

LOT'S OF IMAGES ARE ENTERING MY MIND.

SEE, IT'S THIS SIMPLE.

ONE POINT ADVICE
There are Two Kinds of "Ideas!"
IF YOU DIVIDE YOUR IDEAS THERE ARE TWO KINDS, GRAPHIC AND CONTENT. USE THEM EFFECTIVELY TO CREATE YOUR MANGA

KYOKO'S

○ GRAPHICAL IDEA = AN IDEA WHICH IS EASIER TO EXPRESS THROUGH DRAWING. SUCH AS AN IMPRESSIONABLE ONE SCENE, OR A STRIKING FEATURE OF YOUR CHARACTER, LIKE SOME ARTICLE OF CLOTHING.

 · GOOD POINT = THROUGH PICTURES THE MANGA IS EASY TO UNDERSTAND.

 · WEAK POINT = IT'S HARD TO EXPRESS STORY DETAILS, TWISTS AND UNEXPECTED INCIDENTS.

○ CONTENT IDEA = AN IDEA WHICH IS EASIER TO EXPRESS THROUGH WRITING. SUCH AS CHANGING AND CONSTRUCTING A STORY.

 · GOOD POINT = YOU CAN MAKE INTERESTING POINTS AND INSERT TWISTS IN YOUR STORY.

 · WEAK POINT = IT'S DIFFICULT TO CREATE WITHOUT INSERTING DIALOG OR NARRATION.

● END ●

THE FOLLOWING 12 PAGES ARE WORK FROM A PROFESSIONAL. NOW OPEN TO THE PUBLIC!!

EXAMPLE MANGA

IDEA

WRITE DOWN ALL OF YOUR IDEAS, WORDS, OR DOODLES IN YOUR NOTEBOOK. YOU ARE THE ONLY PERSON WHO NEEDS TO UNDERSTAND THAT NOTEBOOK. THEN PICK OUT THE IDEAS YOU NEED FOR YOUR WORK.

No.

DATE . .

TWO GIRLS LIKE HIM →

GOOD FRIENDS.

COOL SENPAI (UPPERCLASSMAN)

MY FRIEND LIKES THE BOY I LIKE?

A GIRLFRIEND? HE HAS ONE. HE DOESN'T HAVE ONE.

MY FRIEND MIGHT GO OUT WITH HIM?

A CHEERFUL HEROINE.

I WANT TO DO SOMETHING FOR HER BUT I LIKE HIM, TOO

A FRIEND, WHO ALWAYS RELIES ON HEROINE.

I (HEROINE) TOLD HIM ABOUT MY FEELINGS. MY FRIEND TOLD HIM HER FEELINGS.

SHE CAN'T DECIDE ANYTHING BY HERSELF.

A FRIEND IS MATURING.

REJECTION. MY FRIEND IS GOING OUT WITH HIM.

LET'S BE A BUDDY WHO CAN TALK ABOUT ANYTHING TO EACH OTHER.

HAPPY END?

DOING ANYTHING FOR MY FRIEND DOESN'T MEAN I'M A REAL FRIEND.

7mm×30行

EXAMPLE MANGA: IDEA

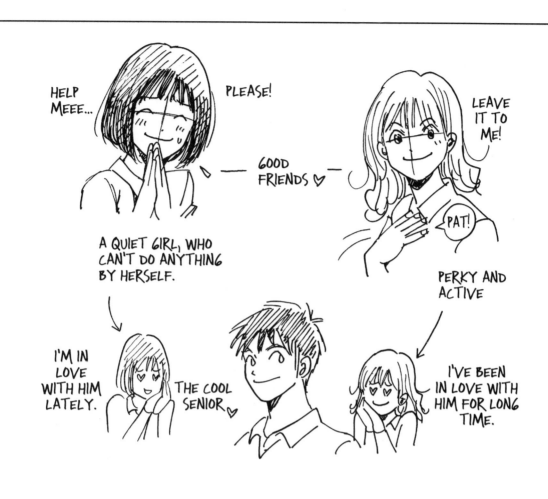

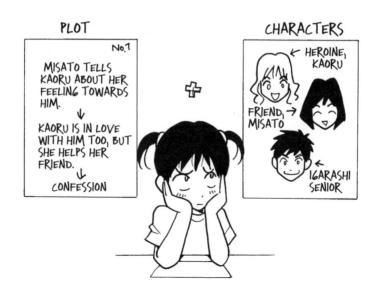

② Let's Think of a "Character" That Readers will go Crazy Over

◎ NECESSARY TOOLS: A NOTEBOOK, A NOTE PAD, PENCIL, OR MECHANICAL PENCIL (B–B2) AND AN ERASER.

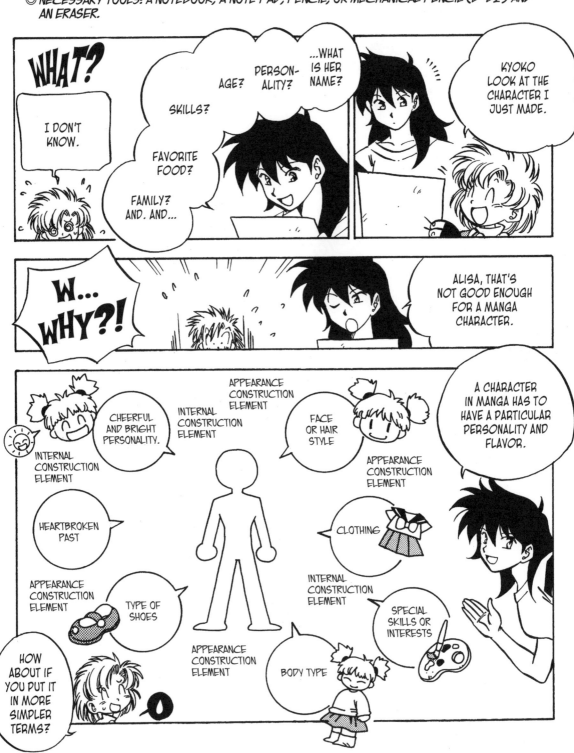

PUTTING THE SAME KIND OF CHARACTER IN YOUR MANGA MAKES IT BORING.

THEN I'LL MAKE LOTS OF UNIQUE CHARACTERS AND PUT THEM IN MY MANGA.

INDIVIDUALITY MAKES A CHARACTER MORE ATTRACTIVE.

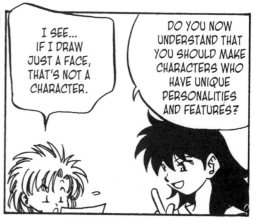

I SEE... IF I DRAW JUST A FACE, THAT'S NOT A CHARACTER.

DO YOU NOW UNDERSTAND THAT YOU SHOULD MAKE CHARACTERS WHO HAVE UNIQUE PERSONALITIES AND FEATURES?

OR SIMPLY KNOWN AS "PERSONAL DATA."

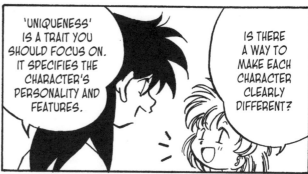

'UNIQUENESS' IS A TRAIT YOU SHOULD FOCUS ON. IT SPECIFIES THE CHARACTER'S PERSONALITY AND FEATURES.

IS THERE A WAY TO MAKE EACH CHARACTER CLEARLY DIFFERENT?

MAKE SURE TO HAVE THIS PERSONAL DATA FOR YOUR HEROINE AND A COUPLE OF YOUR OTHER IMPORTANT CHARACTERS.

THIS WAY, THEY ALL COME OUT DIFFERENT.

★ PERSONAL DATA ★

NAME	KAGUYA RYUSAI AGE 16
NICKNAME	PRINCESS/BLOOD TYPE B
BIRTHDAY	APRIL 22, 20XX TAURUS
BIRTHPLACE	NAGANO PREFECTURE
RESIDENCE	LIVING WITH HER PARENTS
PERSONALITY	CHEERFUL BUT STUBBORN
	GRANDMOTHER'S FAVORITE
INTERESTS	WATCHING STARS.
	PLAYING VIDEO GAMES
FAVORITE SUBJECTS	SCIENCE, PE
WEAK SUBJECT	ENGLISH
HER DREAM	TO BECOME AN ASTRONOMER
	AND LIVE IN MOON.
OTHER	SHE WEARS A RED BELTED
	CONSTELLATION WATCH,
	WHICH WAS A GIFT FROM
	HER GRANDMOTHER.

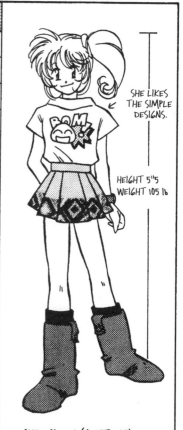

SHE LIKES THE SIMPLE DESIGNS.

HEIGHT 5"5
WEIGHT 105 lb

SHOE SIZE 8 (A BIT BIG)

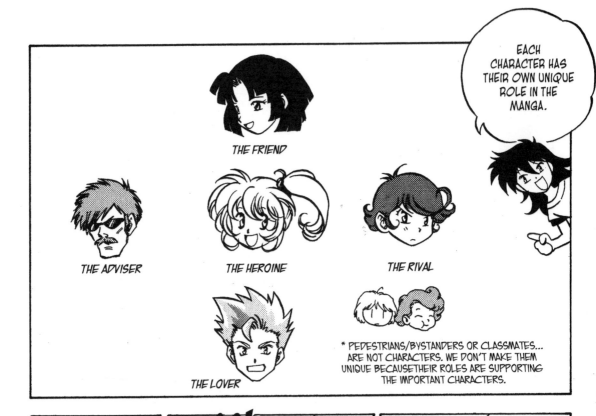

THE FRIEND

THE ADVISER

THE HEROINE

THE RIVAL

THE LOVER

EACH CHARACTER HAS THEIR OWN UNIQUE ROLE IN THE MANGA.

* PEDESTRIANS/BYSTANDERS OR CLASSMATES... ARE NOT CHARACTERS. WE DON'T MAKE THEM UNIQUE BECAUSE THEIR ROLES ARE SUPPORTING THE IMPORTANT CHARACTERS.

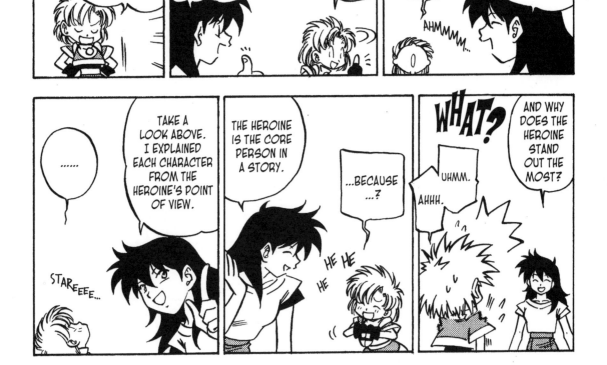

AHEM! IT'S OBVIOUS!

BINGO! CORRECT.

THE HEROINE!

......
......

AHMMMM...

WHO STANDS OUT THE MOST OUT OF THESE CHARACTERS?

......

TAKE A LOOK ABOVE. I EXPLAINED EACH CHARACTER FROM THE HEROINE'S POINT OF VIEW.

STAREEEE...

THE HEROINE IS THE CORE PERSON IN A STORY.

...BECAUSE ...?

HE HE HE

WHAT?

UHMM.

AHHH.

AND WHY DOES THE HEROINE STAND OUT THE MOST?

16

○ THE FRIEND: THIS CHARACTER GIVES SUPPORT AND HELP THE HEROINE.

○ THE ADVISER: HE SUPPORTS THE HEROINE.

○ THE RIVAL: THE HEROINE'S OPPONENT

○ THE HEROINE: SHE IS THE CORE CHARACTER OF THIS MANGA.

SHE IS THE CENTER OF HUMAN RELATION-SHIPS.

○ THE LOVER: THE HEROINE LIKES HIM.

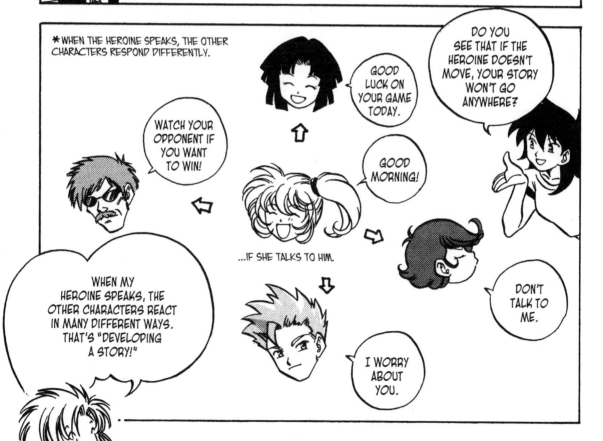

* WHEN THE HEROINE SPEAKS, THE OTHER CHARACTERS RESPOND DIFFERENTLY.

DO YOU SEE THAT IF THE HEROINE DOESN'T MOVE, YOUR STORY WON'T GO ANYWHERE?

GOOD LUCK ON YOUR GAME TODAY.

WATCH YOUR OPPONENT IF YOU WANT TO WIN!

GOOD MORNING!

...IF SHE TALKS TO HIM.

DON'T TALK TO ME.

WHEN MY HEROINE SPEAKS, THE OTHER CHARACTERS REACT IN MANY DIFFERENT WAYS. THAT'S "DEVELOPING A STORY!"

I WORRY ABOUT YOU.

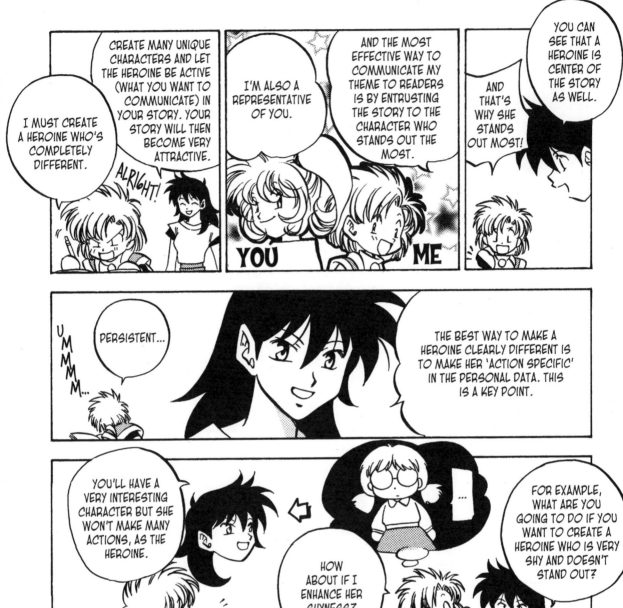

I MUST CREATE A HEROINE WHO'S COMPLETELY DIFFERENT.

CREATE MANY UNIQUE CHARACTERS AND LET THE HEROINE BE ACTIVE (WHAT YOU WANT TO COMMUNICATE) IN YOUR STORY. YOUR STORY WILL THEN BECOME VERY ATTRACTIVE.

ALRIGHT!

I'M ALSO A REPRESENTATIVE OF YOU.

YOU

ME

AND THE MOST EFFECTIVE WAY TO COMMUNICATE MY THEME TO READERS IS BY ENTRUSTING THE STORY TO THE CHARACTER WHO STANDS OUT THE MOST.

AND THAT'S WHY SHE STANDS OUT MOST!

YOU CAN SEE THAT A HEROINE IS CENTER OF THE STORY AS WELL.

UMMMM...

PERSISTENT...

THE BEST WAY TO MAKE A HEROINE CLEARLY DIFFERENT IS TO MAKE HER 'ACTION SPECIFIC' IN THE PERSONAL DATA. THIS IS A KEY POINT.

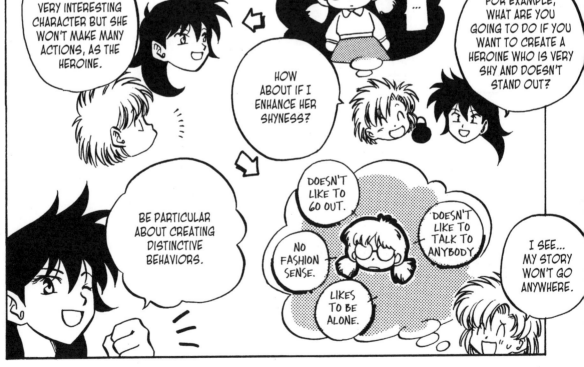

YOU'LL HAVE A VERY INTERESTING CHARACTER BUT SHE WON'T MAKE MANY ACTIONS, AS THE HEROINE.

...

HOW ABOUT IF I ENHANCE HER SHYNESS?

FOR EXAMPLE, WHAT ARE YOU GOING TO DO IF YOU WANT TO CREATE A HEROINE WHO IS VERY SHY AND DOESN'T STAND OUT?

BE PARTICULAR ABOUT CREATING DISTINCTIVE BEHAVIORS.

DOESN'T LIKE TO GO OUT.

NO FASHION SENSE.

DOESN'T LIKE TO TALK TO ANYBODY

LIKES TO BE ALONE.

I SEE... MY STORY WON'T GO ANYWHERE.

18

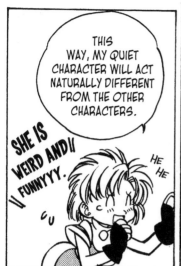

THIS WAY, MY QUIET CHARACTER WILL ACT NATURALLY DIFFERENT FROM THE OTHER CHARACTERS.

SHE IS WEIRD AND!! FUNNYYY.

HE HE

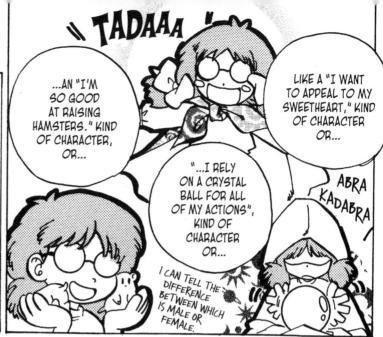

"TADAAA"

...AN "I'M SO GOOD AT RAISING HAMSTERS." KIND OF CHARACTER, OR...

LIKE A "I WANT TO APPEAL TO MY SWEETHEART," KIND OF CHARACTER OR...

"...I RELY ON A CRYSTAL BALL FOR ALL OF MY ACTIONS", KIND OF CHARACTER OR...

ABRA KADABRA

I CAN TELL THE DIFFERENCE BETWEEN WHICH IS MALE OR FEMALE.

SCRIBBLE SCRIBBLE

I CAN DECIDE HOW EACH CHARACTER SHOULD SPEAK OR ACT IN SIMILAR SITUATIONS.

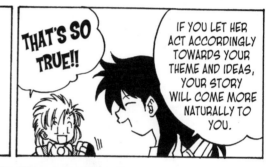

THAT'S SO TRUE!!

IF YOU LET HER ACT ACCORDINGLY TOWARDS YOUR THEME AND IDEAS, YOUR STORY WILL COME MORE NATURALLY TO YOU.

APPEARANCE IS IMPORTANT, ISN'T IT!?

WELL NEXT, WE'LL DESIGN WHAT THE HEROINE LOOKS LIKE.

BUT HOW CAN I DO THAT?

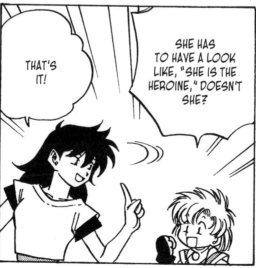

THAT'S IT!

SHE HAS TO HAVE A LOOK LIKE, "SHE IS THE HEROINE," DOESN'T SHE?

CREATE "A STRIKING CHARACTER POINT."

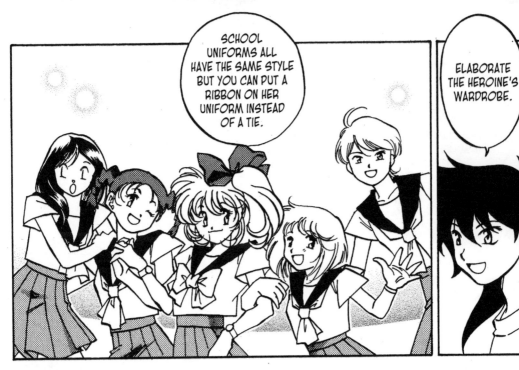

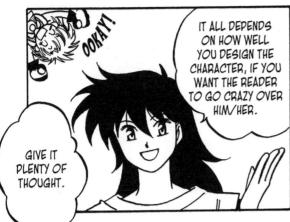

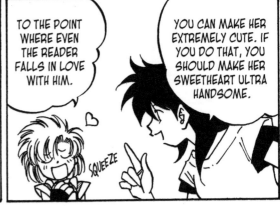

PERSONAL DATA ITEMS

○ *APPEARANCE:*
FACE, HAIR, BODY TYPE, CLOTHING
○ *NAME:*
MAKE READERS CARE ABOUT EACH
CHARACTER'S EXISTENCE. THINK, "NAME
DESCRIBES CHARACTER" WHEN NAMING
YOUR CHARACTER.
○ *AGE, SEX, HEIGHT, WEIGHT:*
THIS DATA WILL HELP YOU TO CREATE A
CHARACTER'S BODY TYPE OR SOCIAL
STATUS.
○ *PERSONALITY:*
YOU CAN DECIDE HOW THEY SPEAK
OR ACT BY USING THIS DATA.
○ *SPECIAL SKILLS, INTERESTS:*
HOBBIES CAN CREATE INDIVIDUALITY
IN ADDITION TO OR DESPITE VISUAL
DIFFERENCES. DECIDE HOW SPECIAL
YOUR CHARACTER CAN BE BY USING
THIS DATA.
○ *DREAMS:*
USE THIS DATA TO DECIDE THEIR
ACTIONS.
○ *OTHER:*
ADD THIS SECTION TO WRITE DOWN
ABOUT THEIR FAVORITE FOODS, FAMILY
STRUCTURE OR PAST INCIDENTS, IF
YOU LIKE.

ONE POINT ADVICE
Make a File for the Characters You Made!

AFTER YOU'VE MADE YOUR "PERSONAL DATA" FILE FOR YOUR CHARACTER, YOU CAN ATTACH OR COPY IT TO YOUR NOTEBOOK.

IT'LL BE EASIER FOR REFERENCE IF YOU DIVIDE A FILE BY SEX AND AGE. THIS WAY YOU CAN DOUBLE CHECK, ACCESS MORE INFORMATION ABOUT YOUR CHARACTERS, OR REARRANGE THEM FOR USE IN YOUR NEXT PROJECT. KEEPING THE FILE WILL HELP YOU IMPROVE YOUR CHARACTER MAKING SKILLS.

AFTER YOU'VE FINALIZED YOUR CHARACTERS, SHOW THEM TO YOUR FRIENDS. IT'LL BE FUN TO LET THEM VOTE FOR WHICH CHARACTER THEY LIKE THE BEST. THIS WAY, YOU'LL FIND THE ONE THAT WILL ATTRACT READERS THE MOST AND AT THE SAME TIME YOU'LL GET TO HEAR YOUR FRIENDS' OPINIONS. IT'S A LEARNING OPPORTUNITY.

YOU CAN BRUSH UP ON YOUR MANGA SKILLS BY SHOWING OTHER PEOPLE. DON'T BE SHY. SHOW OFF YOUR STUFF!

● *END* ●

THE FOLLOWING 12 PAGES ARE WORK FROM A PROFESSIONAL. NOW OPEN TO THE PUBLIC!!

EXAMPLE MANGA

CHARACTER

MAKING A CHARACTER DEPENDS ON HOW WELL YOU CAN TRANSFER THE IMAGE OF A CHARACTER IN YOUR MIND INTO ART ON THE PAGE. IF YOU CAN'T EXPRESS EVERYTHING THROUGH YOUR DRAWING, ADD SOME WORDS. IT IS IMPORTANT TO COME BACK LATER AND FIX IT, EVEN IF THE PICTURE WASN'T EVEN CLOSE TO YOUR ORIGINAL IDEA.

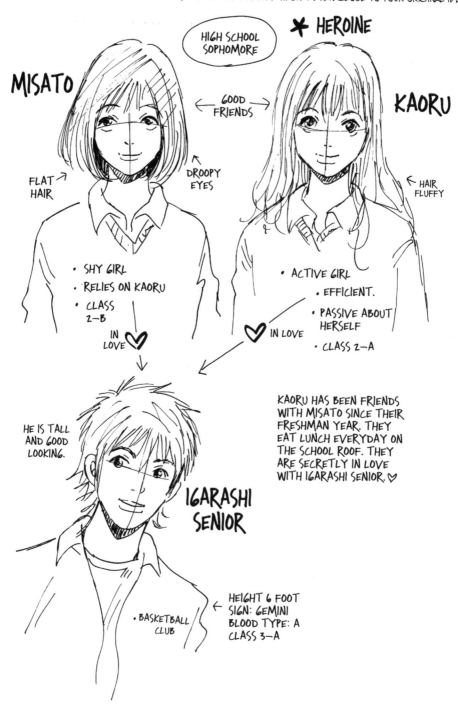

HIGH SCHOOL SOPHOMORE

✳ HEROINE

MISATO

KAORU

← GOOD FRIENDS →

FLAT HAIR

DROOPY EYES

← HAIR FLUFFY

- SHY GIRL
- RELIES ON KAORU
- CLASS 2-B

- ACTIVE GIRL
 - EFFICIENT.
 - PASSIVE ABOUT HERSELF
 - CLASS 2-A

IN LOVE ♥

♥ IN LOVE

HE IS TALL AND GOOD LOOKING.

KAORU HAS BEEN FRIENDS WITH MISATO SINCE THEIR FRESHMAN YEAR. THEY EAT LUNCH EVERYDAY ON THE SCHOOL ROOF. THEY ARE SECRETLY IN LOVE WITH IGARASHI SENIOR. ♡

IGARASHI SENIOR

- BASKETBALL CLUB

← HEIGHT 6 FOOT
SIGN: GEMINI
BLOOD TYPE: A
CLASS 3-A

HEROINE "KAORU"

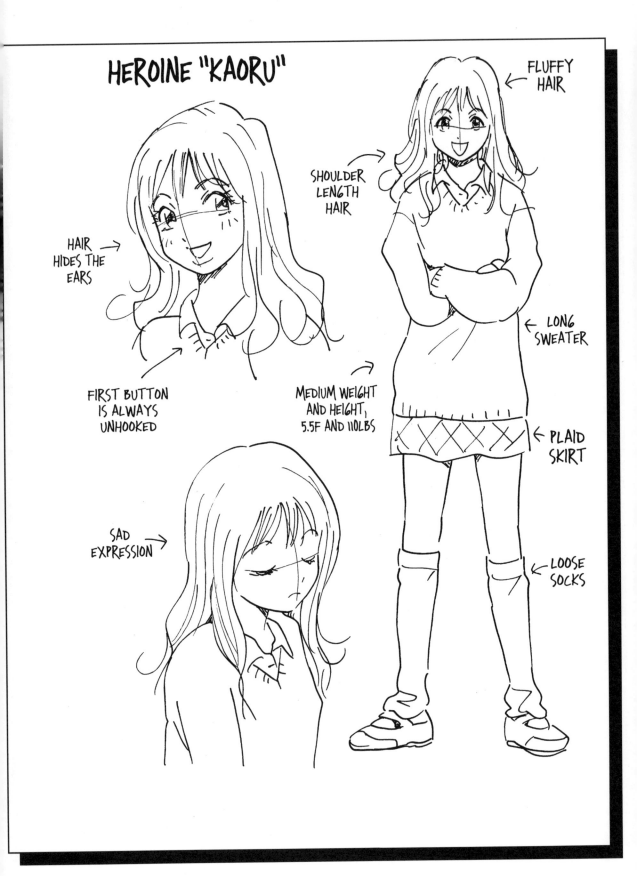

FLUFFY HAIR

SHOULDER LENGTH HAIR

HAIR HIDES THE EARS

LONG SWEATER

FIRST BUTTON IS ALWAYS UNHOOKED

MEDIUM WEIGHT AND HEIGHT, 5.5F AND 110LBS

PLAID SKIRT

SAD EXPRESSION

LOOSE SOCKS

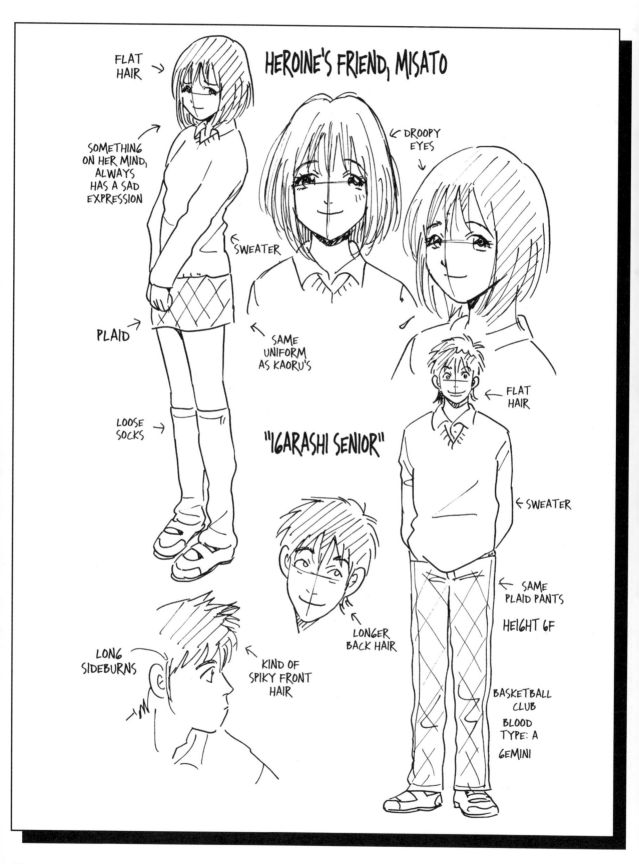

FLAT HAIR →

HEROINE'S FRIEND, MISATO

← DROOPY EYES

SOMETHING ON HER MIND, ALWAYS HAS A SAD EXPRESSION

← SWEATER

PLAID →

SAME UNIFORM AS KAORU'S

LOOSE SOCKS →

"IGARASHI SENIOR"

← FLAT HAIR

← SWEATER

LONGER BACK HAIR

← SAME PLAID PANTS

HEIGHT 6F

LONG SIDEBURNS

KIND OF SPIKY FRONT HAIR

BASKETBALL CLUB

BLOOD TYPE: A

GEMINI

HOW TO DRAW A CHARACTER

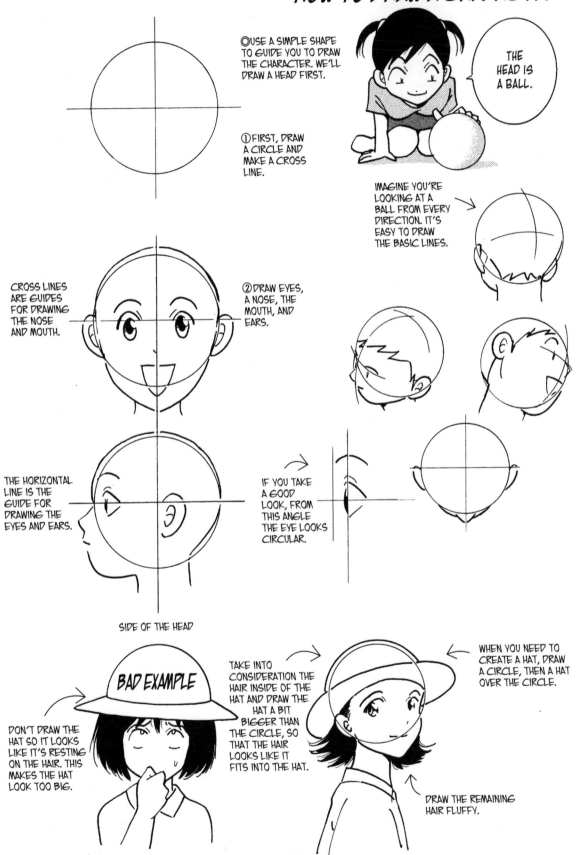

○ USE A SIMPLE SHAPE TO GUIDE YOU TO DRAW THE CHARACTER. WE'LL DRAW A HEAD FIRST.

THE HEAD IS A BALL.

① FIRST, DRAW A CIRCLE AND MAKE A CROSS LINE.

IMAGINE YOU'RE LOOKING AT A BALL FROM EVERY DIRECTION. IT'S EASY TO DRAW THE BASIC LINES.

CROSS LINES ARE GUIDES FOR DRAWING THE NOSE AND MOUTH.

② DRAW EYES, A NOSE, THE MOUTH, AND EARS.

THE HORIZONTAL LINE IS THE GUIDE FOR DRAWING THE EYES AND EARS.

IF YOU TAKE A GOOD LOOK, FROM THIS ANGLE THE EYE LOOKS CIRCULAR.

SIDE OF THE HEAD

BAD EXAMPLE

DON'T DRAW THE HAT SO IT LOOKS LIKE IT'S RESTING ON THE HAIR. THIS MAKES THE HAT LOOK TOO BIG.

TAKE INTO CONSIDERATION THE HAIR INSIDE OF THE HAT AND DRAW THE HAT A BIT BIGGER THAN THE CIRCLE, SO THAT THE HAIR LOOKS LIKE IT FITS INTO THE HAT.

WHEN YOU NEED TO CREATE A HAT, DRAW A CIRCLE, THEN A HAT OVER THE CIRCLE.

DRAW THE REMAINING HAIR FLUFFY.

◎ HANDS AND FEET ARE THE HARDEST THINGS TO DRAW ON THE HUMAN BODY. LEARN THE TIPS AND PRACTICE A LOT.

BACK

① DRAW A RECTANGLE WHERE THE BACK OF THE HAND WOULD BE.

A RECTANGLE AND FIVE LINES ARE THE KEY TO DRAW A HAND.

② DRAW FIVE LINES WHERE THE FINGERS AND THUMB WOULD BE. DRAW SMALL CIRCLES FOR JOINTS. BE AWARE OF THE POSITIONING OF THE THUMB.

DIFFERENT KINDS OF HANDS

INWARD HAND

③ FINALLY DRAW THE MEAT OF THE HAND.

IT'S A GOOD IDEA TO LOOK AT YOUR HAND IN A MIRROR.

STARE...

DIFFERENT FOOT POSES

THINK OF THE FOUR PARTS OF THE FOOT. THE ANKLE, THE HEEL, THE INSTEP AND THE TOES.

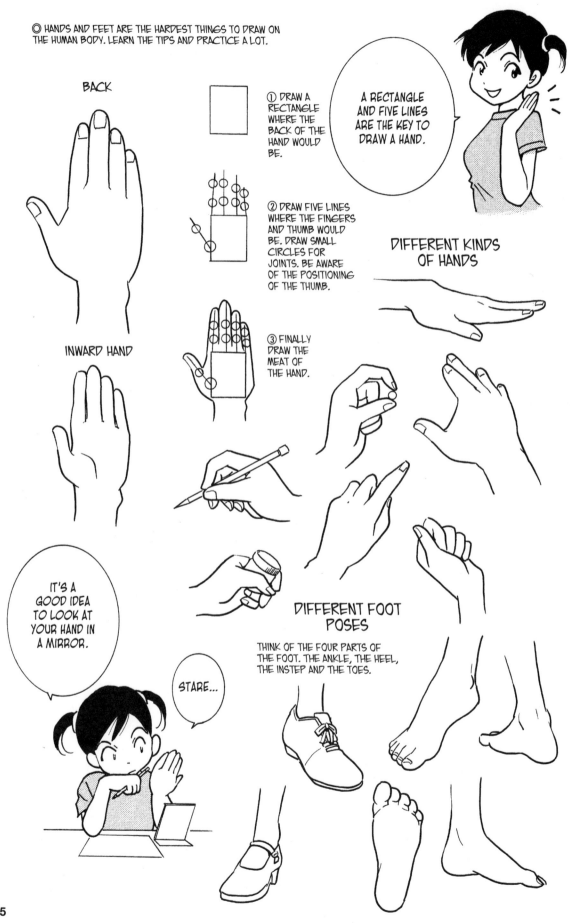

25

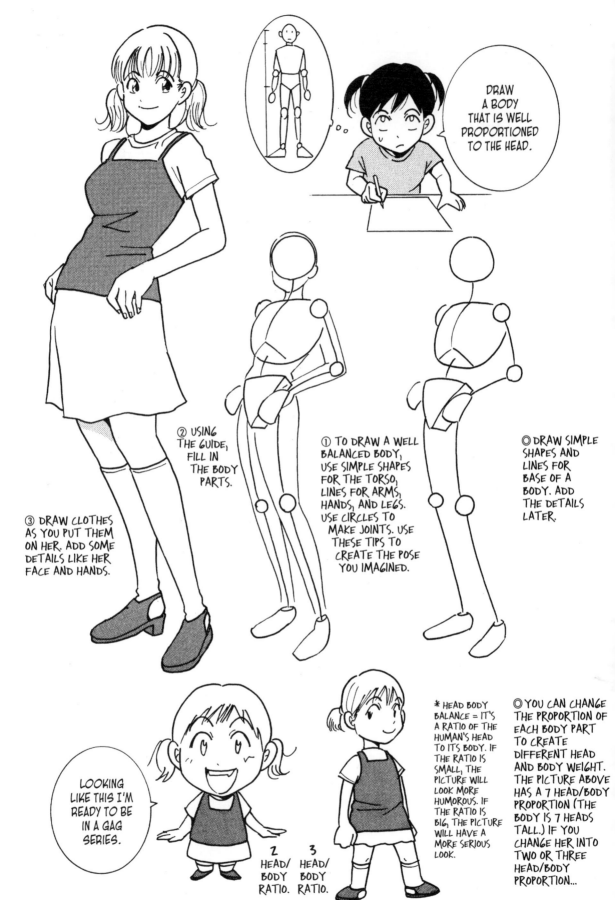

DRAW A BODY THAT IS WELL PROPORTIONED TO THE HEAD.

② USING THE GUIDE, FILL IN THE BODY PARTS.

① TO DRAW A WELL BALANCED BODY, USE SIMPLE SHAPES FOR THE TORSO, LINES FOR ARMS, HANDS, AND LEGS. USE CIRCLES TO MAKE JOINTS. USE THESE TIPS TO CREATE THE POSE YOU IMAGINED.

◎ DRAW SIMPLE SHAPES AND LINES FOR BASE OF A BODY. ADD THE DETAILS LATER.

③ DRAW CLOTHES AS YOU PUT THEM ON HER. ADD SOME DETAILS LIKE HER FACE AND HANDS.

LOOKING LIKE THIS I'M READY TO BE IN A GAG SERIES.

2 HEAD/ BODY RATIO.

3 HEAD/ BODY RATIO.

* HEAD BODY BALANCE = IT'S A RATIO OF THE HUMAN'S HEAD TO ITS BODY. IF THE RATIO IS SMALL, THE PICTURE WILL LOOK MORE HUMOROUS. IF THE RATIO IS BIG, THE PICTURE WILL HAVE A MORE SERIOUS LOOK.

◎ YOU CAN CHANGE THE PROPORTION OF EACH BODY PART TO CREATE DIFFERENT HEAD AND BODY WEIGHT. THE PICTURE ABOVE HAS A 7 HEAD/BODY PROPORTION (THE BODY IS 7 HEADS TALL.) IF YOU CHANGE HER INTO TWO OR THREE HEAD/BODY PROPORTION...

26

③ Think of a "Story" that will Attract Readers

◎ NECESSARY TOOLS: A NOTEBOOK, NOTE PAD, PENCIL OR MECHANICAL PENCIL (B–B2) AND AN ERASER.

NOT AT ALL.

*ARRGH!?

THINKING UP A "STORY" IS... DIFFICULT, ISN'T IT?

KYOKO...

THE DESCRIPTION OF A STORY AND AN EPISODE

○ STORY: A TALE THAT HAS A BEGINNING AND AN END IN A MANGA MANUSCRIPT.

○ EPISODE: SHORT STORIES WITHIN A TALE.

REMEMBER THESE TWO MEANINGS.

I'LL EXPLAIN WHAT THE WORD "STORY" MEANS IN MANGA TERMS, FIRST.

HANG ON, ALISA!!

STORY

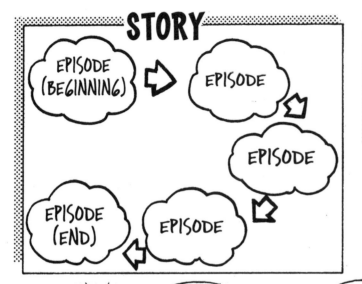

EPISODE (BEGINNING) ⇨ EPISODE ⇨ EPISODE ⇨ EPISODE ⇨ EPISODE (END)

STORY

EPISODE

*IT TAKES SEVERAL COMBINED EPISODES TO MAKE A STORY. THEY'RE LIKE "SHORT STORY BLOCKS." A SHORT MANGA HAS AN "EPISODE" = "STORY" CONSTRUCTION FORMAT.

PEOPLE GET CONFUSED BECAUSE THEY ARE BOTH STORIES.

A STORY CONTAINS A NUMBER OF EPISODES.

WHAAAT!?

THEN LET'S MAKE A STORY OUT OF THAT.

WELL, I... WANTED TO... DRAW A COOL GUY.

HE HE HE

BY THE WAY, WHAT MAKES YOU WANT TO DRAW MANGA?

WHAT?

どきっ
*DONG

THAT AND THIS. THINK MORE....

I ALWAYS THOUGHT... THE STORY WAS... SUPPOSED TO BE... MORE... DIFFICULT TO...

B... BUT.

THAT?

28

BUT HOW DO I EXPLAIN IT?

OH, YEAH.

EXPLAIN THAT AND YOU WILL HAVE YOUR STORY.

YES.

SIMPLY PUT A STORY IS BASICALLY, "THE HEROINE DID THIS", RIGHT?

EXPLAIN "WHO," "WHAT SHE DID," "WHEN," "WHERE," "WHY," AND "WHAT HAPPENED".

IF YOU AREN'T FAMILIAR WITH THIS METHOD, YOU CAN TRY IT OUT MULTIPLE TIMES IF YOU LIKE.

THE BASICS FIRST!... YES.

*MMMMM

THAT'S THE "PRODUCTION METHOD." THE METHODS OF HOW TO MAKE A STORY MORE INTERESTING AND HOW TO ATTRACT READERS.

IT'S LIKE DECORATIONS AFTER FINISHING A STORY.

INDEEEED.

IS THAT ALL?

THE OTHER BOOK SAID YOU GOTTA ADD MORE THINGS.

CREATING A CLIMAX... OR INCIDENT AND CONCLUSION. STUFF LIKE THAT.

WHO, WHAT SHE DID, WHEN, WHERE, WHY AND WHAT HAPPENED

○ **WHO:** IT'S ABOUT THE CHARACTERS. EXPLAIN WHO IS ACTING. IT'S ALMOST ALWAYS ABOUT THE HEROINE.

○ **WHEN:** IT'S ABOUT TIME. "MORNING, AFTERNOON, EVENING", "YESTERDAY, TODAY, TOMORROW", "PAST, PRESENT, FUTURE".

○ **WHERE:** PLACES. EXPLAIN WHAT'S HAPPENING IN THESE PLACES. IS IT "INDOORS OR OUTDOORS", "AT HOME, SCHOOL, IN THE PARK, OR THE STATION".

○ **WHAT SHE DID:** IT'S ABOUT WHAT ACTIONS SHE'S TAKING. EXPLAIN WHAT THE HEROINE IS DOING.

○ **WHY:** EXPLAIN WHY THE HEROINE ACTED THAT WAY.

○ **WHAT HAPPENED:** IT'S ABOUT A CONCLUSION. EXPLAIN WHAT HAPPENED AFTER THE HEROINE CAUSED THE ACTION.

> IF YOU COULDN'T THINK OF ANYTHING TO PLACE INTO A CATEGORY, FALL BACK ONTO YOUR IDEA AS A GUIDE TO WRITE IT UP.

> MY STORY BECOMES EASIER TO EXPLAIN IF I INCLUDE EACH OF THESE CATEGORIES.

↓ *WHO*
THE COOL GUY WAS

↓ *WHEN*
THIS LATE AFTERNOON,

↓ *WHERE*
AT THE PLATFORM,

↓ *WHY*
HE LIKES ALISA,

↓ *WHAT HE DID*
TOLD HER HIS FEELINGS,

↓ *WHAT HAPPENED*
GOING OUT ON A DATE

OOOH, NOW I GET IT.

> WRITE LIKE THIS. SEE, YOU CAN SEE YOUR STORY MORE CLEARLY.

> ALISA, IN YOUR CASE...

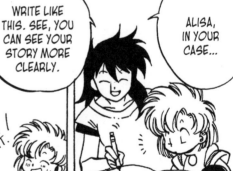

*READ PAGE 14 TO 26, AND CREATE THE COOL GUY.

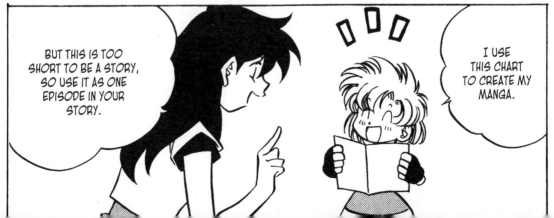

> BUT THIS IS TOO SHORT TO BE A STORY, SO USE IT AS ONE EPISODE IN YOUR STORY.

> I USE THIS CHART TO CREATE MY MANGA.

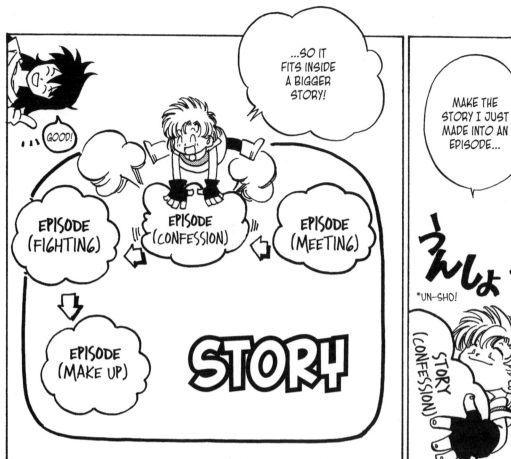

GOOD!

...SO IT FITS INSIDE A BIGGER STORY!

MAKE THE STORY I JUST MADE INTO AN EPISODE...

EPISODE (FIGHTING)

EPISODE (CONFESSION)

EPISODE (MEETING)

EPISODE (MAKE UP)

STORY

*UN-SHO!

STORY (CONFESSION)

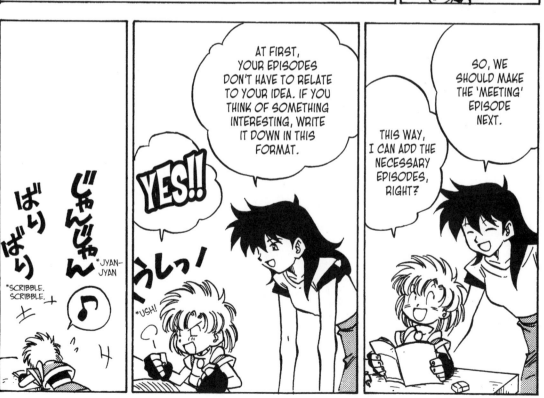

AT FIRST, YOUR EPISODES DON'T HAVE TO RELATE TO YOUR IDEA. IF YOU THINK OF SOMETHING INTERESTING, WRITE IT DOWN IN THIS FORMAT.

YES!!

*JYAN-JYAN

*SCRIBBLE. SCRIBBLE.

*USH!

SO, WE SHOULD MAKE THE 'MEETING' EPISODE NEXT.

THIS WAY, I CAN ADD THE NECESSARY EPISODES, RIGHT?

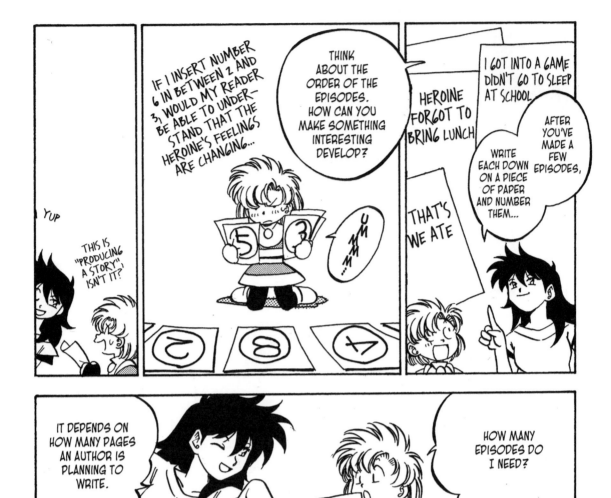

ABOUT THE NUMBER OF PAGES

○ **SHORT STORY:** BELOW 16 PAGES. THIS FORMAT IS USED WHEN DRAWING A GAG MANGA OR A STORY THAT'S BASED OFF SOME ALTERNATE ORIGINAL WORK (SUCH AS A SERIES FOR A MAGAZINE OR A MANGA THAT'S BASED OFF OF AN ANIME) THAT YOU REARRANGE TO CREATE A PARODY MANGA. ONE TO THREE EPISODES ARE RECOMMENDED WHEN CREATING THIS KIND OF MANGA.

○ **MEDIUM LENGTH STORY:** A MANGA THAT HAS 16 TO 60 PAGES. A STORY WITH AN ENDING (THE STORY'S OVER AT THE END OF THE MANGA.) IT'S GOOD FOR A STORY MANGA. PUBLISHERS LOOKING FOR NEW TALENT USUALLY EXPECT ENTRIES TO BE THIS LENGTH. THREE TO EIGHT EPISODES ARE RECOMMENDED WHEN CREATING THIS KIND OF MANGA.

○ **LONG STORY:** BEYOND 60 PAGES. A SERIES IN A MAGAZINE IS ALSO CONSIDERED A LONG STORY. THE AMOUNT OF EPISODES ARE UNLIMITED.

○ **COMIC STRIP:** GENERALLY, IT CONTAINS 4 TO 8 EPISODES.

SO MY MANGA WON'T BECOME UNBALANCED!... RIGHT?

THAT'S GOOD. IF YOU CHALLENGE YOURSELF TO TAKE ON A BIG PROJECT AND DON'T FINISH IT, YOUR MANGA SKILLS WILL SUFFER AS WELL.

I'M A BEGINNER SO I'LL CHOOSE A SHORT OR MEDIUM LENGTH STORY.

THE AMOUNT OF PAGES YOU HAVE SHOULD DEPEND ON YOUR SKILLS.

THAT'S RIGHT.

IT'S FUN TO USE THAT "WHO" AND "WHERE" STUFF.

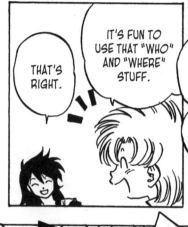

IT'S IMPORTANT TO FINISH YOUR WORK, EVEN IF IT'S SHORT.

DON'T TOSS THEM OUT!! YOU NEED TO KEEP THEM FOR FUTURE PROJECTS!!!

OOKKAYY... I'LL FILE THEM AWAY.

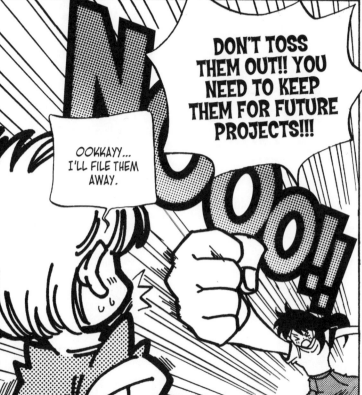

BUT I WENT THROUGH ALL THAT TROUBLE TO MAKE THEM. IT'S A SHAME I HAVE TO THROW THEM OUT...

IF YOU DON'T THINK EVERY EPISODE WILL FIT INTO YOUR PAGES, GET RID OF SOME OF THE UNIMPORTANT STUFF.

ONE POINT ADVICE
The Relationship Between Your Idea, Character, and Story

IF YOU CREATE ONE: AN IDEA, CHARACTER, OR STORY, YOU WILL BE ABLE TO CREATE THE OTHER TWO.

AS I EXPLAINED BEFORE, ONCE YOU COME UP WITH THE SUBJECTS THAT FIT INTO THE FOLLOWING CATEGORIES "WHO, WHAT SHE DID, WHEN, WHERE, WHY, WHAT HAPPENED," YOU'VE JUST MADE A STORY (EPISODE.) YOU CAN USE THIS FORMULA TO FIND THE SUBJECTS THAT YOU ARE MISSING. CREATE ONE OF THESE, THE IDEA, A CHARACTER, OR STORY. THEN THINK OF THE OTHER TWO THAT WOULD COINCIDE WITH THE ONE YOU CREATED FIRST.

FOR EXAMPLE, IF YOU MADE THE CHARACTER FIRST, YOU HAVE THE "WHO" PART OF "WHO, WHAT SHE DID, WHEN, WHERE, WHY, WHAT HAPPENED" FORMAT. YOU CAN THEN FILL IN THE REST OF THE INFORMATION BY USING YOUR PERSONAL DATA. NOW, YOU'VE GOT YOUR STORY (EPISODE!) IF YOU THOUGHT OF YOUR IDEA FIRST, IMAGINE SOME THINGS THAT RELATE TO YOUR IDEA AND PLACE THOSE WORDS THAT FIT INTO THE 'WHO, WHEN, WHERE, WHAT SHE DID, WHAT HAPPENED' CATEGORIES. IF YOU CAME UP WITH YOUR STORY FIRST, YOU ALREADY HAVE THE 'WHEN, WHERE, WHAT SHE DID AND WHAT HAPPENED' PIECES. THEN YOU CAN CREATE A CHARACTER THAT FITS INTO YOUR STORY.

● END ●

④ Create an Interesting "Letter Plot" or "Script"

© NECESSARY TOOLS: A NOTEBOOK, NOTE PAD, PENCIL, OR MECHANICAL PENCIL (B-B2) AND AN ERASER.

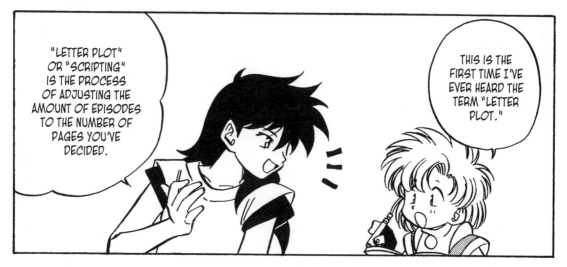

"LETTER PLOT" OR "SCRIPTING" IS THE PROCESS OF ADJUSTING THE AMOUNT OF EPISODES TO THE NUMBER OF PAGES YOU'VE DECIDED.

THIS IS THE FIRST TIME I'VE EVER HEARD THE TERM "LETTER PLOT."

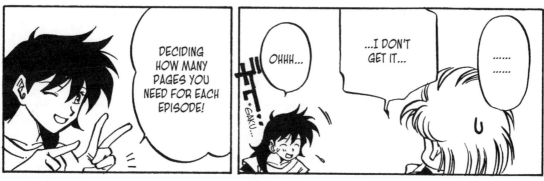

DECIDING HOW MANY PAGES YOU NEED FOR EACH EPISODE!

OHHH...

...I DON'T GET IT...

......
......

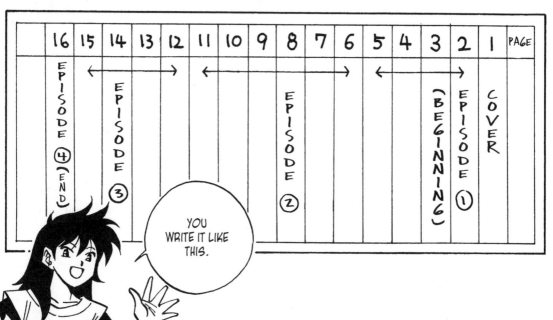

YOU WRITE IT LIKE THIS.

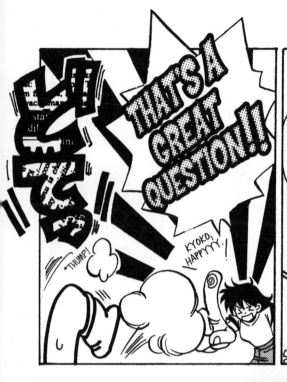

THAT'S A GREAT QUESTION!!

*THUMP!

KYOKO, HAPPYYYY.

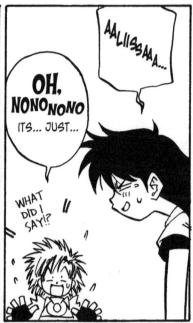

AALIISSAAA...

OH, NONONONO ITS... JUST...

WHAT DID I SAY!?

THIS LOOKS BORING. DO WE HAVE TO DO IT?

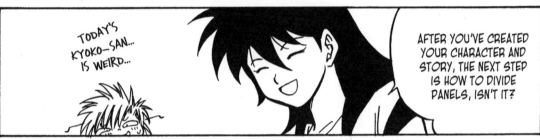

TODAY'S KYOKO-SAN... IS WEIRD...

AFTER YOU'VE CREATED YOUR CHARACTER AND STORY, THE NEXT STEP IS HOW TO DIVIDE PANELS, ISN'T IT?

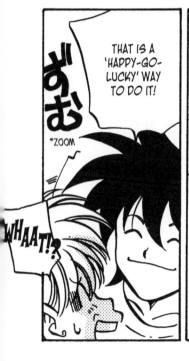

*ZOOM

THAT IS A 'HAPPY-GO-LUCKY' WAY TO DO IT!

WHAAT!?

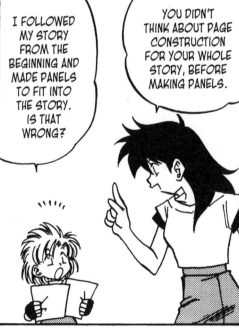

I FOLLOWED MY STORY FROM THE BEGINNING AND MADE PANELS TO FIT INTO THE STORY. IS THAT WRONG?

YOU DIDN'T THINK ABOUT PAGE CONSTRUCTION FOR YOUR WHOLE STORY, BEFORE MAKING PANELS.

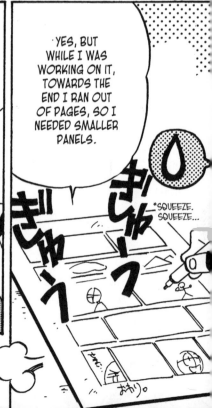

·YES, BUT WHILE I WAS WORKING ON IT, TOWARDS THE END I RAN OUT OF PAGES, SO I NEEDED SMALLER PANELS.

*SQUEEZE. SQUEEZE...

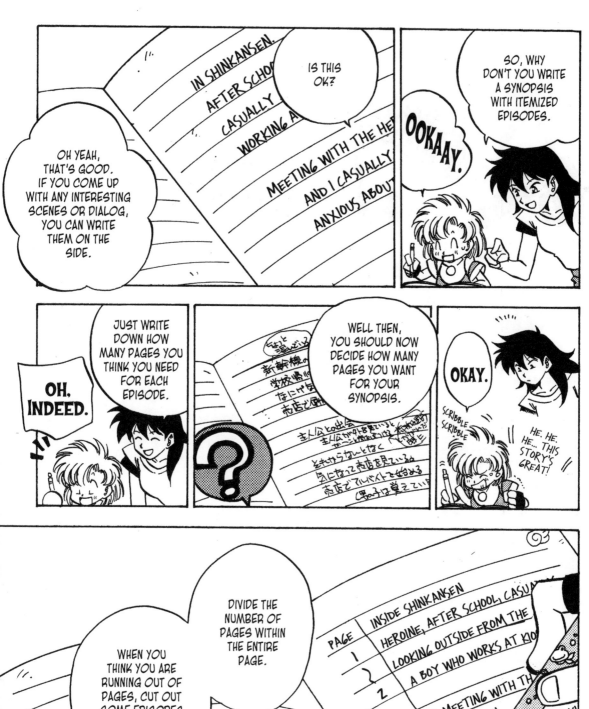

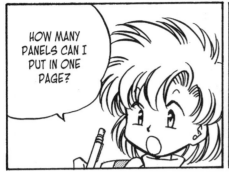

HOW MANY PANELS CAN I PUT IN ONE PAGE?

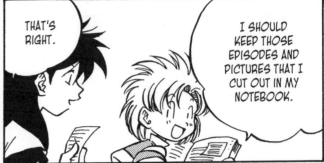

THAT'S RIGHT.

I SHOULD KEEP THOSE EPISODES AND PICTURES THAT I CUT OUT IN MY NOTEBOOK.

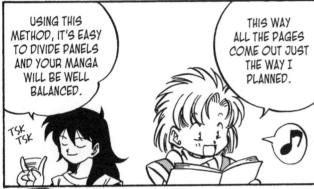

USING THIS METHOD, IT'S EASY TO DIVIDE PANELS AND YOUR MANGA WILL BE WELL BALANCED.

THIS WAY ALL THE PAGES COME OUT JUST THE WAY I PLANNED.

TSK TSK

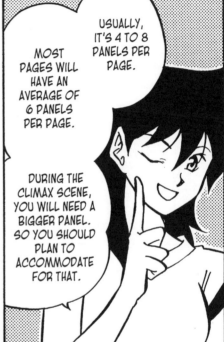

USUALLY, IT'S 4 TO 8 PANELS PER PAGE.

MOST PAGES WILL HAVE AN AVERAGE OF 6 PANELS PER PAGE.

DURING THE CLIMAX SCENE, YOU WILL NEED A BIGGER PANEL. SO YOU SHOULD PLAN TO ACCOMMODATE FOR THAT.

I'LL SHOW YOU IN MORE DETAIL IN THE THUMBNAILS' SECTION.

IT'S REALLY EASY, ISN'T IT?

ONE POINT ADVICE
The Process of Manga Production

KYOKO'S

THERE'S SHORTCUT TO IMPROVE YOUR MANGA, IF YOU KNOW THE RIGHT PROCESS TO USE. YOU CAN FINISH WITH CLEAN COPIES AND YOU WON'T WASTE YOUR TIME. I MADE A CHART OF WHAT WE HAVE LEARNED UP UNTIL NOW AND WHAT WE WILL LEARN NEXT. SO PLEASE TRY TO MEMORIZE IT.

● THE INGREDIENTS FOR CREATING MANGA. (IN THIS STAGE, YOU DON'T HAVE TO FOLLOW THE ORDER)

● PREPRODUCTION: THE WRITING PHASE.

● PRODUCTION: THE ART PHASE.

FINISH ← SCREEN TONES ← WHITE OUT ← ADD BLACKS ← ERASE ← INKS ← PENCILS ← THUMBNAILS ← SCRIPT ← STORY ← CHARACTER ← IDEA

● END ●

THE FOLLOWING 12 PAGES ARE WORK FROM A PROFESSIONAL. NOW OPEN TO THE PUBLIC!!

EXAMPLE MANGA

STORY & SCRIPT

THIS IS AN EXAMPLE OF "SCRIPT." IT IS NOT NECESSARY TO FOLLOW EVERYTHING STEP BY STEP. "SCRIPTING" IS THE PROCESS OF ARRANGING YOUR THOUGHTS BEFORE DRAWING YOUR "THUMBNAILS." YOU SHOULD DESIGN YOUR OWN STYLE OF "SCRIPTING."

DATE　　・　　・

PAGE		
1 P	COVER	
2 P	THE ROOF OF THE SCHOOL	THE HEROINE KAORU IS SHOCKED TO HEAR THAT HER FRIEND MISATO IS IN LOVE WITH SOMEONE.
3 P		SHE WANTS TO SUPPORT MISATO BUT SHE HESITATES WHEN SHE REALIZES IT IS SOMEONE WHOM SHE LIKES.
4 P	IN FRONT OF THE JUNIOR CLASSROOM	SHE RELAYS MISATO'S FEELINGS TO HIM FOR HER.
5 P	IGARASHI APPEARS	KAORU WAS ASKED TO HAND MISATO'S LETTER TO HIM. BUT INSTEAD CONFESSES HER OWN FEELINGS RATHER THAN GIVING HIM THE LETTER. KAORU IS CONFUSED. SHE THOUGHT SHE HAD TOLD HIM MISATO'S FEELINGS.

7mm×30行

6 P	MISATO TELLS KAORU THAT IT LOOKED LIKE KAORU ADMITTED HER OWN FEELINGS TO HIM. KAORU IS SHOCKED TO HEAR THAT.
7 P	KAORU FEELS UNEASY. IN HER DREAM SHE SEE MISATO AND IGARASHI KISS.
8 P	KAORU IS EATING LUNCH ALONE.
9 P	SHE FEELS LONELY ON A ROOF, EATING HER LUNCH. ALONE SHE DECIDES TO COME DOWN. ALONG THE WAY SHE BUMPS INTO IGARASHI. HE SAYS SOMETHING SWEET TO HER AND SHE BURSTS INTO TEARS.
10 P	MISATO RUNS FROM THE SCENE. KAORU ALONE AGAIN BEGINS TO CRY.
11 P	WHILE EATING LUNCH WITH HER OTHER FRIENDS, MISATO LEARNS THAT KAORU LIKED IGARASHI FOR LONG TIME. THIS SHOCKS MISATO.
12 P	THE TWO WORK OUT THE MISUNDERSTANDING AND MAKE UP.

7mm×30行

⑤ Create your Blueprint, or "Thumbnails"

◎ *NECESSARY TOOLS: A NOTEBOOK, NOTE PAD, PENCIL, OR MECHANICAL PENCIL (B–B2) AND AN ERASER.*

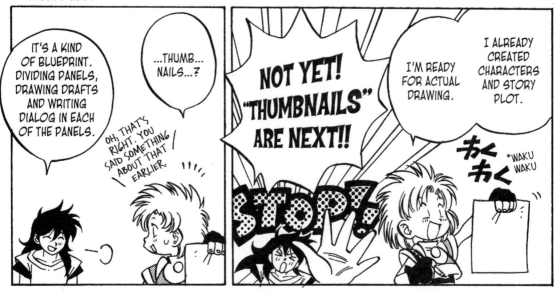

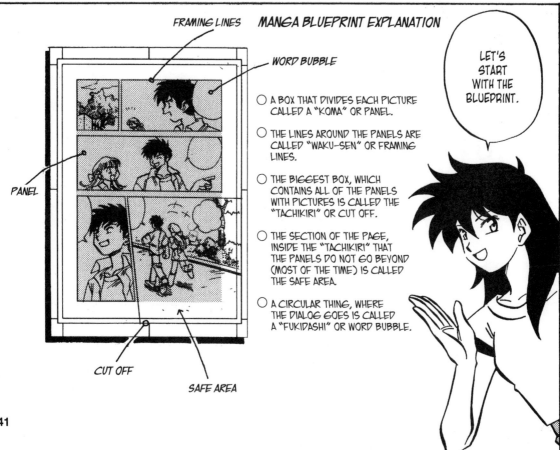

MANGA BLUEPRINT EXPLANATION

FRAMING LINES

WORD BUBBLE

PANEL

CUT OFF

SAFE AREA

○ A BOX THAT DIVIDES EACH PICTURE CALLED A "KOMA" OR PANEL.

○ THE LINES AROUND THE PANELS ARE CALLED "WAKU-SEN" OR FRAMING LINES.

○ THE BIGGEST BOX, WHICH CONTAINS ALL OF THE PANELS WITH PICTURES IS CALLED THE "TACHIKIRI" OR CUT OFF.

○ THE SECTION OF THE PAGE, INSIDE THE "TACHIKIRI" THAT THE PANELS DO NOT GO BEYOND (MOST OF THE TIME) IS CALLED THE SAFE AREA.

○ A CIRCULAR THING, WHERE THE DIALOG GOES IS CALLED A "FUKIDASHI" OR WORD BUBBLE.

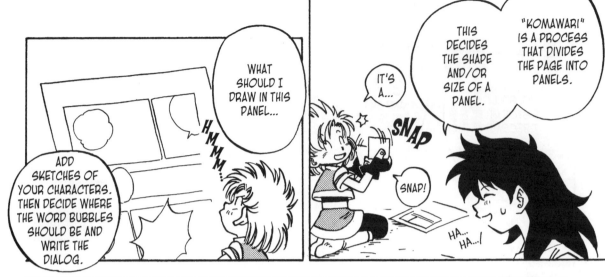

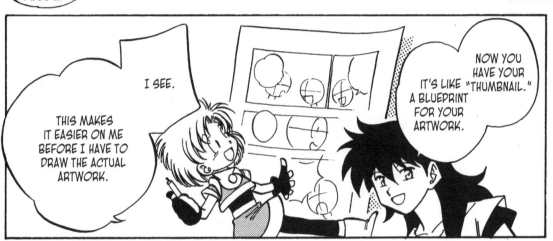

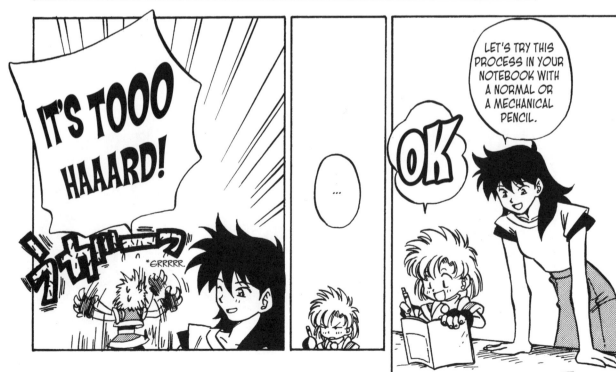

 THAT'S RIGHT. IF YOU CAN'T FOLLOW THE STORY THEN IT BECOMES CONFUSING AND HARD TO READ.

 IF YOU GET AHEAD OF YOURSELF AND SKIP SOME PANELS YOU'LL BE MISSING OUT.

YUP. BUT IT'S VERY IMPORTANT.

 IS IT REALLY OKAY TO START THAT SIMPLE?

THE MOST IMPORTANT THING IS TO DIVIDE THE PANELS IN ORDER.

PAT

 I MIGHT BE DOING THAT.

...IS THAT RIGHT...

SCRATCH SCRATCH

IT'S QUITE COMMON TO FIND MANGA IN WHICH THE AUTHOR GOT TOO INVOLVED WITH THEIR STORY THAT THEY DIVIDED THE PANELS IN A CONFUSING MANNER.

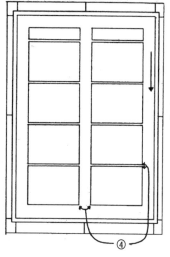

WHILE DRAWING A COMIC STRIP

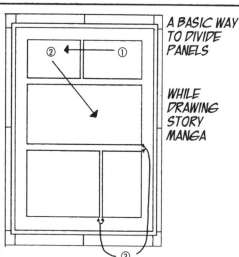

A BASIC WAY TO DIVIDE PANELS

WHILE DRAWING STORY MANGA

① RIGHT TO LEFT (IF A BOOK OPENS TO THE RIGHT)

② TOP TO BOTTOM

③ IN CASE OF A STORY MANGA, IN BETWEEN THE PANELS, MAKE THE HORIZONTAL GAPS NARROW AND MAKE THE VERTICAL ONES WIDE.

④ IN CASE OF A COMIC STRIP, IN BETWEEN THE PANELS, MAKE THE HORIZONTAL GAPS WIDE AND MAKE THE VERTICAL ONES NARROW.

 IT'S GOOD TO REMEMBER THESE FOUR BASIC RULES.

BUT THE OTHER BOOK SAID,

THERE WERE MORE THAN FOUR BASICS.

AS LONG AS YOU FOLLOW THE BASICS, YOU CAN CHANGE A PANEL INTO DIFFERENT SHAPES.

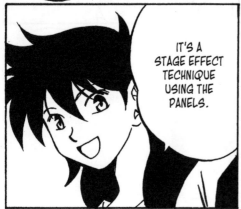

IT'S A STAGE EFFECT TECHNIQUE USING THE PANELS.

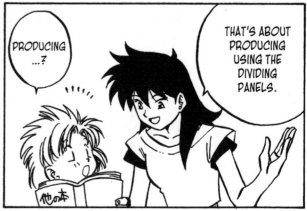

PRODUCING ...?

THAT'S ABOUT PRODUCING USING THE DIVIDING PANELS.

STAGE EFFECT WHICH USING THE PANELS

○ MAKE THE PANELS BIGGER OR SMALLER

○ MAKE A SCENE WHICH CONNECTS THIS PAGE TO THE NEXT PAGE IN THE LAST PANEL.

○ DRAW A CHARACTER'S FACE THAT IS LOOKING TOWARDS THE READER.

○ DON'T CHANGE THE ANGLE OF A CHARACTER'S FACE.

○ THINK ABOUT READERS' READING TEMPO.

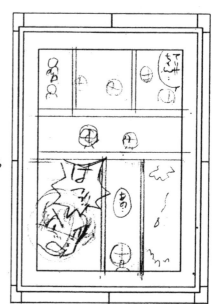

FOR EXAMPLE.

YOU CONFUSED THEM AS ONE THING.

*HE. HE.

I SEE, IN THIS BOOK, THE "BASICS OF HOW TO DIVIDE PANELS" AND "PRODUCING EFFECTS USING DIVISION PANELS" ARE MIXED UP.

YES!

RUB RUB

WELL, YOU CLEARED YOUR HEAD. WHY DON'T YOU DRAW YOUR "THUMBNAILS" FOR EACH EPISODE BASED ON SCRIPT!

......WHAT'S WRONG ALISA?

KYUUUU

......
......

*FUN FUN

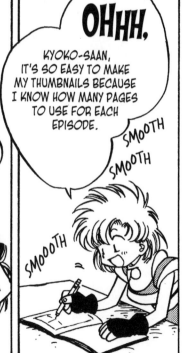

OHHH,

KYOKO-SAAN, IT'S SO EASY TO MAKE MY THUMBNAILS BECAUSE I KNOW HOW MANY PAGES TO USE FOR EACH EPISODE.

SMOOTH SMOOTH

SMOOOTH

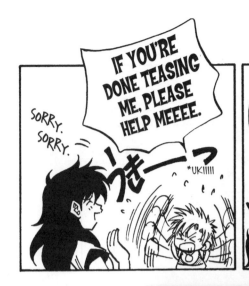

SORRY. SORRY.

IF YOU'RE DONE TEASING ME, PLEASE HELP MEEEE.

*UKIIIII

GOOD!! YOU'RE STARTING TO CATCH YOUR OWN MISTAKES, ALISA.

KYOKO-SAN...

THE THUMBNAIL I MADE... IT'S SO SIMPLE...

IT'S NOT VERY INTERESTING...

EVERYONE STARTS OUT THIS WAY. WE CAN TAKE THE PANELS AND PRODUCE THEM, NEXT TIME.

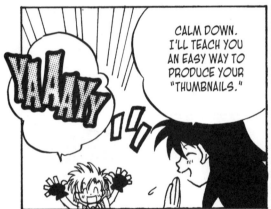

YAAAYY

CALM DOWN. I'LL TEACH YOU AN EASY WAY TO PRODUCE YOUR "THUMBNAILS."

I WANT TO DRAW LIKE A PRO, NOWWW!!

*UKIIIIIII

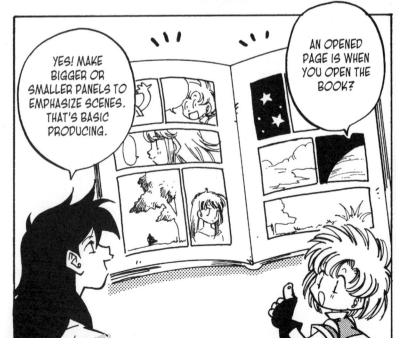

YES! MAKE BIGGER OR SMALLER PANELS TO EMPHASIZE SCENES. THAT'S BASIC PRODUCING.

AN OPENED PAGE IS WHEN YOU OPEN THE BOOK?

OK? WHEN YOU'RE CREATING YOUR "THUMBNAILS," THINK OF THEM AS AN OPENED PAGE (TWO PAGES AT SAME TIME.)

46

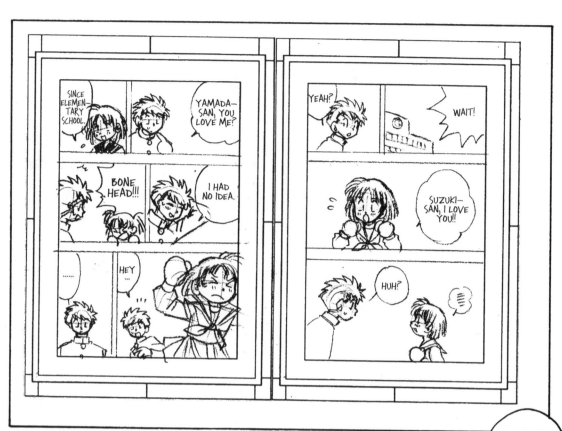

WELL, CHECK YOUR "THUMBNAILS" AGAIN AND ENHANCE THE PANELS THAT ARE MOST IMPORTANT.

MMMM... ...

YES. I WASN'T ABLE TO FIGURE OUT IF THE PANELS SHOULD BE BIG OR SMALL.

BOO... HOO...

AH, I SEE. THE CLIMAX SCENE FOR A LOVE STORY MANGA.

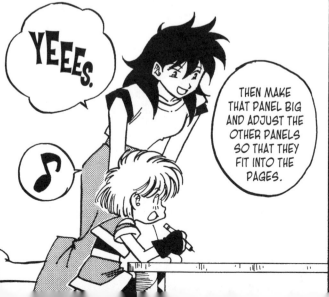

YEEES.

THEN MAKE THAT PANEL BIG AND ADJUST THE OTHER PANELS SO THAT THEY FIT INTO THE PAGES.

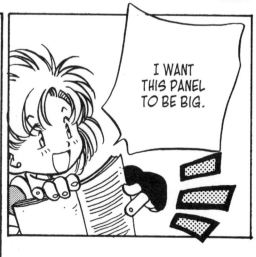

I WANT THIS PANEL TO BE BIG.

*IN THE PROCESS OF WORKING ON THE SIZE OF THE PANELS OR LAYOUT, YOU MIGHT WANT TO RECONSIDER THE NECESSITY OF A PARTICULAR PANEL, AND ELIMINATE IT. IN THESE SCENES, THE LAST PANEL WAS ELIMINATED.

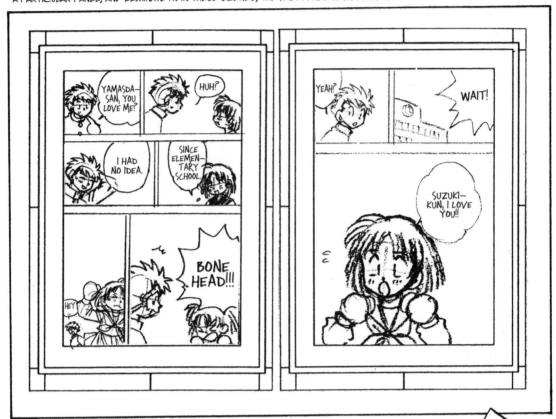

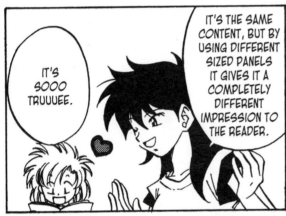

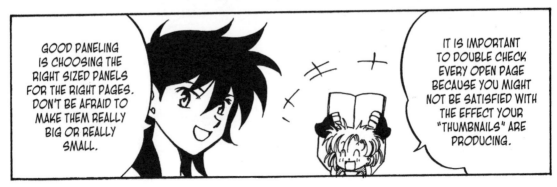

THUMBNAILS ARE LIKE A BLUEPRINT FOR MANGA. USE A NOTE PAD TO DRAW THE PANELING, COMPOSITION, AND DIALOG... IMAGINE YOUR FINISHED WORK. IN CASE OF STORY MANGA, START PANELING FROM THE SECOND PAGE BECAUSE THE FIRST PAGE IS FOR THE COVER PICTURE.

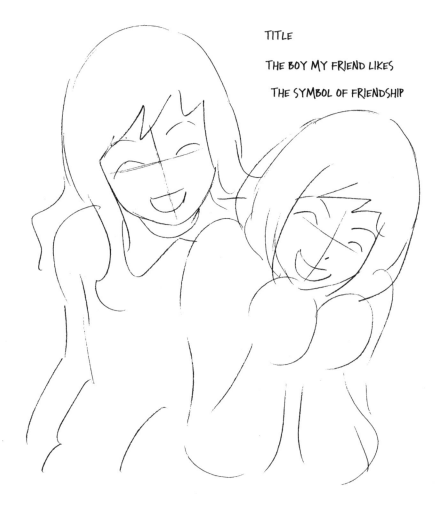

TITLE

THE BOY MY FRIEND LIKES

THE SYMBOL OF FRIENDSHIP

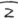

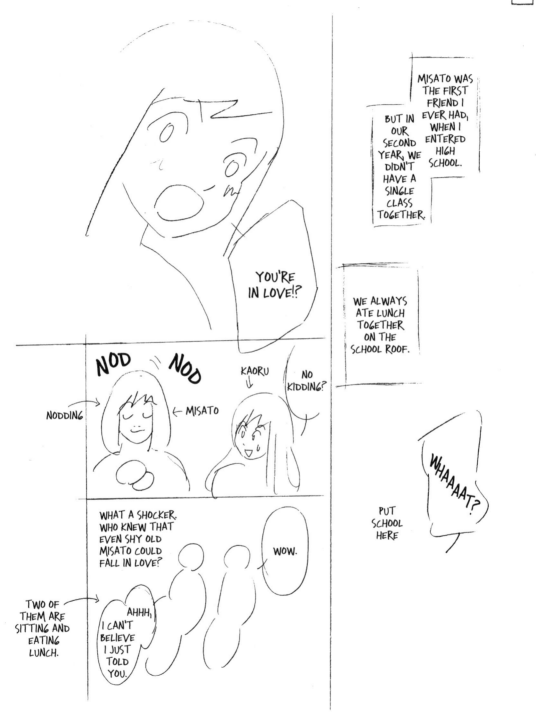

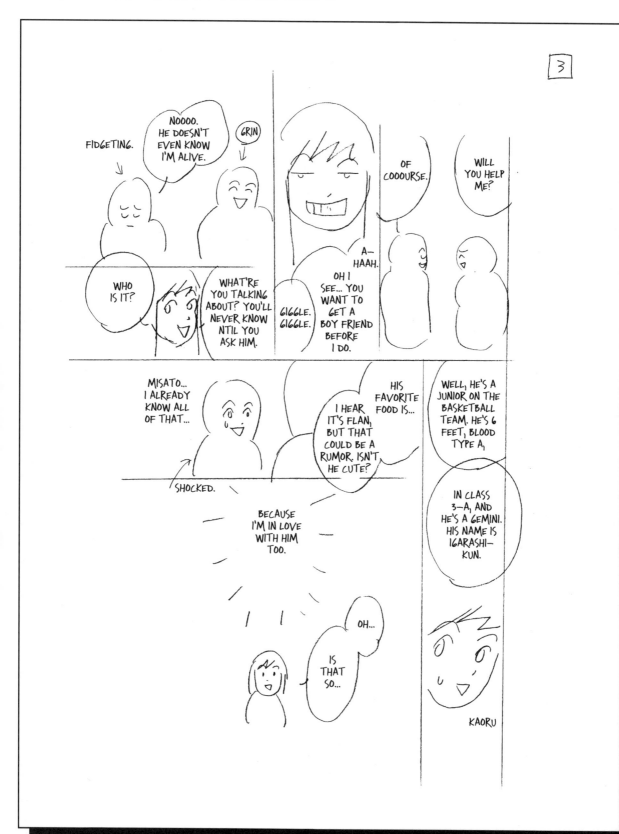

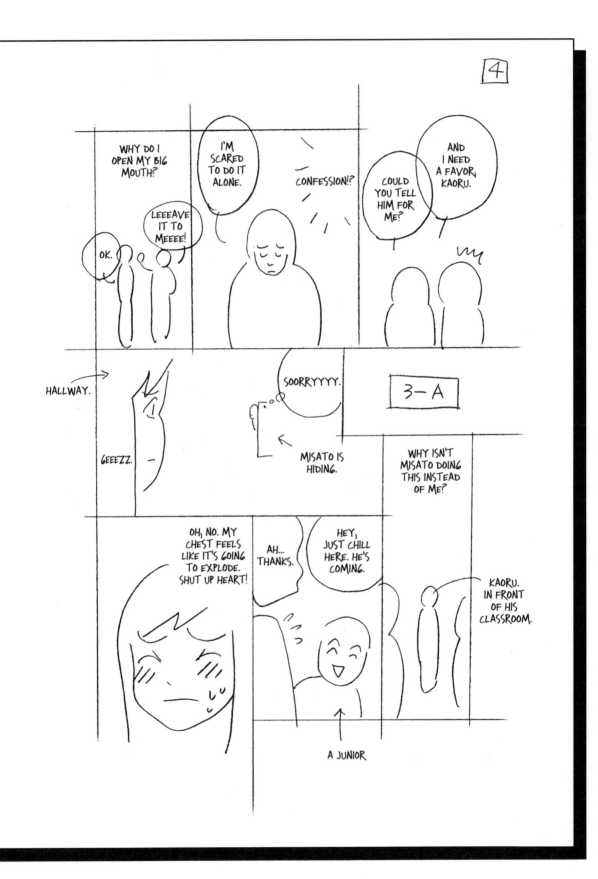

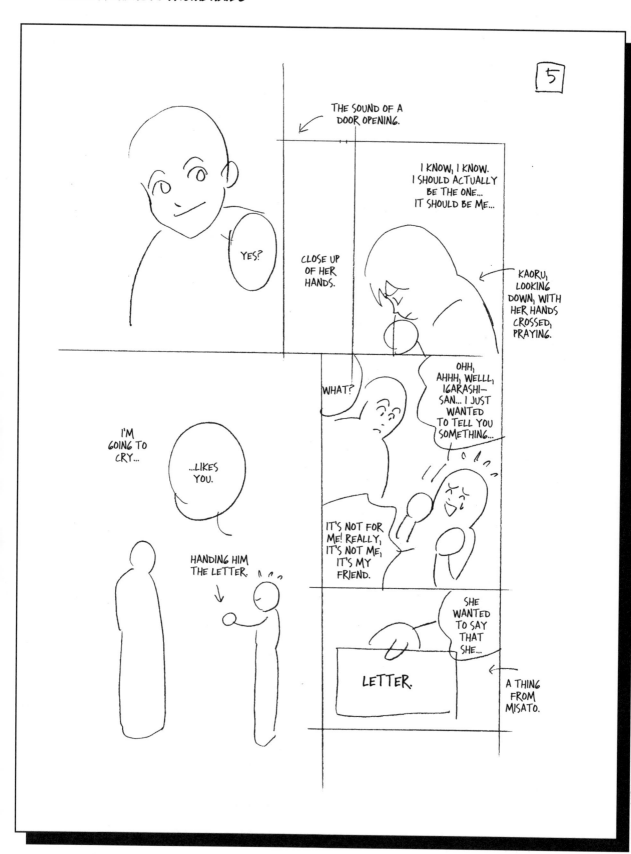

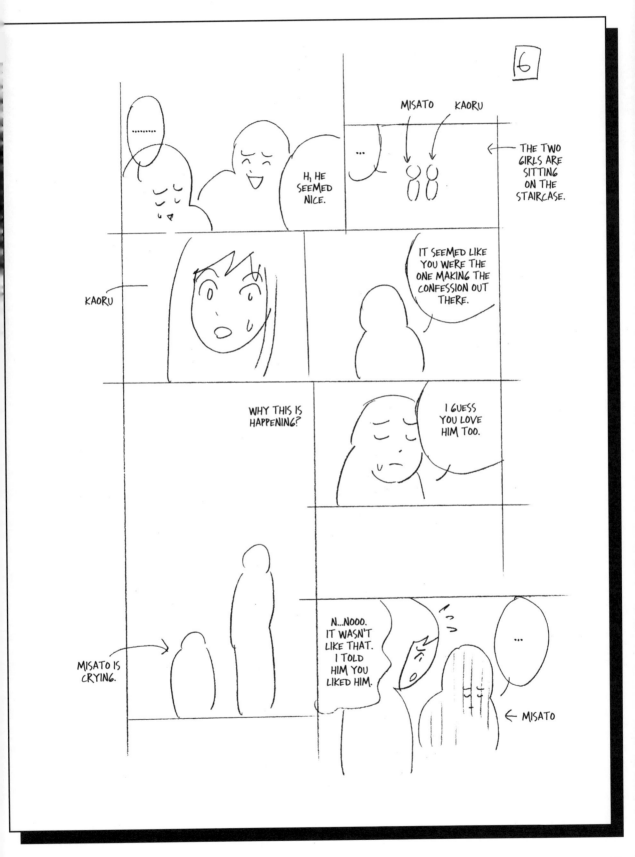

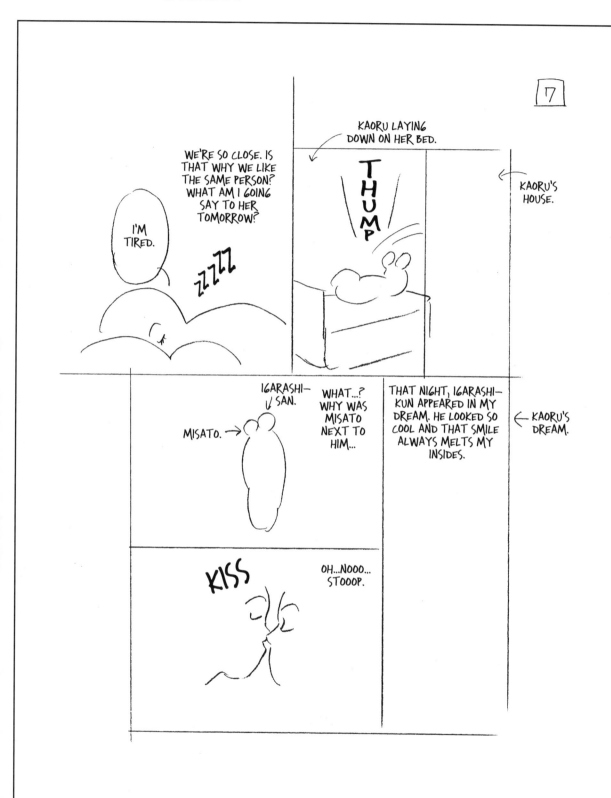

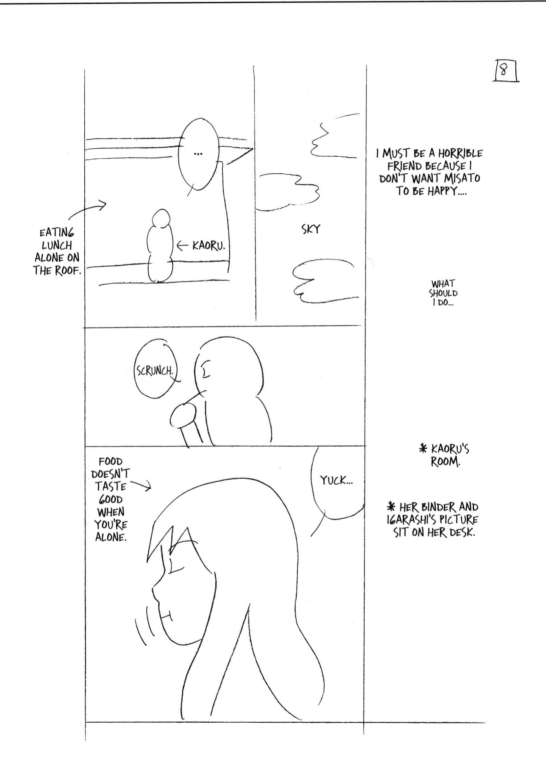

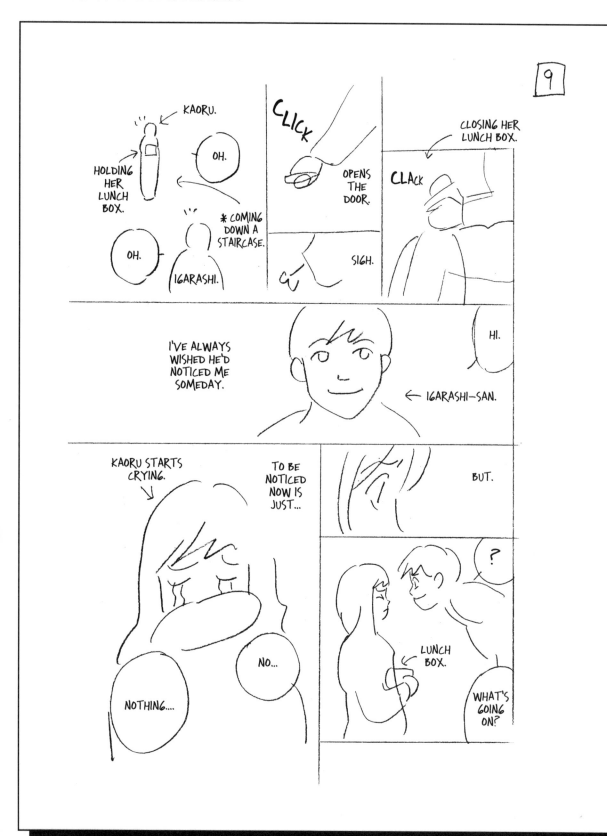

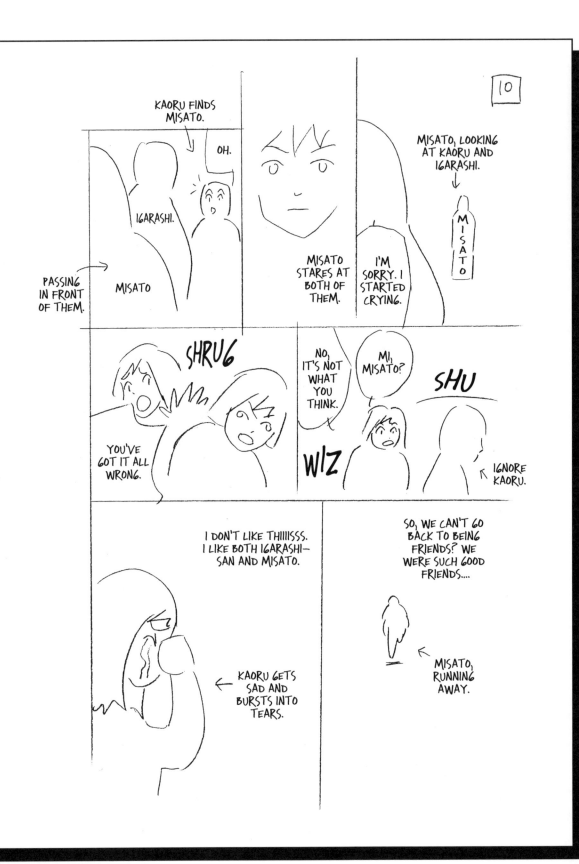

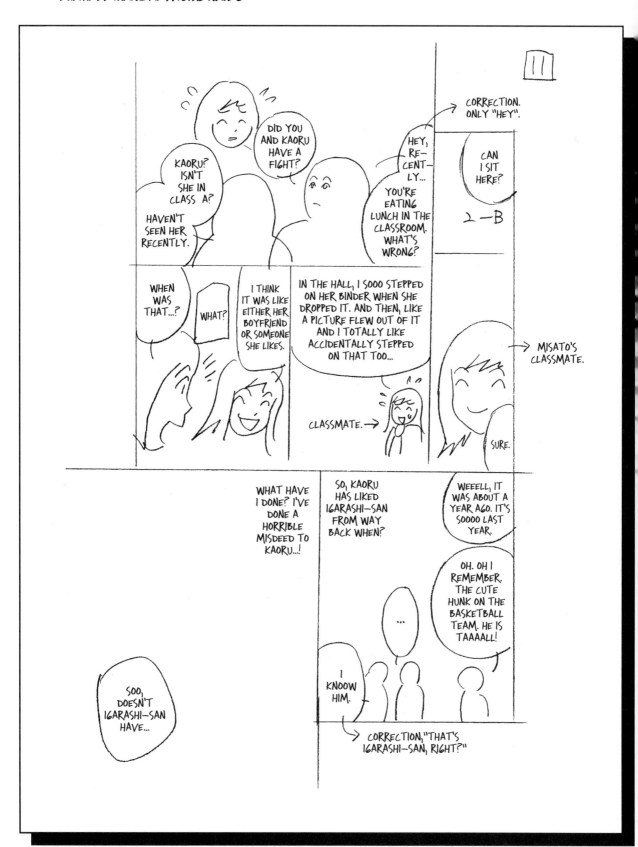

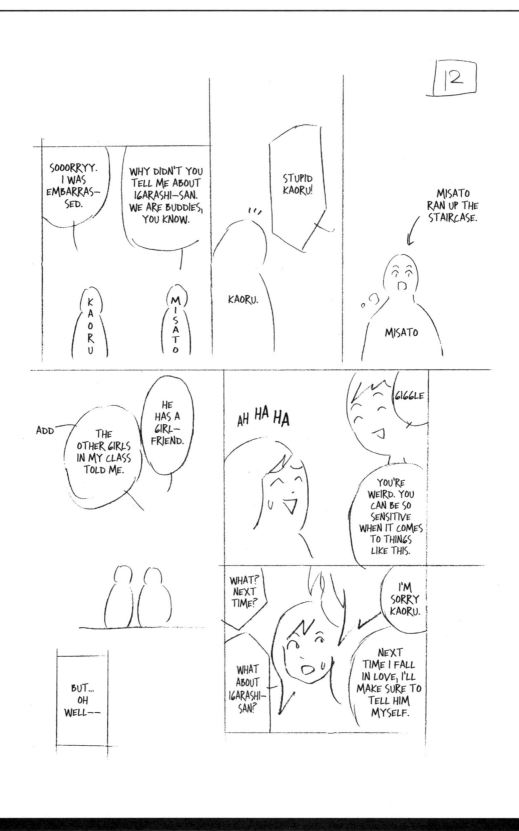

⑥ Creating Good "Drafts" or "Pencils" to Make Good Drawings.

◎ NECESSARY TOOLS: A NOTEBOOK, NOTE PAD, PENCIL OR MECHANICAL PENCIL (B-B2) AND AN ERASER.
◎ USEFUL TOOLS IF YOU HAVE THEM: A SOFT ERASER AND A LIGHT BOX.

YEAH, THE OTHER BOOK SAID THAT I COULD USE KENT PAPER. IS THAT OK?

WAIT A MINUTE ALISA. IS THAT THE PAPER YOU'RE GOING TO USE?

*HE HE HE

FINALLY, WE GET TO DRAW THE ACTUAL MANGA.

YOU CAN BUY SPECIAL PRE-FORMATTED PAPER FOR DRAWING MANGA.

*TADAA.

BUT IT'S TOO MUCH WORK TO MEASURE EACH PAGE.

WHAAAT?

THE PAPER FOR MANGA HAS A STANDARD SIZE FOR DRAWING PICTURES.

I DON'T HAVE TO MEASURE AND IT'S EASY TO DIVIDE PANELS.

THE SPECIAL PAPER FOR MANGA IS EXTREMELY CONVENIENT BECAUSE IT'S ALREADY PRE-MEASURED AND PRINTED WITH LIGHT BLUE OR YELLOW INK.

SELF-PUBLISHED PAPER (SIZE A 4) & GENERAL PUBLISHED PAPER (SIZE B 4)

＊SIZE B 5 (VERTICAL 257MM (10 1/8 IN) X HORIZONTAL 182MM (7 1/16 IN)) IS THE STANDARD MANGA SIZE USED BY AUTHORS WHO ARE SUBMITTING TO PUBLISHERS.

＊BOTH TYPES OF PAPER OUT ON THE MARKET HAVE THE BASIC FRAMES PRINTED ON THEM; THE TACHIKIRI 1 FRAME AND THE TACHIKIRI 2 FRAME. THE PRINTABLE AREA ENDS AT THE TACHIKIRI 1 FRAME LINE. HOWEVER, IF YOUR PICTURE ENDS AT THIS LINE, WHEN YOUR BOOK IS PRINTED THERE WILL BE A VISIBLE WHITE GAP ALONGSIDE THE EDGE. THAT'S WHY WE SUGGEST YOUR DRAWING END AT THE TACHIKIRI 2 FRAME LINE.

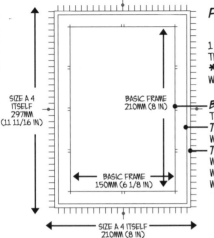

SIZE A 4 ITSELF 297MM (11 11/16 IN)

BASIC FRAME 210MM (8 IN)

BASIC FRAME 150MM (6 1/8 IN)

BASIC FRAME 210MM (8 IN)

SIZE A 4 ITSELF 210MM (8 IN)

FOR SELF- PUBLISHING (DOUJINN-YO), SIZE A 4 MANUSCRIPT PAPER

THE SIZE A 4 (297MM (11 11/16IN) X 210MM(8 1/4IN)) PAPER IS PRINTED WITH THE TACHIKIRI 1 FRAME JUST LIKE THE B 5 PAPER. WHEN A PUBLISHER WANTS TO MAKE THE MANGA SIZE B 5, THEY USE THE ORIGINAL MEASUREMENTS.

＊DOUJINN-SHI, SELF-PUBLISH BOOK (AUTHORS WHO USE THEIR OWN MONEY TO PUBLISH THEIR WORK) USE THE SIZE A 4 FOR THIS KIND OF PUBLISHING.

BASIC FRAME
THIS FRAME IS USED WHEN YOUR PANELS DON'T BLEED OFF OF THE PAGE.

TACHIKIRI FRAME 1
WHEN THE BOOK IS PRINTED THIS IS WHERE THE BOOK WILL BE CUT

TACHIKIRI FRAME 2
WHEN DRAWING ARTWORK ON THE PAGE MAKE SURE TO DRAW UP TO THIS LINE. THAT WAY YOU WILL BE GUARANTEED THAT THERE WILL BE ARTWORK ON THE EDGE RATHER THAN A WHITE GAP WHEN IT COMES BACK FROM THE PRINTERS.

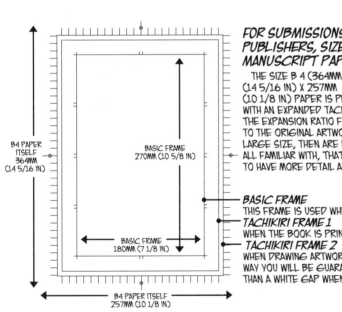

B4 PAPER ITSELF 364MM (14 5/16 IN)

BASIC FRAME 270MM (10 5/8 IN)

BASIC FRAME 180MM (7 1/8 IN)

B4 PAPER ITSELF 257MM (10 1/8 IN)

FOR SUBMISSIONS TO PUBLISHERS, SIZE B4 MANUSCRIPT PAPER

THE SIZE B 4 (364MM (14 5/16 IN) X 257MM (10 1/8 IN) PAPER IS PRINTED WITH AN EXPANDED TACHIKIRI 1 FRAME. THE EXPANSION RATIO FROM THE FINAL BOOK TO THE ORIGINAL ARTWORK IS USUALLY 120%. THE ORIGINALS ARE CREATED IN THIS LARGE SIZE, THEN ARE REDUCED AND PRINTED IN THE MANGA FORMAT WHICH WE ARE ALL FAMILIAR WITH, THAT ARE FOUND IN BOOKSTORES. THIS WAY THE ARTWORK APPEARS TO HAVE MORE DETAIL AND A FINISHED BEAUTIFUL LOOK.

BASIC FRAME
THIS FRAME IS USED WHEN YOUR PANELS DON'T BLEED OFF OF THE PAGE.

TACHIKIRI FRAME 1
WHEN THE BOOK IS PRINTED THIS IS WHERE THE BOOK WILL BE CUT

TACHIKIRI FRAME 2
WHEN DRAWING ARTWORK ON THE PAGE MAKE SURE TO DRAW UP TO THIS LINE. THAT WAY YOU WILL BE GUARANTEED THAT THERE WILL BE ARTWORK ON THE EDGE RATHER THAN A WHITE GAP WHEN IT COMES BACK FROM THE PRINTERS.

● ADDITIONAL ●

○ SIZE B 5 (257MM (10 1/8 IN) X 182MM (7 3/16))/NOTEBOOK SIZE (IN JAPAN).
"RIBBON" AND "SHONEN JUMP" ARE BOTH THIS SIZE.

○ SIZE A 5 (210MM (8 IN) X 148MM (7 3/16 IN))/SMALL TEXT BOOK (IN JAPAN). "KORO KORO COMIC" IS THIS SIZE

＊ YOU CAN FIND THE SPECIAL MANGA PAPER IN SPECIALIZED STORES. THEY USE SPECIAL INK (IN THE FRAME LINES,) WHICH WON'T SHOW UP IN PRINTING OR COPING. USE THESE FRAMES TO DRAW AT YOUR CONVENIENCE. ALSO, THIS KIND OF PAPER IS TEXTURED SO THAT IT IS EASY TO USE WITH THE TSUKE-PEN, SO IT'S SUITABLE FOR BEGINNERS. YOU CAN FIND THIS PAPER AND TSUKE-PENS AT SPECIALIZED ART STORES AND MANGA SUPPLY STORES.

＊ IF YOU'RE SELF-PUBLISHING WORK USE THE SAME SIZED PAPER AND THE SAME TACHIKIRI GUIDELINES AS THE PROS WHO ARE BEING PUBLISHED.

＊ THE SIZES OF SELF-PUBLISHING BOOKS ARE A 5 AND B 5. LATELY, THEY ARE SIZE A 4 (TWO OF A 5) OR B 6 (HALF OF B 5) FOR SELF-PUBLISHED BOOKS.

GENERALLY, THERE ARE TWO DIFFERENT SIZES.

DIFFERENT SIZES FOR REGULAR PUBLISHING AND SELF-PUBLISHING.

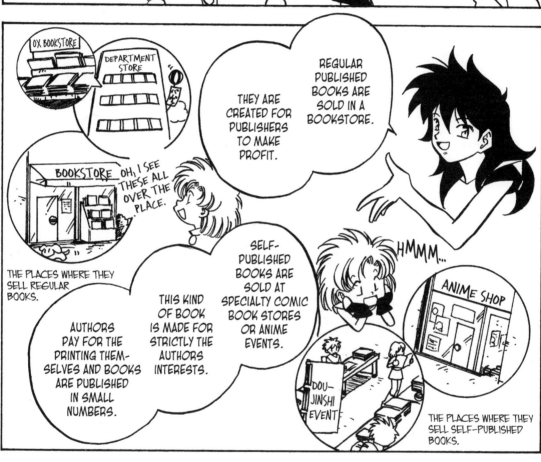

OX BOOKSTORE

DEPARTMENT STORE

REGULAR PUBLISHED BOOKS ARE SOLD IN A BOOKSTORE.

THEY ARE CREATED FOR PUBLISHERS TO MAKE PROFIT.

BOOKSTORE

OH, I SEE THESE ALL OVER THE PLACE.

THE PLACES WHERE THEY SELL REGULAR BOOKS.

AUTHORS PAY FOR THE PRINTING THEMSELVES AND BOOKS ARE PUBLISHED IN SMALL NUMBERS.

THIS KIND OF BOOK IS MADE FOR STRICTLY THE AUTHORS INTERESTS.

SELF-PUBLISHED BOOKS ARE SOLD AT SPECIALTY COMIC BOOK STORES OR ANIME EVENTS.

HMMM...

ANIME SHOP

DOU-JINSHI EVENT

THE PLACES WHERE THEY SELL SELF-PUBLISHED BOOKS.

HUUUUUGE !!

AND THE RULES SAY MY SUBMISSION SHOULD BE SIZE B4.

WELL, I'M GOING TO ENTER A NEW ARTIST CONTEST.

THE MANUSCRIPT FOR A COMIC STRIP

THE MANUSCRIPT FOR A STORY MANGA

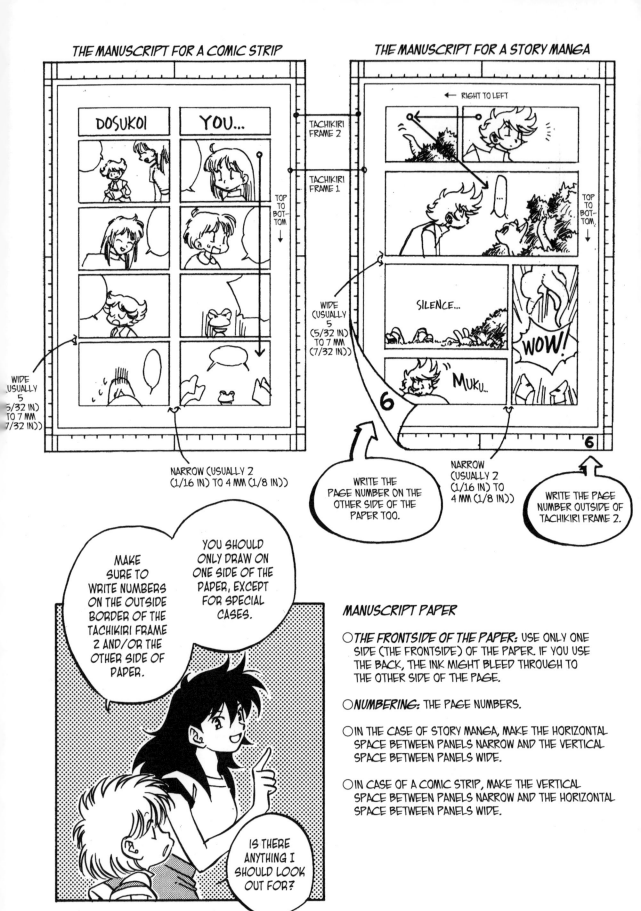

DOSUKOI

YOU...

← RIGHT TO LEFT

TACHIKIRI FRAME 2

TACHIKIRI FRAME 1

TOP TO BOTTOM ↓

TOP TO BOTTOM ↓

SILENCE...

WOW!

"MUKU...

WIDE (USUALLY 5 (5/32 IN) TO 7 MM (7/32 IN))

WIDE USUALLY 5 (5/32 IN) TO 7 MM (7/32 IN))

NARROW (USUALLY 2 (1/16 IN) TO 4 MM (1/8 IN))

NARROW (USUALLY 2 (1/16 IN) TO 4 MM (1/8 IN))

WRITE THE PAGE NUMBER ON THE OTHER SIDE OF THE PAPER TOO.

WRITE THE PAGE NUMBER OUTSIDE OF TACHIKIRI FRAME 2.

MAKE SURE TO WRITE NUMBERS ON THE OUTSIDE BORDER OF THE TACHIKIRI FRAME 2 AND/OR THE OTHER SIDE OF PAPER.

YOU SHOULD ONLY DRAW ON ONE SIDE OF THE PAPER, EXCEPT FOR SPECIAL CASES.

IS THERE ANYTHING I SHOULD LOOK OUT FOR?

MANUSCRIPT PAPER

○ **THE FRONTSIDE OF THE PAPER:** USE ONLY ONE SIDE (THE FRONTSIDE) OF THE PAPER. IF YOU USE THE BACK, THE INK MIGHT BLEED THROUGH TO THE OTHER SIDE OF THE PAGE.

○ **NUMBERING:** THE PAGE NUMBERS.

○ IN THE CASE OF STORY MANGA, MAKE THE HORIZONTAL SPACE BETWEEN PANELS NARROW AND THE VERTICAL SPACE BETWEEN PANELS WIDE.

○ IN CASE OF A COMIC STRIP, MAKE THE VERTICAL SPACE BETWEEN PANELS NARROW AND THE HORIZONTAL SPACE BETWEEN PANELS WIDE.

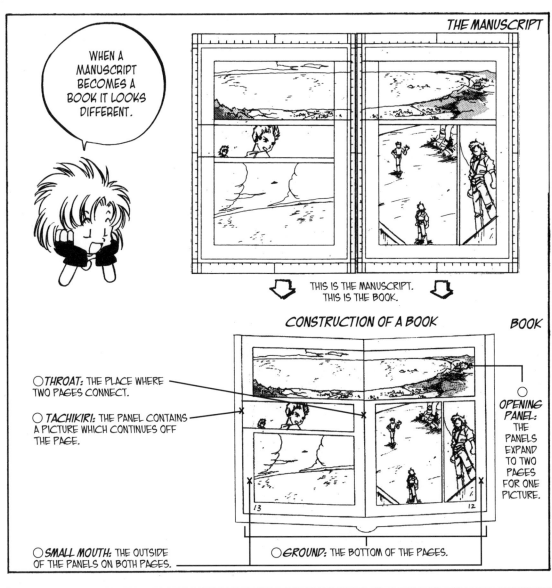

THE MANUSCRIPT

WHEN A MANUSCRIPT BECOMES A BOOK IT LOOKS DIFFERENT.

THIS IS THE MANUSCRIPT. THIS IS THE BOOK.

CONSTRUCTION OF A BOOK

BOOK

○ THROAT: THE PLACE WHERE TWO PAGES CONNECT.

○ TACHIKIRI: THE PANEL CONTAINS A PICTURE WHICH CONTINUES OFF THE PAGE.

○ OPENING PANEL: THE PANELS EXPAND TO TWO PAGES FOR ONE PICTURE.

○ SMALL MOUTH: THE OUTSIDE OF THE PANELS ON BOTH PAGES.

○ GROUND: THE BOTTOM OF THE PAGES.

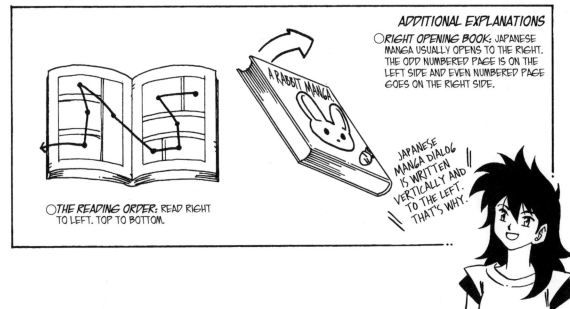

ADDITIONAL EXPLANATIONS

○ RIGHT OPENING BOOK: JAPANESE MANGA USUALLY OPENS TO THE RIGHT. THE ODD NUMBERED PAGE IS ON THE LEFT SIDE AND EVEN NUMBERED PAGE GOES ON THE RIGHT SIDE.

A RABBIT MANGA

JAPANESE MANGA DIALOG IS WRITTEN VERTICALLY AND TO THE LEFT. THAT'S WHY.

○ THE READING ORDER: READ RIGHT TO LEFT. TOP TO BOTTOM.

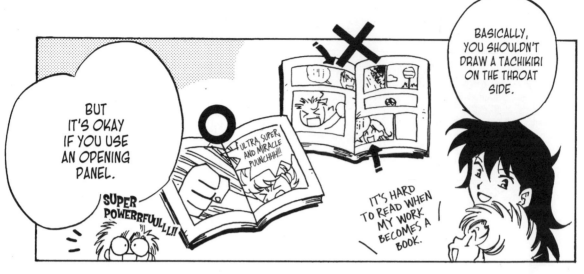

BASICALLY, YOU SHOULDN'T DRAW A TACHIKIRI ON THE THROAT SIDE.

IT'S HARD TO READ WHEN MY WORK BECOMES A BOOK.

BUT IT'S OKAY IF YOU USE AN OPENING PANEL.

ULTRA SUPER AND MIRACLE PUUNCHHH!!!!

SUPER POWERRFUULLL!!

WHY NOT?

DON'T START OFF WITH A PEN.

FINALLLLYYY.

OK. START YOUR WORK ON MANUSCRIPT PAPER.

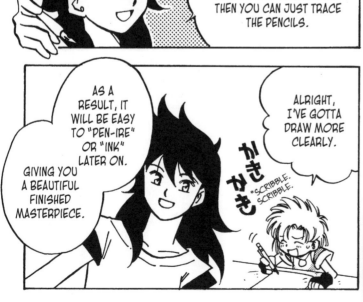

IF YOU AREN'T FAMILIAR WITH THE WORK, YOU SHOULD DRAW GOOD PENCILS AND THEN YOU CAN JUST TRACE THE PENCILS.

AS A RESULT, IT WILL BE EASY TO "PEN-IRE" OR "INK" LATER ON.

GIVING YOU A BEAUTIFUL FINISHED MASTERPIECE.

ALRIGHT, I'VE GOTTA DRAW MORE CLEARLY.

かき かき
*SCRIBBLE. SCRIBBLE.

WON'T IT BE HARD TO FIX YOUR WORK IF YOU MADE A MISTAKE?

OH, I CAN'T ERASE IT. CAN I?

*MMMM.
MMMM.

*SCRIBBLE.
SCRIBBLE.

OOKAAYY

IF YOU USE A HARD PENCIL OR MECHANICAL PENCIL, YOU MIGHT SCRATCH THE PAPER.

YOU SHOULD USE A "B" OR "B2" LEAD.

IN THAT CASE, YOU SHOULD USE A KNEADED ERASER AND WORK ON SMALL DETAILS.

THE LINES ARE ALL MESSED UP.

OOHH, NOOO. I CAN'T DRAWWW.

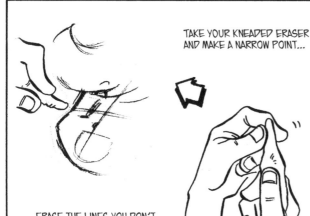

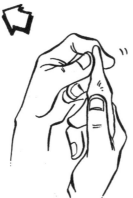

TAKE YOUR KNEADED ERASER AND MAKE A NARROW POINT...

ERASE THE LINES YOU DON'T NEED. THEN IT'S ALL GOOD!

IF YOU DRAW A PICTURE WITH TOO MANY CONFUSING LINES, YOU WON'T BE ABLE TO TELL WHICH LINES ARE FOR TRACING LATER...

**A KNEADED ERASER CAN BE FORMED FREELY LIKE CLAY. YOU CAN FIND THIS AT ANY ART SUPPLY SHOP.

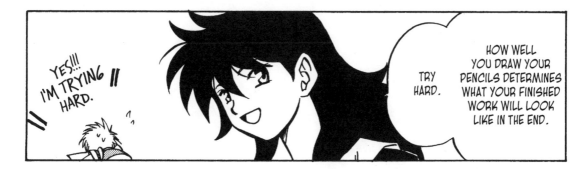

YES!!! I'M TRYING HARD.

TRY HARD.

HOW WELL YOU DRAW YOUR PENCILS DETERMINES WHAT YOUR FINISHED WORK WILL LOOK LIKE IN THE END.

DO YOU EVER HAVE TROUBLE DRAWING YOUR CHARACTER FROM DIFFERENT ANGLES? YOU DRAW THE CHARACTER FACING RIGHT THEN FACING LEFT AND HE/SHE LOOKS COMPLETELY DIFFERENT. USUALLY PEOPLE HAVE ONE STRONG SIDE IN WHICH THEY DRAW THEIR CHARACTER. FOR THOSE OF YOU OUT THERE WHO HAVE THIS PROBLEM, DO NOT WORRY! WE HAVE THE TRICK FOR YOU! IT'S CALLED "URA-GAKI" OR REVERSE DRAWING. EVEN THE PROS ARE USING THIS AND IT'LL COME IN HANDY ONCE YOU REMEMBER IT.

ONE POINT ADVICE

THE OPEN SIDE

① DRAW A ROUGH SKETCH OF YOUR CHARACTER FACING THE OPPOSITE DIRECTION OF THE ANGLE THAT YOU'RE GOOD AT DRAWING.

② FLIP THE PAPER OVER AND USE A LIGHTBOX OR WINDOW TO SEE THROUGH TO THE OPPOSITE SIDE. (THIS SHOULD BE THE ANGLE THAT YOU ARE GOOD AT DRAWING). DRAW YOUR CHARACTER. WHEN YOU ARE DRAWING YOUR CHARACTER, REMEMBER TO DRAW THE HAIRSTYLE OR A COLLAR IN REVERSE.

③ FLIP THE PAPER OVER. THEN LOOK THROUGH THE PAGE ONCE AGAIN.

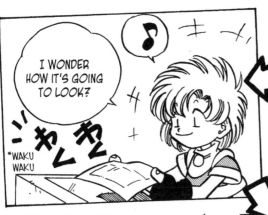

I WONDER HOW IT'S GOING TO LOOK?

*WAKU WAKU

④ TRACE THE PICTURE.

THE FRONT

⑤ FINISHED!

WOW!

GREEAATT

● END ●

68

THE FOLLOWING 12 PAGES ARE WORK FROM A PROFESSIONAL. NOW OPEN TO THE PUBLIC!!

EXAMPLE MANGA

PENCILS

FROM HERE ON IN, WE WILL WORK ON REAL MANUSCRIPT PAPER. IF YOU WERE LAZY ABOUT DRAWING YOUR PENCILS, THE FINISHED WORK WILL SUFFER. THAT'S WHY YOU SHOULD DRAW DETAILED PENCILS NOT JUST THE CHARACTERS BUT INCLUDE BACKGROUNDS OR BUILDINGS TOO. THIS EXAMPLE DOESN'T INCLUDE DIALOG, BUT YOU CAN INSERT THAT IN LATER.

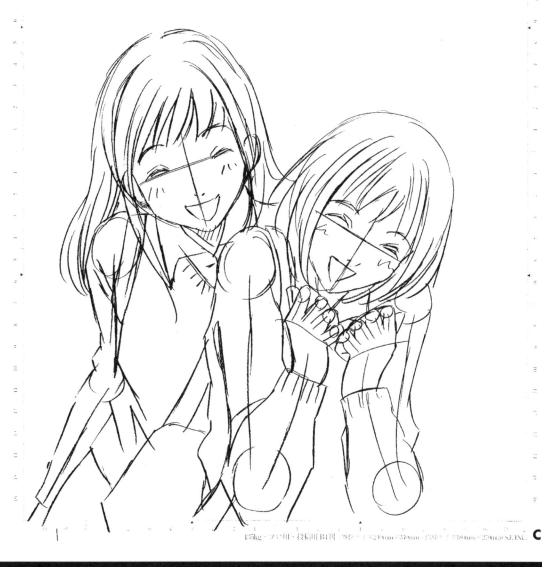

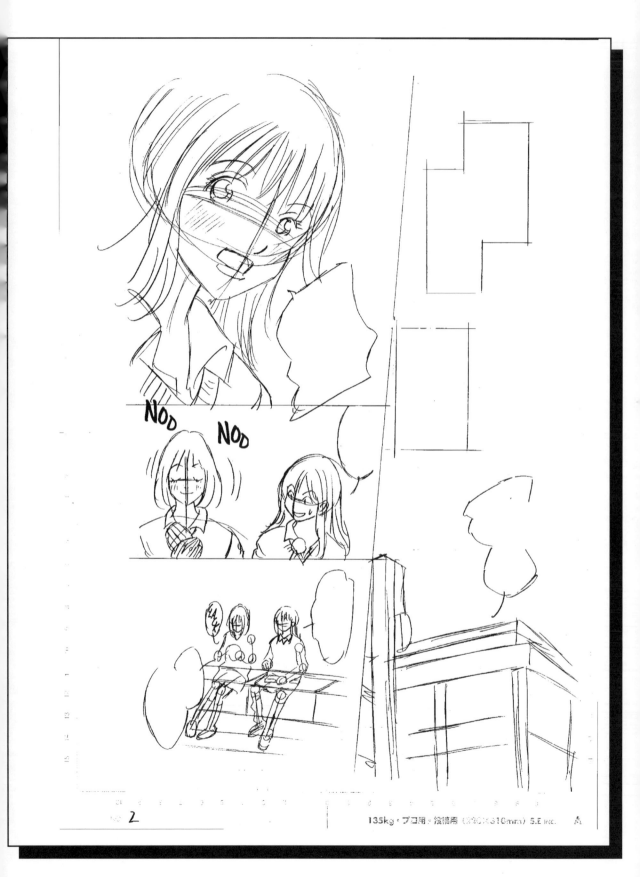

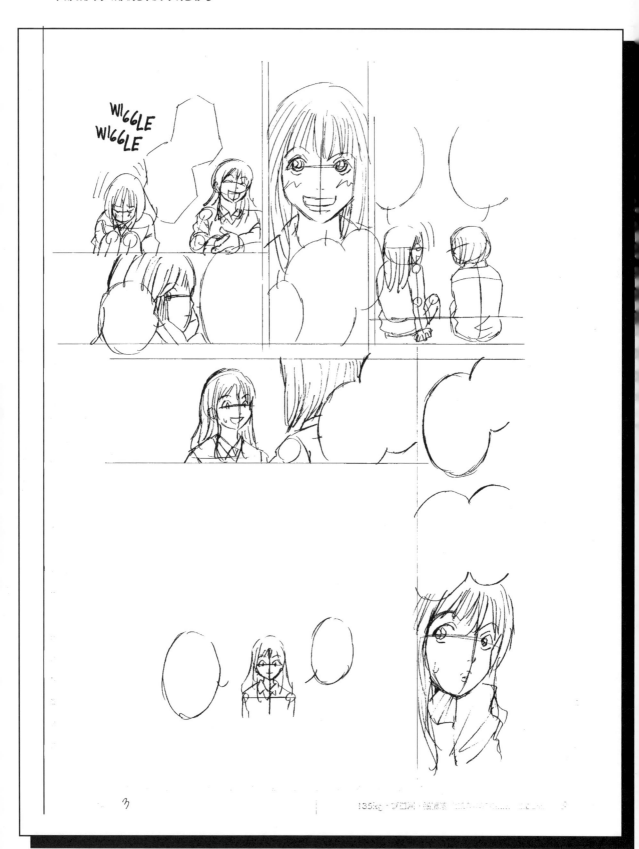

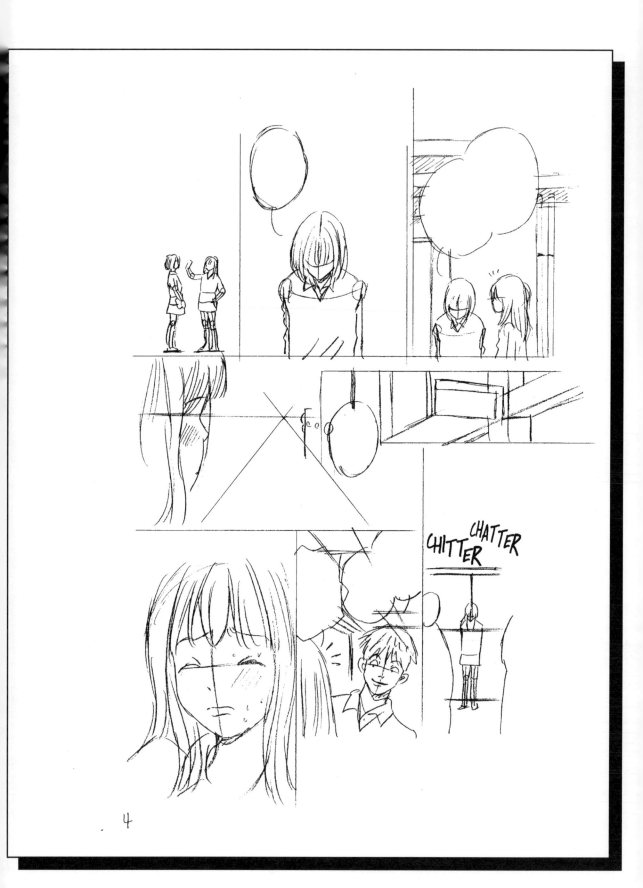

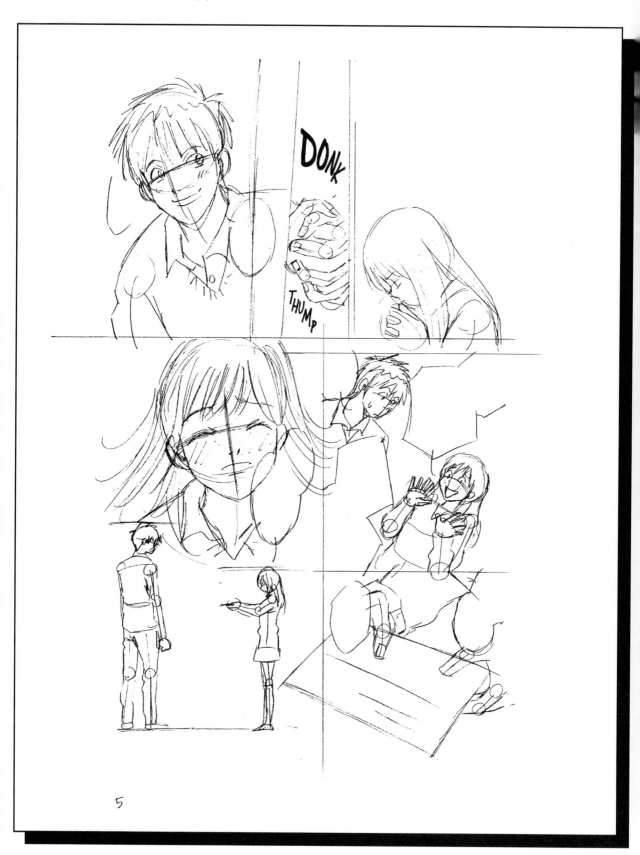

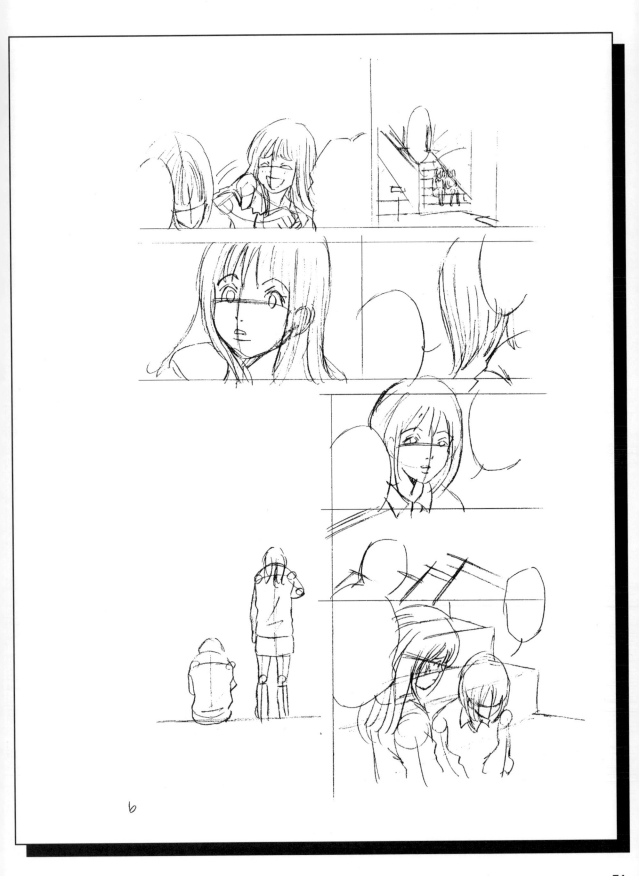

6

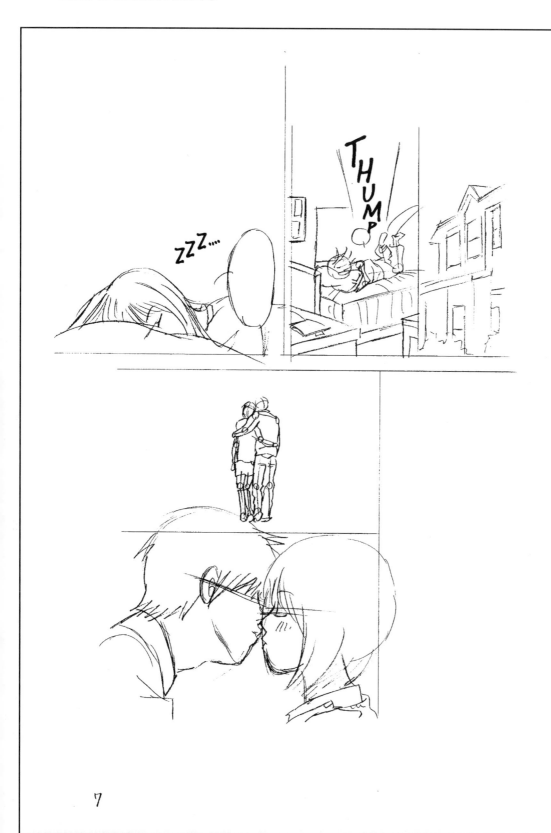

7

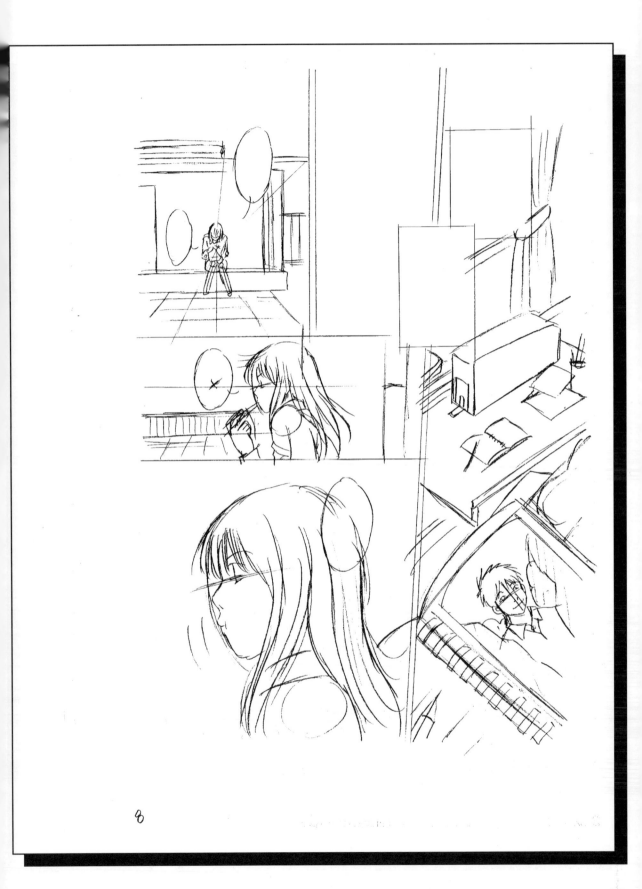

8

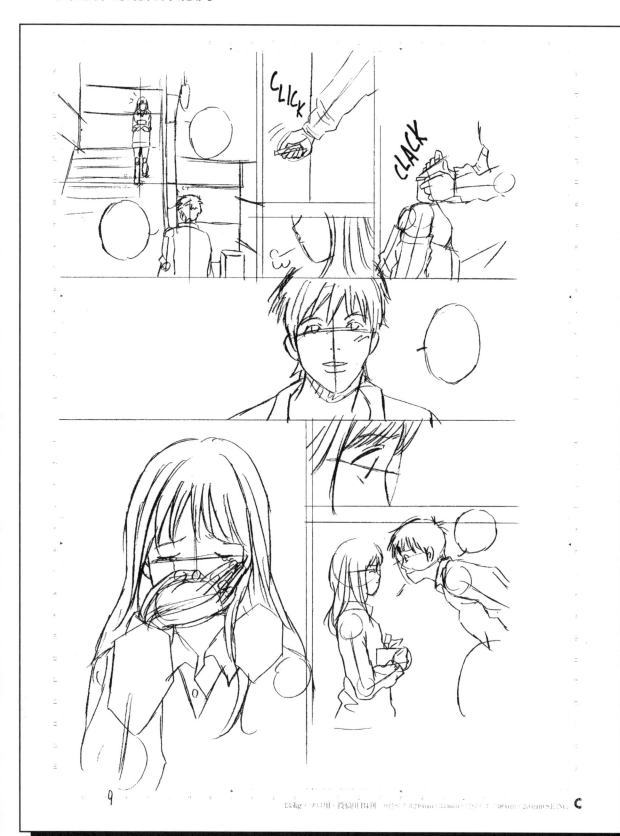

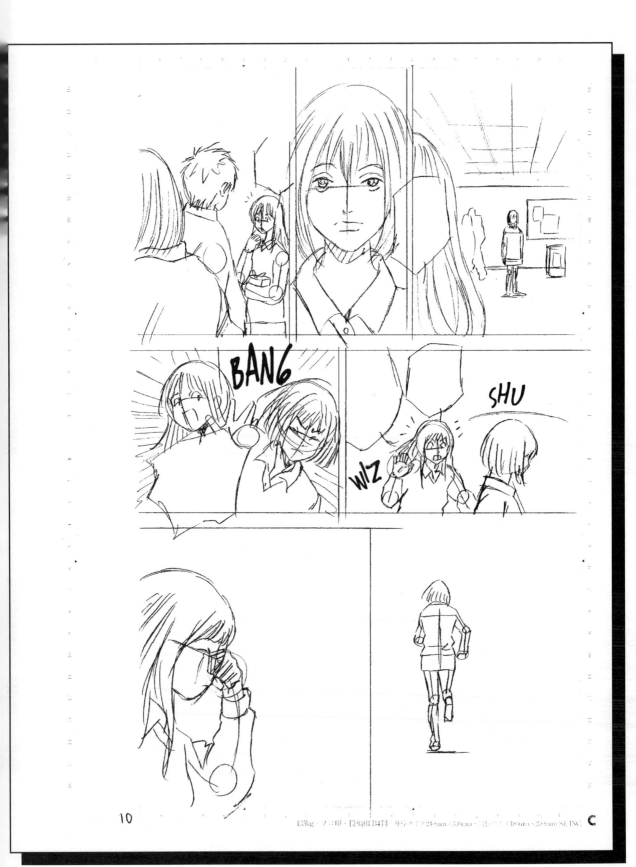

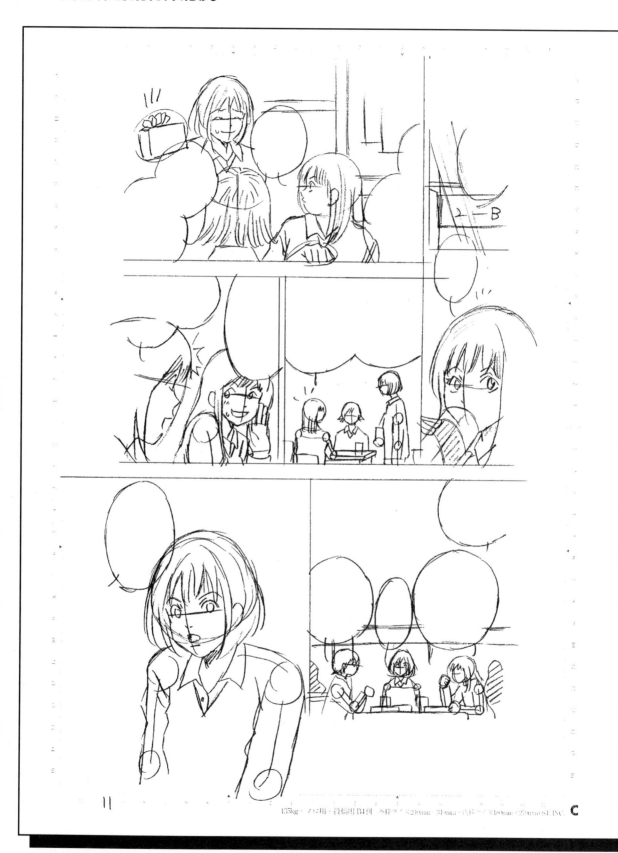

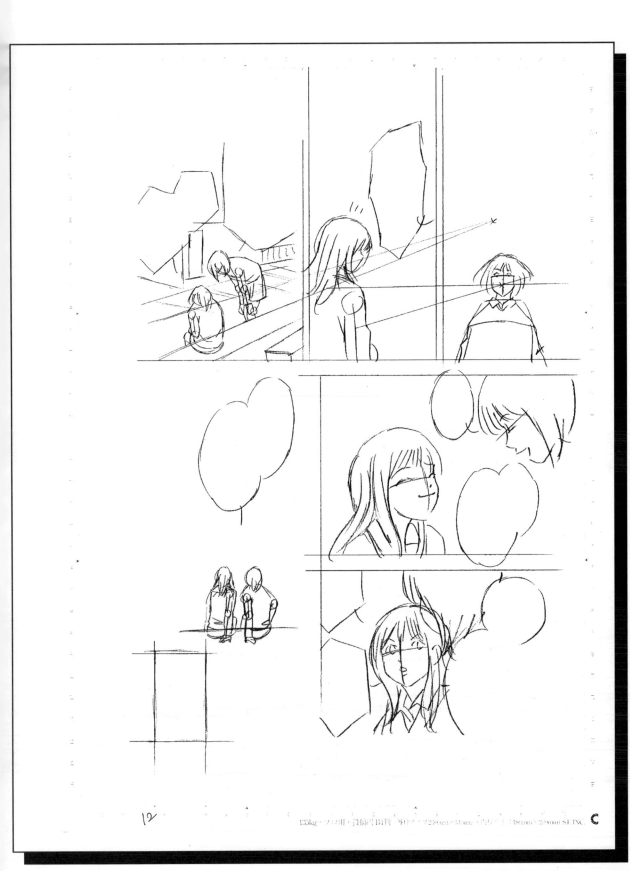

HOW TO DRAW IN PERSPECTIVE

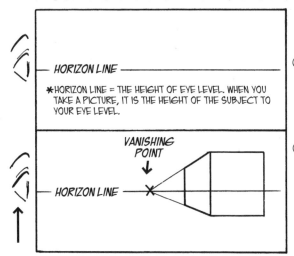

ONE POINT PERSPECTIVE DRAWING

① IF YOU WANT TO USE THIS TECHNIQUE, DECIDE WHERE THE HORIZON LINE SHOULD BE FIRST.

② DECIDE WHERE THE VANISHING POINT SHOULD BE ON THE HORIZON LINE YOU JUST DREW.

HORIZON LINE

*HORIZON LINE = THE HEIGHT OF EYE LEVEL. WHEN YOU TAKE A PICTURE, IT IS THE HEIGHT OF THE SUBJECT TO YOUR EYE LEVEL.

VANISHING POINT

HORIZON LINE

PERSPECTIVE DRAWING IS A TECHNIQUE THAT IS USED TO GIVE YOUR PICTURES DEPTH.

EYE LEVEL

HORIZON LINE

VANISHING POINT

③ IN A PICTURE, THE CLOSER A SUBJECT GETS TO THE VANISHING POINT, THE SMALLER THE SUBJECT SHOULD BE DRAWN. THIS TECHNIQUE CALLED ONE POINT PERSPECTIVE.

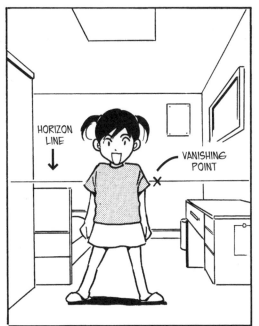

HORIZON LINE

VANISHING POINT

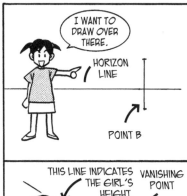

I WANT TO DRAW OVER THERE.

HORIZON LINE

POINT B

① FOR EXAMPLE, IF YOU WANT TO DRAW ONE MORE CHARACTER ON POINT "B"...

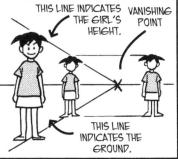

THIS LINE INDICATES THE GIRL'S HEIGHT.

VANISHING POINT

THIS LINE INDICATES THE GROUND.

② IF THE PICTURE IS IN BETWEEN BOTH THE "A" LINES, THE OTHER PICTURE WILL BE SAME SIZE AS THE FIRST ONE. JUST IN PERSPECTIVE.

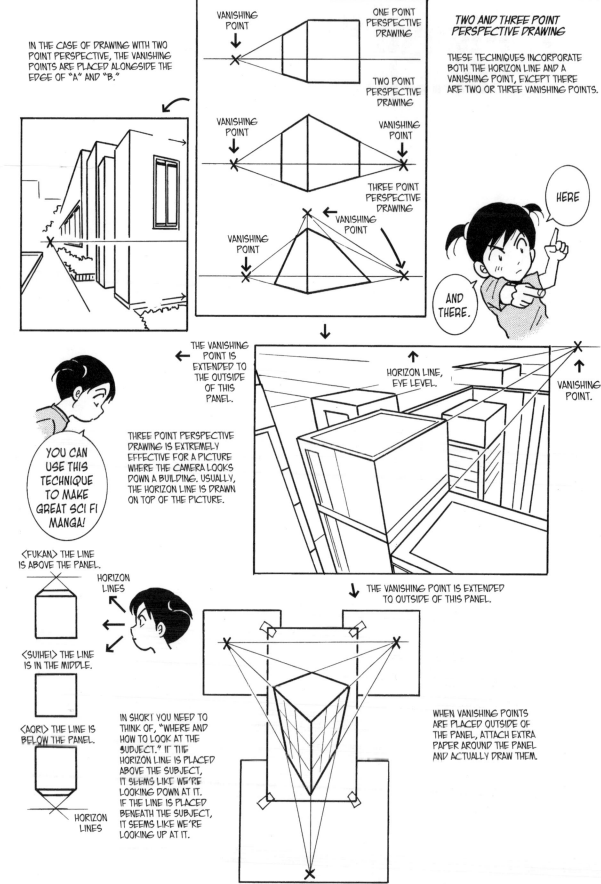

IN THE CASE OF DRAWING WITH TWO POINT PERSPECTIVE, THE VANISHING POINTS ARE PLACED ALONGSIDE THE EDGE OF "A" AND "B."

VANISHING POINT

ONE POINT PERSPECTIVE DRAWING

TWO POINT PERSPECTIVE DRAWING

VANISHING POINT

VANISHING POINT

THREE POINT PERSPECTIVE DRAWING

VANISHING POINT

VANISHING POINT

VANISHING POINT

TWO AND THREE POINT PERSPECTIVE DRAWING

THESE TECHNIQUES INCORPORATE BOTH THE HORIZON LINE AND A VANISHING POINT, EXCEPT THERE ARE TWO OR THREE VANISHING POINTS.

HERE

AND THERE.

THE VANISHING POINT IS EXTENDED TO THE OUTSIDE OF THIS PANEL.

HORIZON LINE, EYE LEVEL.

VANISHING POINT.

YOU CAN USE THIS TECHNIQUE TO MAKE GREAT SCI FI MANGA!

THREE POINT PERSPECTIVE DRAWING IS EXTREMELY EFFECTIVE FOR A PICTURE WHERE THE CAMERA LOOKS DOWN A BUILDING. USUALLY, THE HORIZON LINE IS DRAWN ON TOP OF THE PICTURE.

THE VANISHING POINT IS EXTENDED TO OUTSIDE OF THIS PANEL.

<FUKAN> THE LINE IS ABOVE THE PANEL.

HORIZON LINES

<SUIHEI> THE LINE IS IN THE MIDDLE.

<AORI> THE LINE IS BELOW THE PANEL.

HORIZON LINES

IN SHORT YOU NEED TO THINK OF, "WHERE AND HOW TO LOOK AT THE SUBJECT." IF THE HORIZON LINE IS PLACED ABOVE THE SUBJECT, IT SEEMS LIKE WE'RE LOOKING DOWN AT IT. IF THE LINE IS PLACED BENEATH THE SUBJECT, IT SEEMS LIKE WE'RE LOOKING UP AT IT.

WHEN VANISHING POINTS ARE PLACED OUTSIDE OF THE PANEL, ATTACH EXTRA PAPER AROUND THE PANEL AND ACTUALLY DRAW THEM.

Digital Manga Publishing
1123 Dominguez Street, Unit K
Carson, California 90746-3539

Digital Manga Publishing
1123 Dominguez Street, Unit K
Carson, California 90746-3539

Attn: Manga Academy

Affix postage
stamp here.

Dear Manga Artist,

We hope you enjoyed our book. As we would like to come up with more manga and anime related books and products for you, please help us out by filling in your answers for the questions below and mail it back to us. Additional comments and suggestions are more than welcome.

1. Which book did you purchase? _____ Did you like it? (Yes / No)
2. Where did you buy this book? Store: _____ City / State _____ / _____
3. What are your favorite manga?
a.) _____ b.) _____ c.) _____
4. What are your favorite anime?
a.) _____ b.) _____ c.) _____
5. Who is your favorite a.) Manga/Anime Character? b.) Artist?
Characters: _____ Artists: _____

6. What would you like to see in a our future Let's Draw Manga?
() Horror () Monsters & Aliens () Combat () Super Deformed
() Urban Culture () Fantasy () Backgrounds () Heros & Villians
7. What new subjects, if not mentioned above, would you like to see?
a.) _____ b.) _____ c.) _____
8. Are you planning to a.) become a professional artist? _____ b.) publish doujinshi (fan comics)? _____ c.) anime? _____
9. What is your monthly expenditure on a.) manga? _____ b.) art supplies? _____
10. Which of the following best describes how you feel about drawing manga?
a.) I draw for fun _____ b.) A career in art sounds good _____ c.) Art school for me! _____ d.) I want to work in Japan _____

Your name: _____ Age: _____ Occupation/School: _____
Street Address: _____ City: _____ State / Country _____
Email address: _____

For even more learning, log on to Manga Academy and enroll for free today!

manga academy

www.mangaacademy.com

⑦ Manga Special Technique: "Pen-ire" or "Inking"

◎ *NECESSARY TOOLS: MANUSCRIPT PAPER, A NIB, PEN AXIS, MILI-PEN, INK OR SUMI INK AND FACIAL TISSUE PAPER.*

......

*SCRIBBLE. SCRIBBLE.

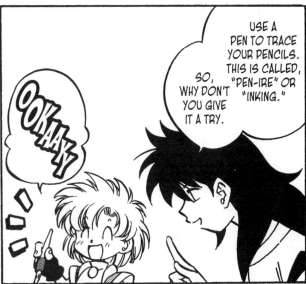

USE A PEN TO TRACE YOUR PENCILS. THIS IS CALLED, "PEN-IRE" OR "INKING."

SO, WHY DON'T YOU GIVE IT A TRY.

OOKAAAY

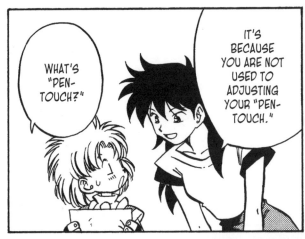

WHAT'S "PEN-TOUCH?"

IT'S BECAUSE YOU ARE NOT USED TO ADJUSTING YOUR "PEN-TOUCH."

I LIKE MY PENCILS BUT I'M NOT SURE ABOUT MY INKING.

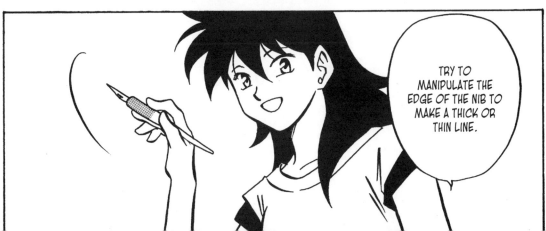

TRY TO MANIPULATE THE EDGE OF THE NIB TO MAKE A THICK OR THIN LINE.

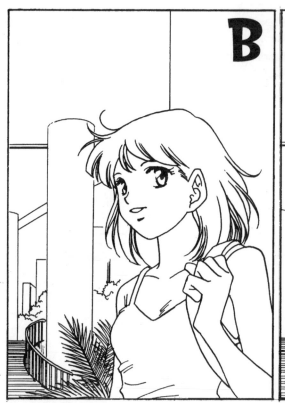

B

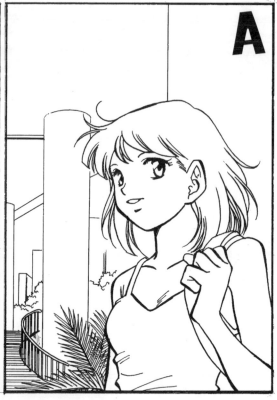

A

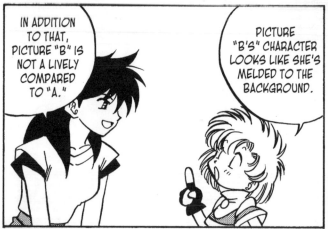

IN ADDITION TO THAT, PICTURE "B" IS NOT A LIVELY COMPARED TO "A."

PICTURE "B'S" CHARACTER LOOKS LIKE SHE'S MELDED TO THE BACKGROUND.

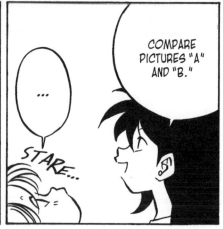

...

STARE...

COMPARE PICTURES "A" AND "B."

にょぽ *PON!

I SEE! BY MANIPULATING THE TIP OF A NIB, MY PICTURE WILL LOOK MORE ALIVE AND INVOKE EMOTION. THAT'S THE "PEN-TOUCH."

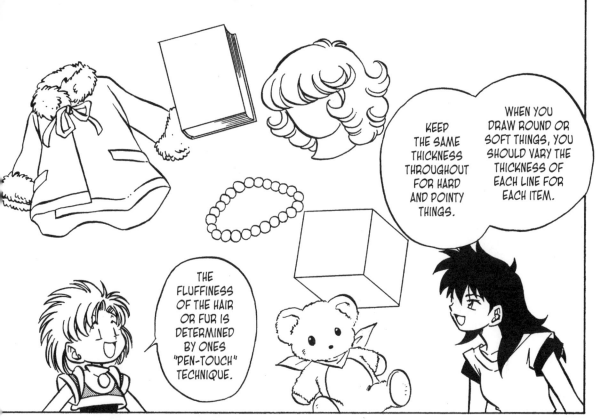

WHEN YOU DRAW ROUND OR SOFT THINGS, YOU SHOULD VARY THE THICKNESS OF EACH LINE FOR EACH ITEM.

KEEP THE SAME THICKNESS THROUGHOUT FOR HARD AND POINTY THINGS.

THE FLUFFINESS OF THE HAIR OR FUR IS DETERMINED BY ONES "PEN-TOUCH" TECHNIQUE.

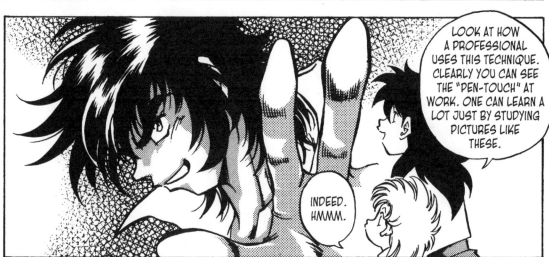

LOOK AT HOW A PROFESSIONAL USES THIS TECHNIQUE. CLEARLY YOU CAN SEE THE "PEN-TOUCH" AT WORK. ONE CAN LEARN A LOT JUST BY STUDYING PICTURES LIKE THESE.

INDEED. HMMM.

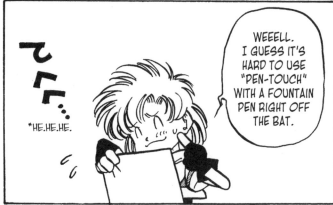

WEEELL. I GUESS IT'S HARD TO USE "PEN-TOUCH" WITH A FOUNTAIN PEN RIGHT OFF THE BAT.

*HE.HE.HE.

PRACTICING.

SCRIBBLE SCRIBBLE

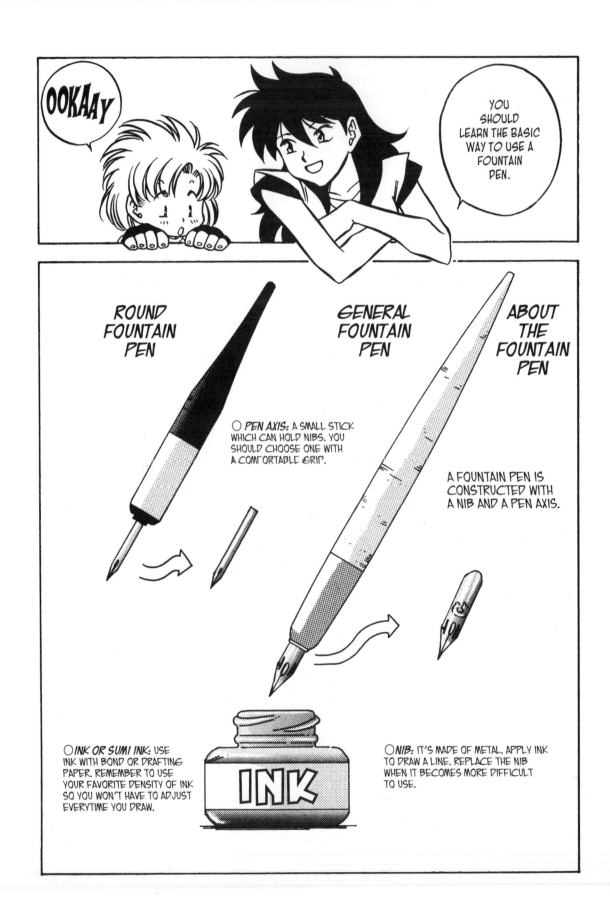

OOKAAY

YOU SHOULD LEARN THE BASIC WAY TO USE A FOUNTAIN PEN.

ROUND FOUNTAIN PEN

GENERAL FOUNTAIN PEN

ABOUT THE FOUNTAIN PEN

○ PEN AXIS: A SMALL STICK WHICH CAN HOLD NIBS. YOU SHOULD CHOOSE ONE WITH A COMFORTABLE GRIP.

A FOUNTAIN PEN IS CONSTRUCTED WITH A NIB AND A PEN AXIS.

○ INK OR SUMI INK: USE INK WITH BOND OR DRAFTING PAPER. REMEMBER TO USE YOUR FAVORITE DENSITY OF INK SO YOU WON'T HAVE TO ADJUST EVERYTIME YOU DRAW.

INK

○ NIB: IT'S MADE OF METAL. APPLY INK TO DRAW A LINE. REPLACE THE NIB WHEN IT BECOMES MORE DIFFICULT TO USE.

○ SCHOOL-PEN: THIS PEN IS LIKE THE G-PEN EXCEPT THE EDGE OF NIB IS A BIT HARDER THAN G-PEN. THIS PEN IS SUITABLE FOR SOMEONE WHO DRAWS WITH STRONG WRITING PRESSURE.

TYPES OF NIBS

YOU CAN CHOOSE YOUR FAVORITE NIB FOR EASY DRAWING.

○ JAPANESE LETTER-PEN: IT'S LIKE THE SPOON-PEN YET ITS TIP IS EVEN SOFTER THAN A SPOON-PEN. THIS PEN IS SUITABLE FOR SOMEONE WHO DRAWS WITH WEAK WRITING PRESSURE.

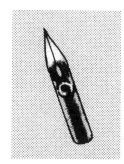

○ G-PEN: THE EDGE OF THIS NIB BENDS LIKE ELASTIC AND IS EASY TO MANIPULATE. USUALLY, IT'S USED FOR DRAWING FACIAL LINES.

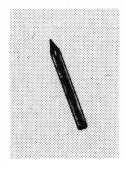

○ ROUND-PEN: THIS PEN IS FOR DRAWING BACKGROUNDS OR SPECIAL EFFECTS. YOU CAN MAKE CONSISTENT THIN LINES. ALSO, IT'S GOOD FOR DRAWING BOLD LINES BECAUSE ITS TIP IS SOFT LIKE THE G-PEN.

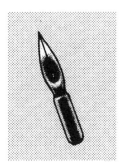

○ SPOON-PEN: THIS NIB CREATES A THICKNESS IN BETWEEN THE G-PEN AND ROUND-PEN. IT'S EASY TO USE AND VERY SUITABLE FOR BEGINNERS.

DEPENDING ON THE BRANDS, THEY ALL HAVE A DIFFERENT FEEL.

YOU SHOULD TRY VARIOUS NIBS AND FIND THE ONE THAT'S RIGHT FOR YOU.

THERE ARE SO MANY KINDS OF NIBS.

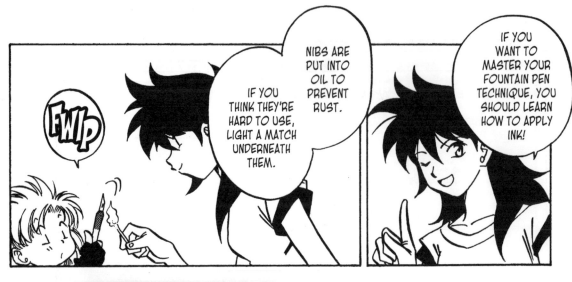

FWIP

IF YOU THINK THEY'RE HARD TO USE, LIGHT A MATCH UNDERNEATH THEM.

NIBS ARE PUT INTO OIL TO PREVENT RUST.

IF YOU WANT TO MASTER YOUR FOUNTAIN PEN TECHNIQUE, YOU SHOULD LEARN HOW TO APPLY INK!

BUT BE CAREFUL NOT TO START ANY FIRES!

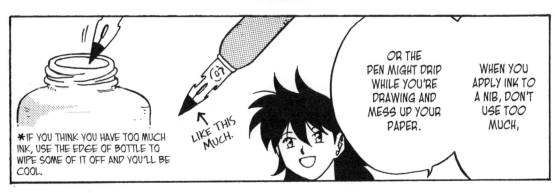

*IF YOU THINK YOU HAVE TOO MUCH INK, USE THE EDGE OF BOTTLE TO WIPE SOME OF IT OFF AND YOU'LL BE COOL.

↑ LIKE THIS MUCH.

OR THE PEN MIGHT DRIP WHILE YOU'RE DRAWING AND MESS UP YOUR PAPER.

WHEN YOU APPLY INK TO A NIB, DON'T USE TOO MUCH,

UH OHHH...

*THAT'S BAD.

DRIP

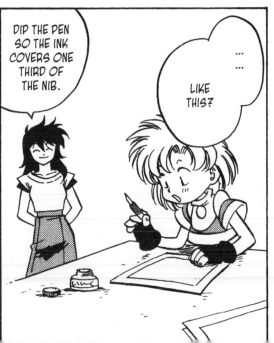

DIP THE PEN SO THE INK COVERS ONE THIRD OF THE NIB.

...
...

LIKE THIS?

BASICS FOR HOW TO USE A FOUNTAIN PEN

○ *THE ANGLE AGAINST PAPER AND HOW MUCH PRESSURE TO USE*

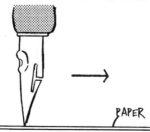

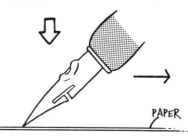

PAPER

PAPER

■ *HOLD THE PEN STRAIGHT*
HOLDING THE PEN STRAIGHT AT A 90 DEGREE ANGLE AND NOT USING TOO MUCH PRESSURE (BECAUSE YOU MIGHT SCRATCH THE PAPER) WILL CAUSE THE NIB TO ONLY OPEN SLIGHTLY, SO YOU CAN DRAW A STEADY THIN LINE.

■ *HOLD THE PEN WITH AN ANGLE*
IF YOU ANGLE THE PEN (45 DEGREES) AND THEN APPLY PRESSURE (ANGLED PENS WILL NOT SCRATCH THE PAPER) AGAINST THE PAPER, THE PEN WILL OPEN MORE CREATING A THICK BOLD LINE.

○ *HOW TO USE A PEN*

■ *MOVING DOWN*
OPENING THE EDGE OF A NIB IS EASY, SO DRAWING A BOLD LINE SHOULD BE SIMPLE.

■ *MOVING TO THE SIDE*
IF YOU DON'T OPEN THE EDGE OF A NIB, YOU'LL BE ABLE TO DRAW A STEADY THIN LINE.

■ *MOVING UP*
THIS WILL CAUSE THE PEN TO SCRATCH THE PAPER. SO WE HIGHLY RECOMMEND AGAINST DOING THIS.

○ *HOW TO USE THE "NUKI" TECHNIQUE*

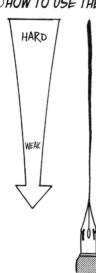

HARD

WEAK

■ WHEN YOU APPLY PRESSURE TO THE PAPER, PUSH HARD AT FIRST THEN RELEASE SLOWLY BIT BY BIT, THIS TECHNIQUE WILL ALLOW YOU TO DRAW A BOLD TO THIN LINE. THIS IS CALLED, "NUKI."

○ *HOW TO DRAW A CURVED LINE*

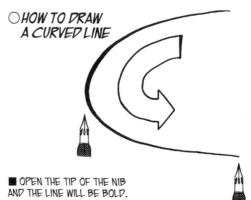

■ OPEN THE TIP OF THE NIB AND THE LINE WILL BE BOLD.

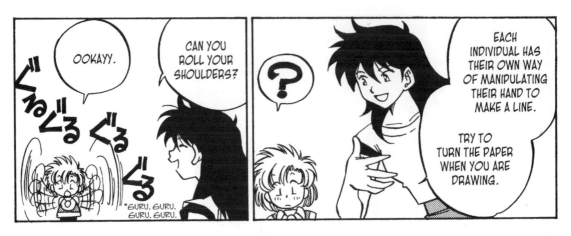

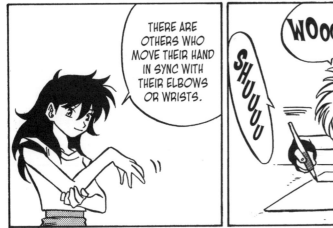

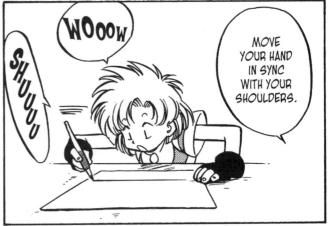

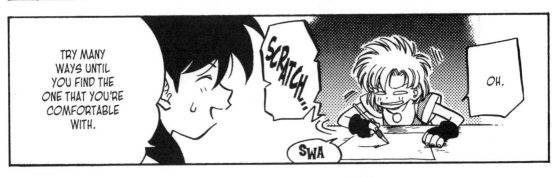

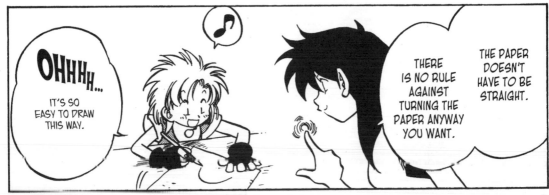

OH, I SEE.

......

FLAP!

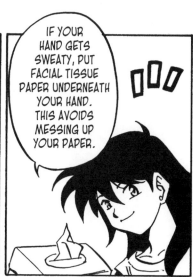

IF YOUR HAND GETS SWEATY, PUT FACIAL TISSUE PAPER UNDERNEATH YOUR HAND. THIS AVOIDS MESSING UP YOUR PAPER.

AHA

WHAT?

THAT'S A GOOD IDEA.

IN YOUR CASE, ALISA...

I DECIDED TO USE FACIAL TISSUE PAPER JUST IN CASE I MESS UP THE PAPER.

I'LL JUST PRACTICE A LOT!

REALLY?

*AAALRAAAIGHT.

WELL, NEXT I'LL TEACH YOU A SIMPLE TRICK FOR SOMEONE WHO IS NOT USED TO THE 'TSUKE-PEN' TECHNIQUE.

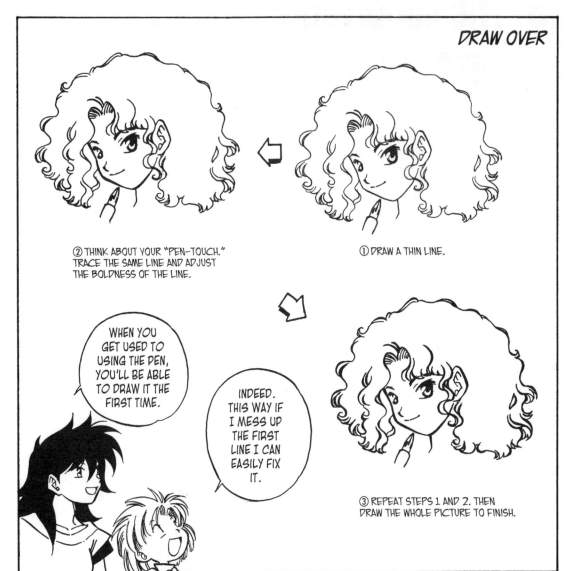

② THINK ABOUT YOUR "PEN-TOUCH." TRACE THE SAME LINE AND ADJUST THE BOLDNESS OF THE LINE.

① DRAW A THIN LINE.

WHEN YOU GET USED TO USING THE PEN, YOU'LL BE ABLE TO DRAW IT THE FIRST TIME.

INDEED. THIS WAY IF I MESS UP THE FIRST LINE I CAN EASILY FIX IT.

③ REPEAT STEPS 1 AND 2. THEN DRAW THE WHOLE PICTURE TO FINISH.

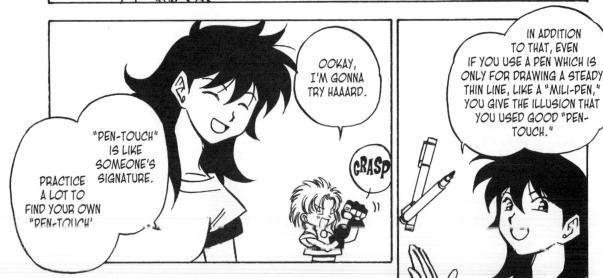

OOKAY, I'M GONNA TRY HAAARD.

"PEN-TOUCH" IS LIKE SOMEONE'S SIGNATURE.

PRACTICE A LOT TO FIND YOUR OWN "PEN-TOUCH"

GRASP

IN ADDITION TO THAT, EVEN IF YOU USE A PEN WHICH IS ONLY FOR DRAWING A STEADY THIN LINE, LIKE A "MILI-PEN," YOU GIVE THE ILLUSION THAT YOU USED GOOD "PEN-TOUCH."

● END ●

⑧ The Importance of "Keshigomu-kake" or "Erasing"

◎ NECESSARY TOOLS: MANUSCRIPT PAPER, AN ERASER, AND FACIAL TISSUE PAPER
◎ USEFUL TOOLS IF YOU HAVE THEM: FEATHER BRUSH, HAIR DRYER

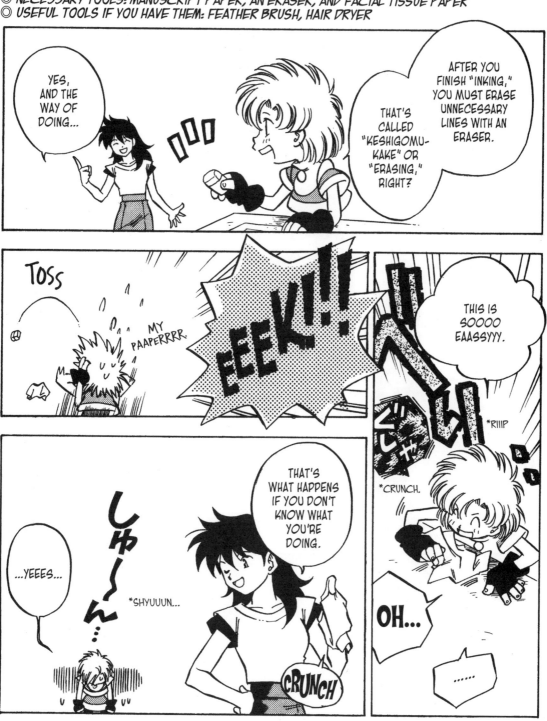

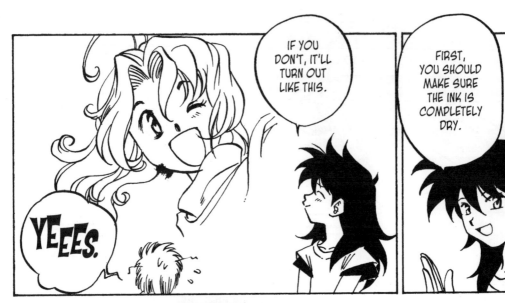

IF YOU DON'T, IT'LL TURN OUT LIKE THIS.

YEEES.

FIRST, YOU SHOULD MAKE SURE THE INK IS COMPLETELY DRY.

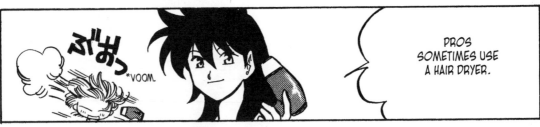

*VOOM.

PROS SOMETIMES USE A HAIR DRYER.

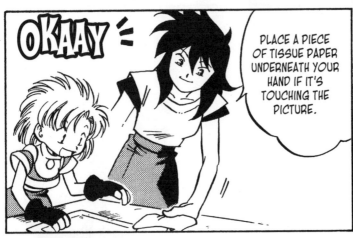

OKAAY

PLACE A PIECE OF TISSUE PAPER UNDERNEATH YOUR HAND IF IT'S TOUCHING THE PICTURE.

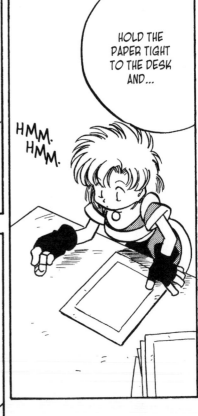

HOLD THE PAPER TIGHT TO THE DESK AND...

HMM. HMM.

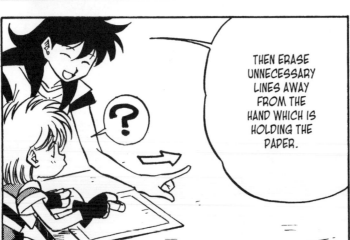

THEN ERASE UNNECESSARY LINES AWAY FROM THE HAND WHICH IS HOLDING THE PAPER.

94

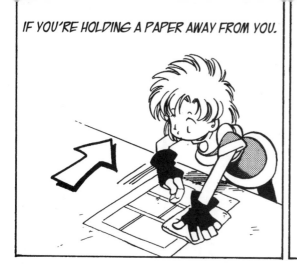

IF YOU'RE HOLDING A PAPER AWAY FROM YOU.

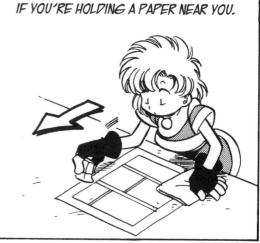

IF YOU'RE HOLDING A PAPER NEAR YOU.

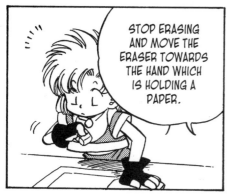

STOP ERASING AND MOVE THE ERASER TOWARDS THE HAND WHICH IS HOLDING A PAPER.

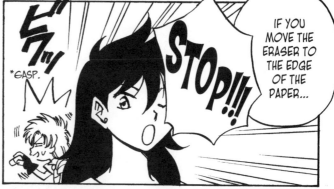

*GASP.

STOP!!!

IF YOU MOVE THE ERASER TO THE EDGE OF THE PAPER...

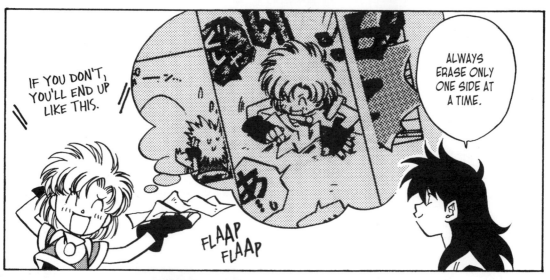

IF YOU DON'T, YOU'LL END UP LIKE THIS.

FLAAP FLAAP

ALWAYS ERASE ONLY ONE SIDE AT A TIME.

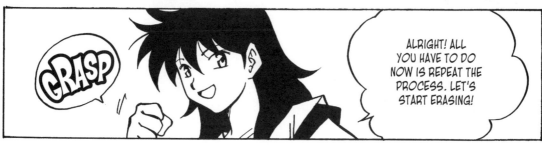

GRASP

ALRIGHT! ALL YOU HAVE TO DO NOW IS REPEAT THE PROCESS. LET'S START ERASING!

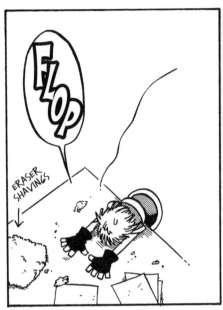

FLOP

ERASER
SHAVINGS

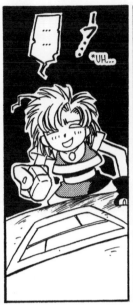

*UH...

SCRUB...

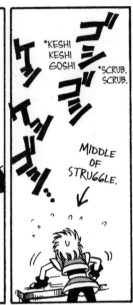

*KESHI
KESHI
GOSHI

*SCRUB.
SCRUB.

MIDDLE
OF
STRUGGLE.

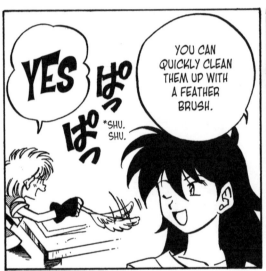

YES

*SHU.
SHU.

YOU CAN QUICKLY CLEAN THEM UP WITH A FEATHER BRUSH.

MY ARM IS SOOOO TIRED...

WEEZE

WEEZE

I HAVE A LOT OF SHAVINGS FROM THE ERASER LEFT OVER...

YEEES.

GO ME...

I DIDN'T KNOW ERASING WAS THIS HARD...

SMILE

YOUR DESK SHOULD ALWAYS BE CLEAN.

● END ●

THE FOLLOWING 12 PAGES ARE WORK FROM A PROFESSIONAL. NOW OPEN TO THE PUBLIC!!

EXAMPLE MANGA "INKING" & "ERASING"

AFTER "INKING" AND "ERASING" YOUR WORK YOU CAN ADD DIALOG WITH A PENCIL IN THE WORD BUBBLES. IF YOU ARE COLLABORATING WITH ANOTHER, YOU SHOULD WRITE THE DIALOG NEATLY, SO IT IS EASY TO READ.

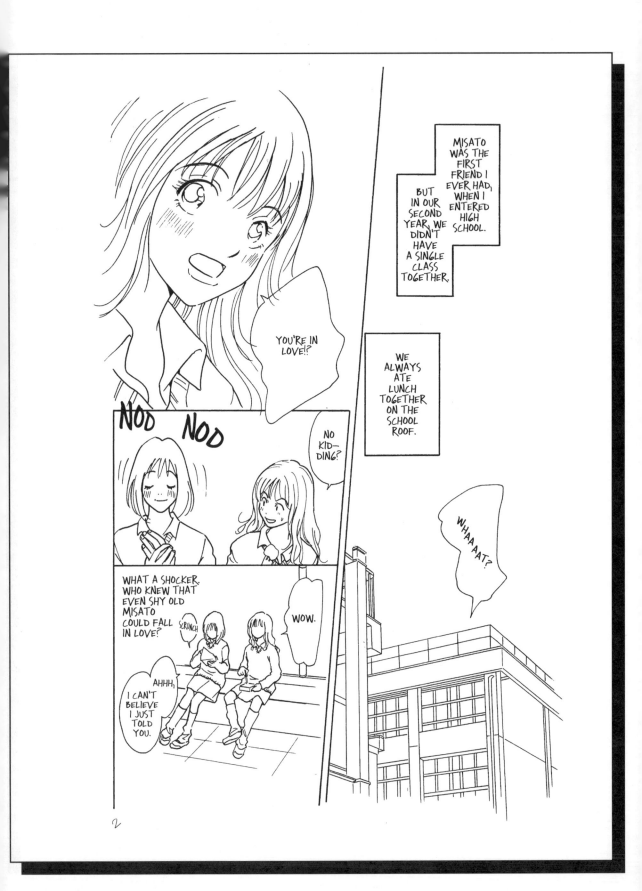

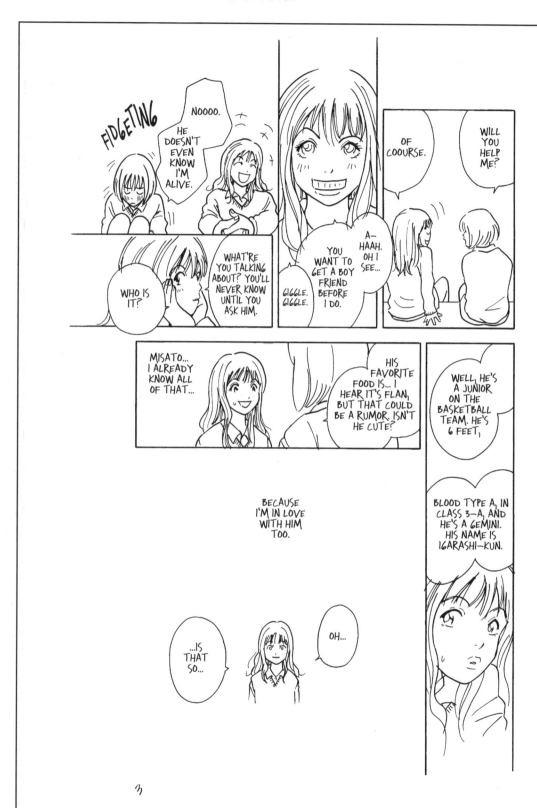

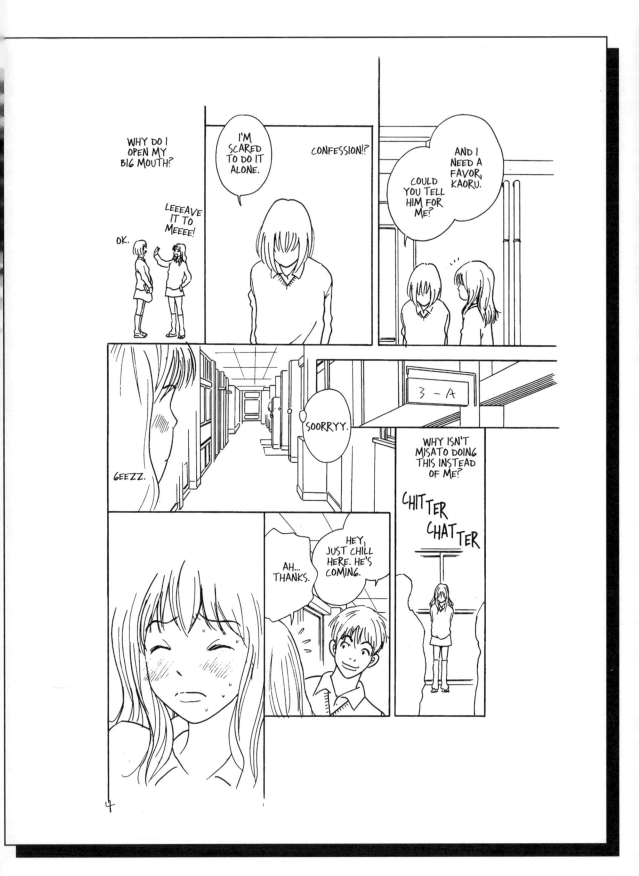

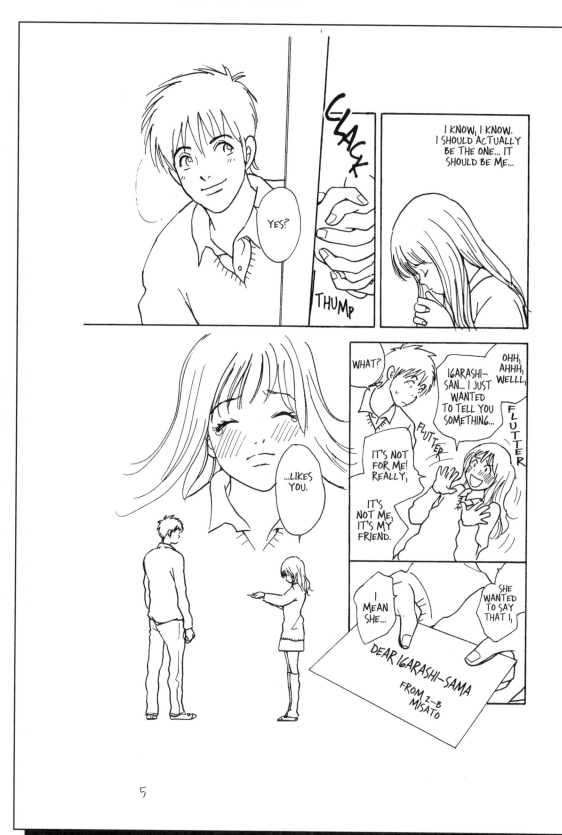

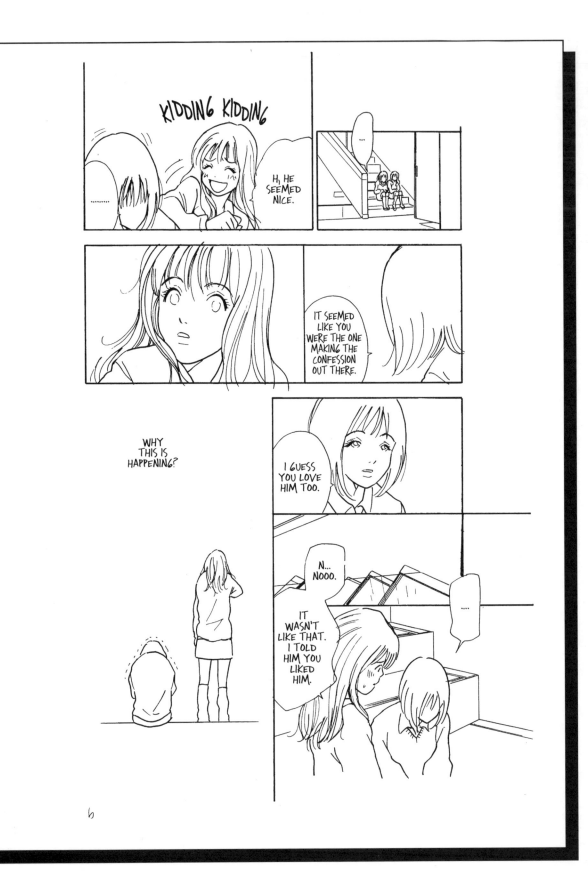

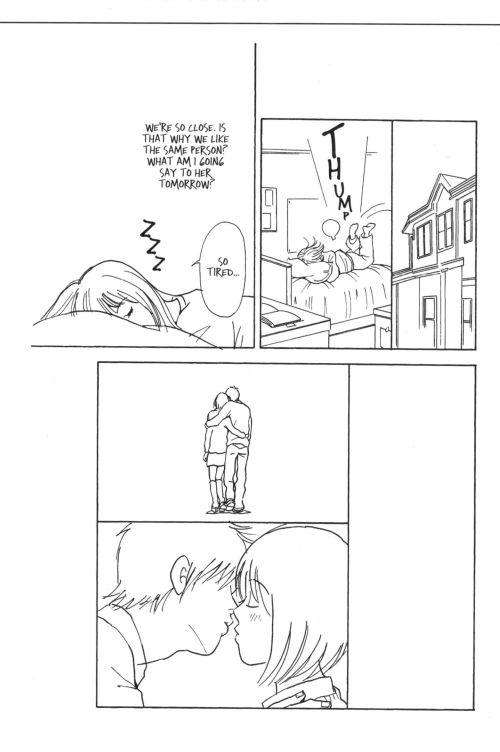

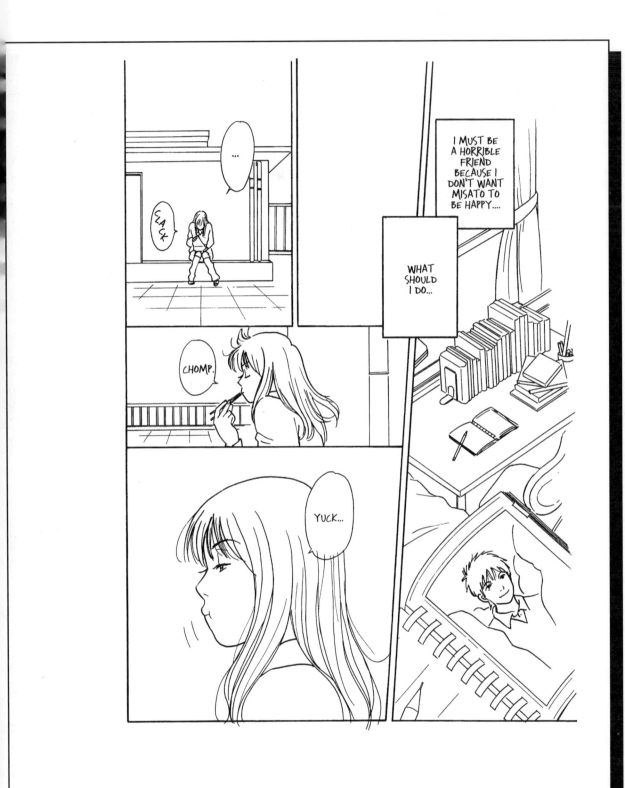

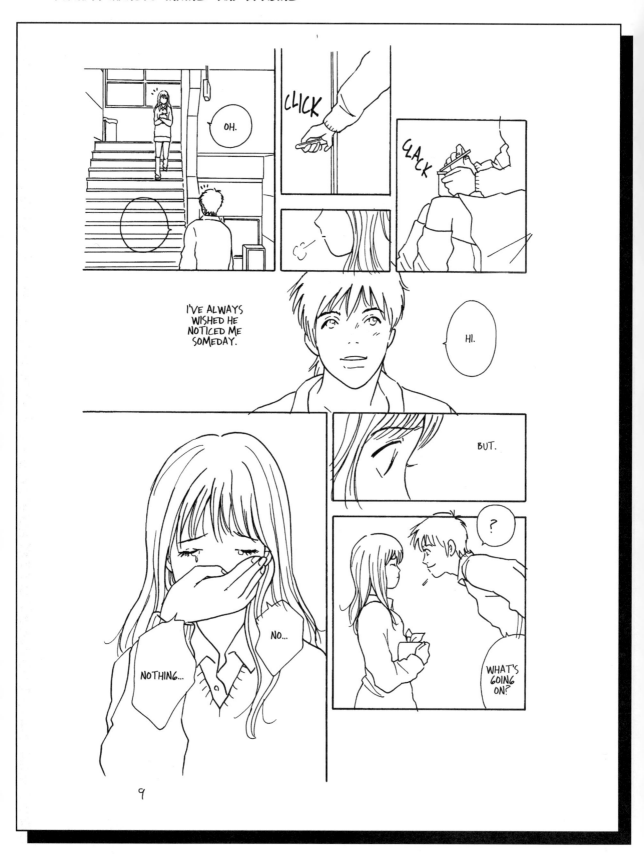

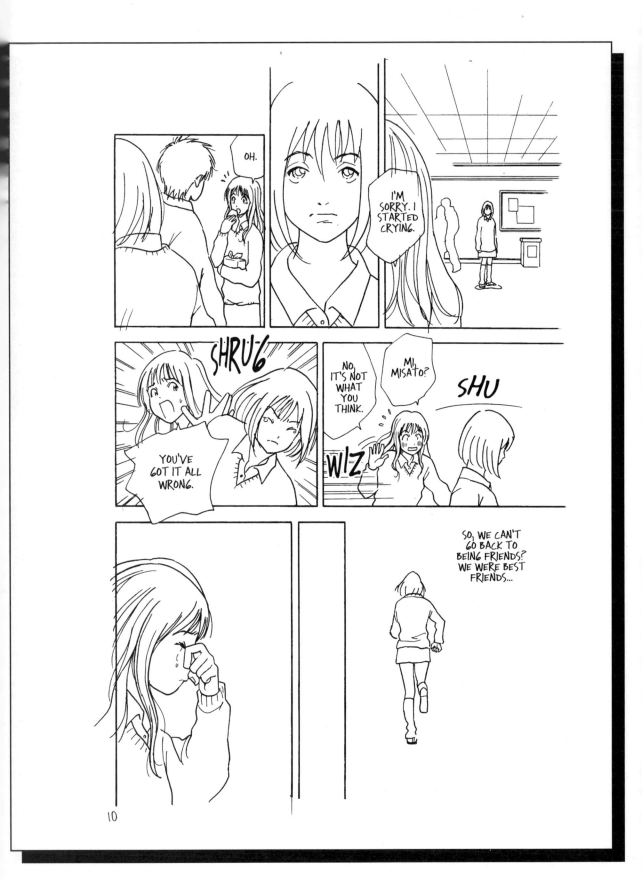

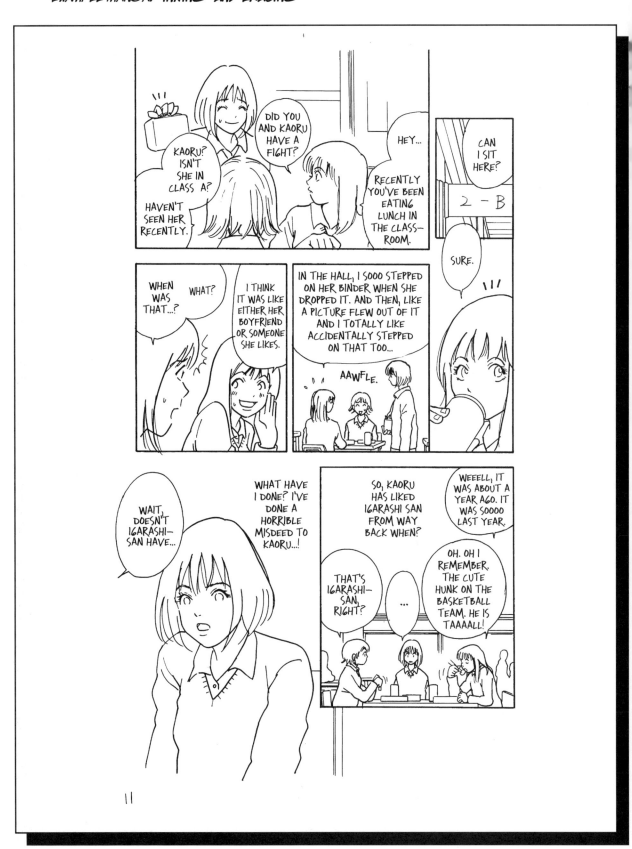

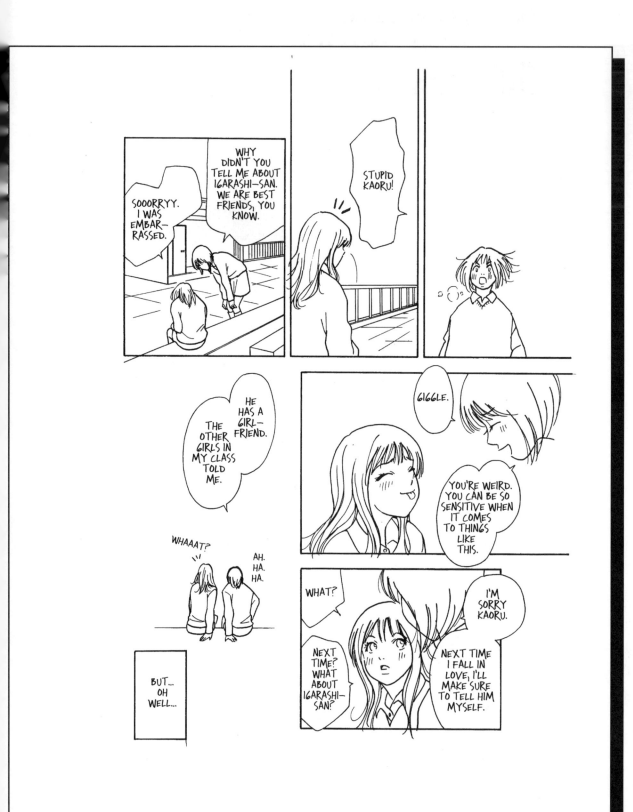

⑨ Creating Contrast by Filling in the "Black"

◎ *NECESSARY TOOLS: MANUSCRIPT PAPER, A BRUSH, A BRUSH CLEANER, INK SUMI INK, MILI-PEN, MARKERS, AND FACIAL TISSUE PAPER*
◎ *USEFUL TOOLS IF YOU HAVE ONE: HAIR DRYER*

IT SOUNDS TECHNICAL. ANY TIPS?

WHEN YOU ADD THE LARGE BLACK AREAS WITH PAINT, IT'S CALLED FILLING IN YOUR "BLACKS."

FILL EVERYTHING EVENLY AND DON'T GO OVER THE LINES.

FIRST, YOU SHOULD DOUBLE CHECK YOUR TOOLS.

HE HE HE

SOOO, TRUUUE...

THE TOOLS YOU NEED FOR ADDING YOUR "BLACKS"

○ *INK & SUMI INK:* USE THE INK ON BOND OR DRAFTING PAPER. IF THE INK IS TOO STRONG ADD SOME WATER TO DILUTE IT. HOWEVER IF YOU ADD TOO MUCH WATER, THE INK WILL BECOME PALE AND UNEVEN. TRY TO REMEMBER WHAT COLOR THE INK WAS WHEN IT WAS FRESH OUT OF THE BOTTLE.

○ *BRUSH:* IT WOULD BE BEST TO US A BRUSH WITH A POINTED HEAD LIKE A "MENSOU BRUSH" OR A "HAKKEI BRUSH." BUT IN THE LONG RUN ANY BRUSH THAT YOU ARE COMFORTABLE WITH FILLING IN THE BLACKS WILL DO FINE. DO NOT USE THE SAME BRUSH FOR ADDING THE "WHITES."

○ *MARKERS:* USE A WATER BASED BLACK INK. YOU SHOULD DOUBLE CHECK THE DENSITY OF THE INK. IF IT'S TOO THICK, YOUR BLACKS WILL BE UNEVEN. YOU MIGHT USE AN OIL BASED INK AS WELL. WHEN YOU NEED TO FILL IN A LARGE AREA, THIS TOOL IS USEFUL BECAUSE MOST MARKER TIPS ARE WIDE.

○ *MILI-PEN:* THE PEN USES A WATER BASED BLACK INK. YOU SHOULD ALSO DOUBLE CHECK ON THE DENSITY OF THE INK BEFORE YOU START WORKING. AN OIL BASED INK IS NOT REALLY SUITABLE FOR FILLING IN DETAILED PICTURES BECAUSE THE INK MAY BLEED INTO UNWANTED AREAS.

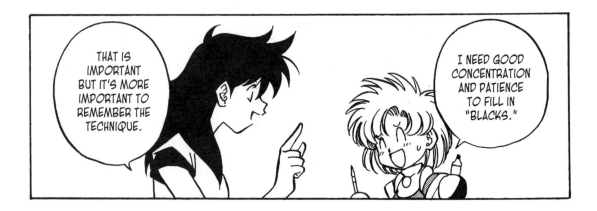

THAT IS IMPORTANT BUT IT'S MORE IMPORTANT TO REMEMBER THE TECHNIQUE.

I NEED GOOD CONCENTRATION AND PATIENCE TO FILL IN "BLACKS."

THE RIGHT ORDER OF FILLING IN THE "BLACKS"

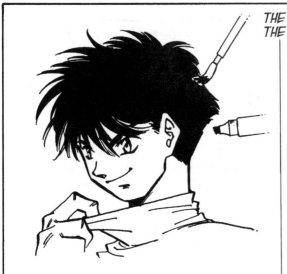

② USE A MARKER OR A REGULAR BRUSH FOR THE LARGE AREAS.

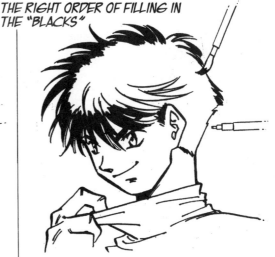

① USE A MILI-PEN OR A BRUSH THAT HAS A POINTY HEAD, AND WORK ON THE DETAIL OF YOUR PICTURE FIRST. FOCUS YOUR CONCENTRATION ON THE TIP OF THE MILI-PEN SO THAT YOU DON'T GO OVER THE LINES. MAKE SMALL MOTIONS WITH YOUR HAND WHEN USING A MILI-PEN BECAUSE IT TENDS TO SMUDGE EASILY.

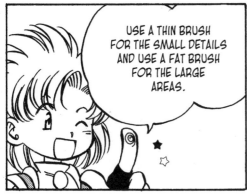

USE A THIN BRUSH FOR THE SMALL DETAILS AND USE A FAT BRUSH FOR THE LARGE AREAS.

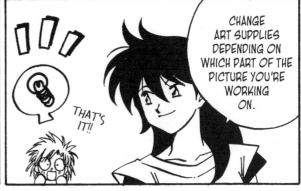

THAT'S IT!!

CHANGE ART SUPPLIES DEPENDING ON WHICH PART OF THE PICTURE YOU'RE WORKING ON.

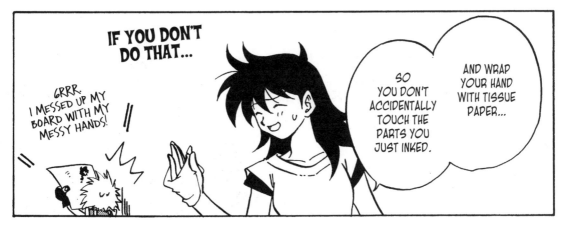

IF YOU DON'T DO THAT...

GRRR. I MESSED UP MY BOARD WITH MY MESSY HANDS!

SO YOU DON'T ACCIDENTALLY TOUCH THE PARTS YOU JUST INKED.

AND WRAP YOUR HAND WITH TISSUE PAPER...

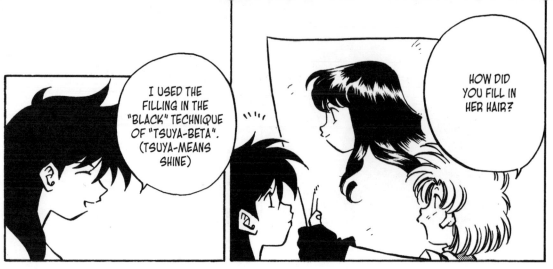

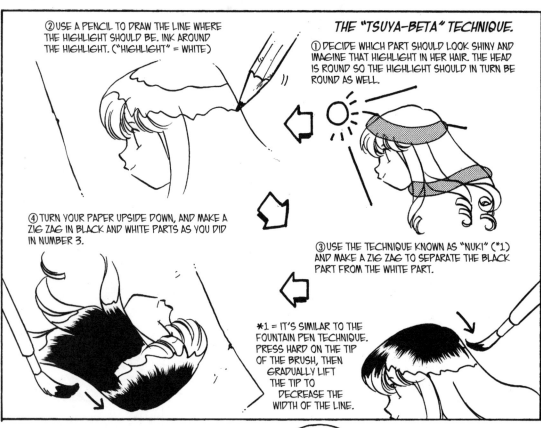

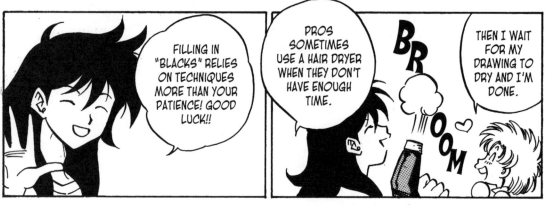

● END ●

⑩ Using "White" to Correct & Effect

◎ NECESSARY TOOLS: NECESSARY TOOLS: MANUSCRIPT PAPER, A BRUSH, BRUSH CLEANER, WHITE POSTER PAINT, WHITEOUT, A WHITEOUT PEN, FACIAL TISSUE PAPER
◎ USEFUL TOOLS IF YOU HAVE THEM: MASKING TAPE AND A HAIR DRYER

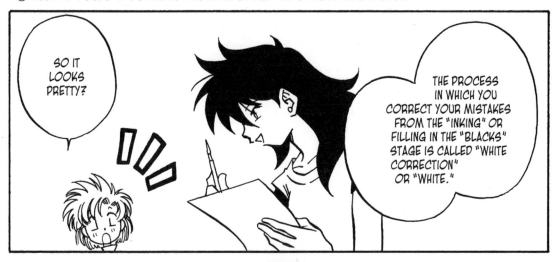

SO IT LOOKS PRETTY?

THE PROCESS IN WHICH YOU CORRECT YOUR MISTAKES FROM THE "INKING" OR FILLING IN THE "BLACKS" STAGE IS CALLED "WHITE CORRECTION" OR "WHITE."

I SEEEEE!

WHEN YOU MAKE A COPY OR A PRINT OF YOUR MANUSCRIPT, EVERY DROP OF BLACK YOU INKED WILL SHOW. THAT'S WHY YOU SHOULD COVER IT UP WITH WHITE PAINT.

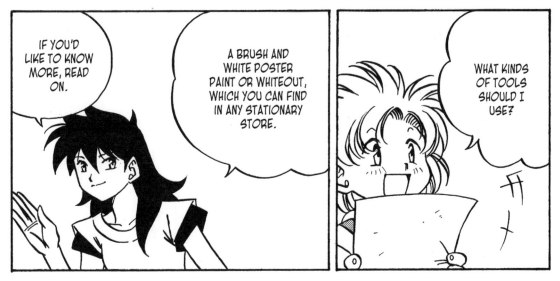

IF YOU'D LIKE TO KNOW MORE, READ ON.

A BRUSH AND WHITE POSTER PAINT OR WHITEOUT, WHICH YOU CAN FIND IN ANY STATIONARY STORE.

WHAT KINDS OF TOOLS SHOULD I USE?

○*POSTER COLOR OR POSTER PAINT:* USE WHITE. RECENTLY, SOME COMPANIES HAVE MADE A SPECIAL WHITE CORRECTION INK SPECIFICALLY FOR MANGA. IF THE POSTER PAINT'S CONSISTENCY IS TOO THIN, THE AREA THAT YOU JUST COVERED UP MIGHT SMUDGE OR LOOK UNEVEN. ON THE CONTRARY, IF THE POSTER PAINT IS TOO THICK, THE PAINT WILL PEEL OFF AFTER IT'S COMPLETELY DRY.

○*WHITEOUT:* YOU SHOULD USE A WHITEOUT THAT IS BOTH OIL AND WATER BASED. USE THE BRUSH THAT COMES WITH THE TOP OF THE WHITEOUT BOTTLE. THE WHITEOUT PAINTS EVENLY BUT DRIES QUICKLY, WHICH MIGHT CHANGE THE TEXTURE OF THE SPACE. ONCE THE PAINT IS DRIES, YOU HAVE TO USE PAINT THINNER TO REMOVE IT SO BE CAREFUL.

○*BRUSH:* USE ONLY WITH WHITE POSTER PAINT. USE A BRUSH THAT HAS A POINTY TIP LIKE "MENSOU" OR "HAKKEI BRUSH." THIS BRUSH IS USEFUL FOR CORRECTING SMALL DETAILS IN YOUR ARTWORK. DO NOT USE THE SAME BRUSH AS THE ONE YOU USE FOR ADDING IN "BLACK."

○*WHITEOUT PEN:* IT'S WHITEOUT IN A PEN. USE ONE THAT'S BOTH OIL AND WATER BASED. COMPARED TO REGULAR WHITEOUT, ITS TEXTURE DOESN'T CHANGE SO THIS PEN CAN COME IN PRETTY HANDY.

○*BRUSH CLEANER:* A CONTAINER WHICH IS USED FOR CLEANING A BRUSH OR ADJUSTING THE POSTER PAINT'S CONSISTENCY.

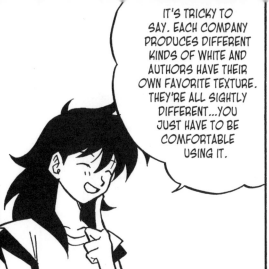

IT'S TRICKY TO SAY. EACH COMPANY PRODUCES DIFFERENT KINDS OF WHITE AND AUTHORS HAVE THEIR OWN FAVORITE TEXTURE. THEY'RE ALL SIGHTLY DIFFERENT...YOU JUST HAVE TO BE COMFORTABLE USING IT.

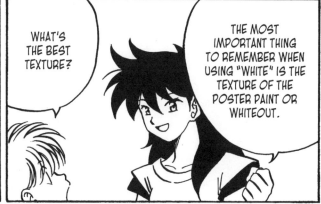

WHAT'S THE BEST TEXTURE?

THE MOST IMPORTANT THING TO REMEMBER WHEN USING "WHITE" IS THE TEXTURE OF THE POSTER PAINT OR WHITEOUT.

TEXTURE OF WHITEOUT

I PUT THE STANDARDS FOR GOOD TEXTURE BELOW.

HMMMMM....

EXPERIENCE AND PRACTICE ARE THE ONLY KEY...

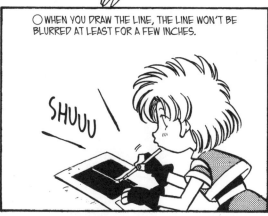

○ WHEN YOU DRAW THE LINE, THE LINE WON'T BE BLURRED AT LEAST FOR A FEW INCHES.

SHUUU

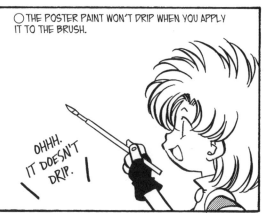

○ THE POSTER PAINT WON'T DRIP WHEN YOU APPLY IT TO THE BRUSH.

OHHH. IT DOESN'T DRIP.

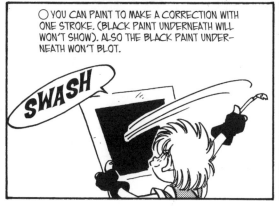

○ YOU CAN PAINT TO MAKE A CORRECTION WITH ONE STROKE. (BLACK PAINT UNDERNEATH WILL WON'T SHOW). ALSO THE BLACK PAINT UNDERNEATH WON'T BLOT.

SWASH

○ AFTER YOU'VE USED IT, THE POSTER PAINT WON'T RAISE ABOVE THE PAPER.

HMMM... LIKE THIS MUCH...?

HOW TO APPLY WHITEOUT

② BE CAREFUL NOT TO TOUCH THE SURFACE OF THE PAGE. SOME CASES, YOU SHOULD PLACE A PIECE OF FACIAL TISSUE PAPER UNDER YOUR HAND WHEN HOLDING YOUR BRUSH.

① CHECK THE INK AFTER YOU HAVE FINISHED "INKING" AND ADDING IN "BLACK."

③ CORRECT WITH WHITEOUT. IF YOU APPLY WHITEOUT TOO MANY TIMES, THE BLACK INK UNDERNEATH WILL MIX IN. SO APPLY TWICE AT MOST.

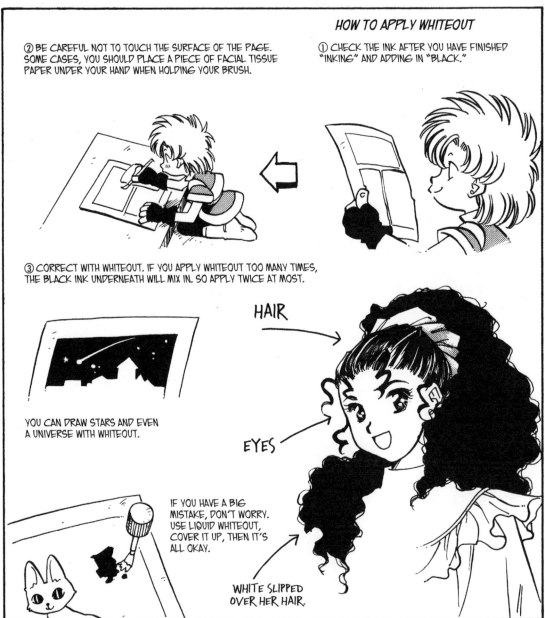

YOU CAN DRAW STARS AND EVEN A UNIVERSE WITH WHITEOUT.

HAIR

EYES

IF YOU HAVE A BIG MISTAKE, DON'T WORRY. USE LIQUID WHITEOUT, COVER IT UP, THEN IT'S ALL OKAY.

WHITE SLIPPED OVER HER HAIR.

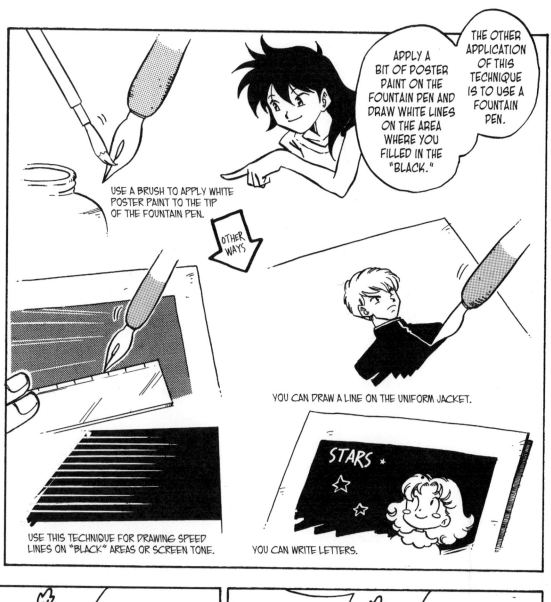

THE OTHER APPLICATION OF THIS TECHNIQUE IS TO USE A FOUNTAIN PEN.

APPLY A BIT OF POSTER PAINT ON THE FOUNTAIN PEN AND DRAW WHITE LINES ON THE AREA WHERE YOU FILLED IN THE "BLACK."

USE A BRUSH TO APPLY WHITE POSTER PAINT TO THE TIP OF THE FOUNTAIN PEN.

OTHER WAYS

YOU CAN DRAW A LINE ON THE UNIFORM JACKET.

USE THIS TECHNIQUE FOR DRAWING SPEED LINES ON "BLACK" AREAS OR SCREEN TONE.

STARS *

YOU CAN WRITE LETTERS.

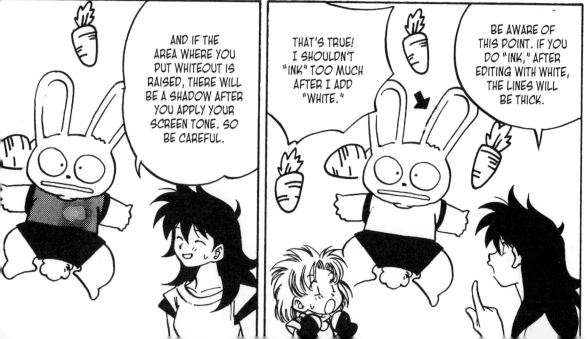

AND IF THE AREA WHERE YOU PUT WHITEOUT IS RAISED, THERE WILL BE A SHADOW AFTER YOU APPLY YOUR SCREEN TONE. SO BE CAREFUL.

THAT'S TRUE! I SHOULDN'T "INK" TOO MUCH AFTER I ADD "WHITE."

BE AWARE OF THIS POINT. IF YOU DO "INK," AFTER EDITING WITH WHITE, THE LINES WILL BE THICK.

"BLOWING" IS THE MOST ADVANCE TECHNIQUE IN "WHITE" OR "BLACK" PAINTING. APPLY THE WHITE POSTER PAINT ON THE TIP OF THE BRUSH THEN BLOW THE TIP IN DIFFERENT DIRECTIONS TO MAKE AN UNLIMITED AMOUNT OF TINY WHITE DOTS. TRY THIS TECHNIQUE WITH A REGULAR OR SUMI INK. FOR EXAMPLE, YOU CAN MAKE SPECIAL EFFECTS SUCH AS EXPLOSIONS, COLLISIONS, OR EVEN BRILLIANT STARS IN A NIGHT SKY. THIS TECHNIQUE WILL MAKE YOUR WORK LOOK AWESOME.

KYOKO'S **ONE POINT ADVICE**

The Blowing Technique is Da Bomb!

THE ORDER OF "BLOWING"
① COVER THE AREA THAT YOU DON'T WANT MANIPULATED WITH PAPER.

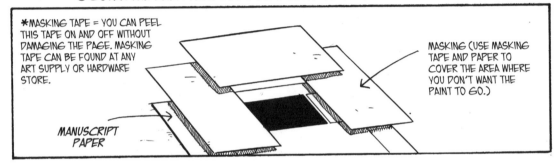

*MASKING TAPE = YOU CAN PEEL THIS TAPE ON AND OFF WITHOUT DAMAGING THE PAGE. MASKING TAPE CAN BE FOUND AT ANY ART SUPPLY OR HARDWARE STORE.

MANUSCRIPT PAPER

MASKING (USE MASKING TAPE AND PAPER TO COVER THE AREA WHERE YOU DON'T WANT THE PAINT TO GO.)

② THE MANY WAYS OF BLOWING

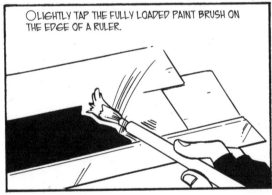

○ LIGHTLY TAP THE FULLY LOADED PAINT BRUSH ON THE EDGE OF A RULER.

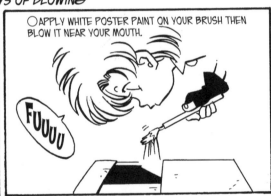

○ APPLY WHITE POSTER PAINT ON YOUR BRUSH THEN BLOW IT NEAR YOUR MOUTH.

FUUUU

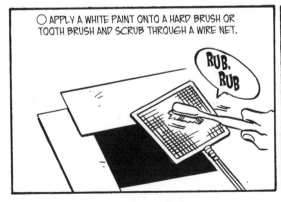

○ APPLY A WHITE PAINT ONTO A HARD BRUSH OR TOOTH BRUSH AND SCRUB THROUGH A WIRE NET.

RUB, RUB

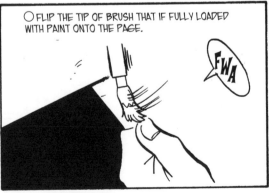

○ FLIP THE TIP OF BRUSH THAT IF FULLY LOADED WITH PAINT ONTO THE PAGE.

FWA

● END ●

EXAMPLE MANGA "BLACKS" & "WHITES"

THESE EXAMPLES OF PROFESSIONAL MANUSCRIPTS TAKE PLACE AFTER ADDING IN THE "BLACKS" AND THE USE OF CORRECTIVE "WHITE." YOU CAN SEE THE DIFFERENCE IN INTENSITY AFTER THE "BLACKS" WERE ADDED. IT'S HARD TO SEE THE CORRECTIVE "WHITE" BECAUSE THAT PROCESS DOES NOT SHOW UP AFTER PRINTING. YET YOU CAN STILL COMPARE THE FOLLOWING 12 PAGES WITH PAGES 95 THROUGH 106.

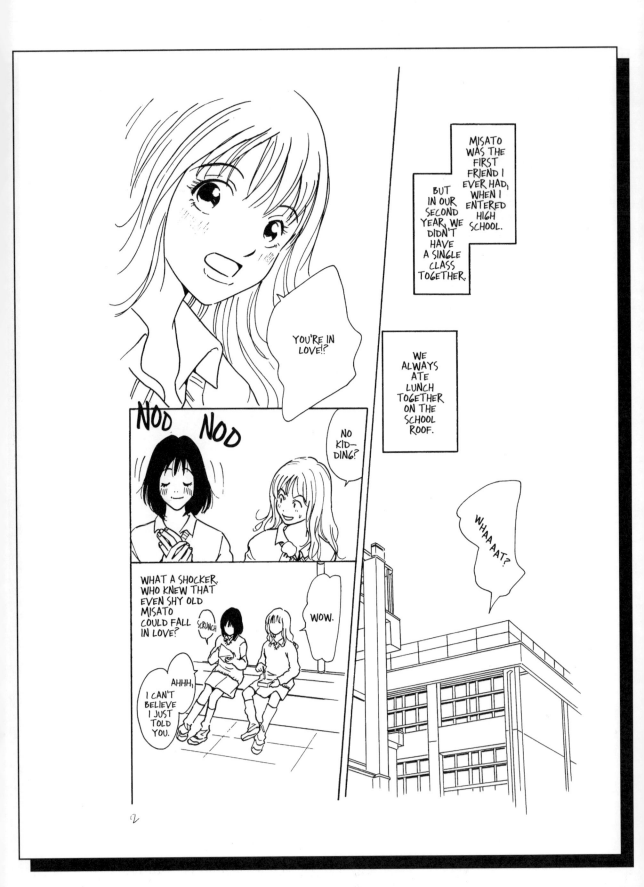

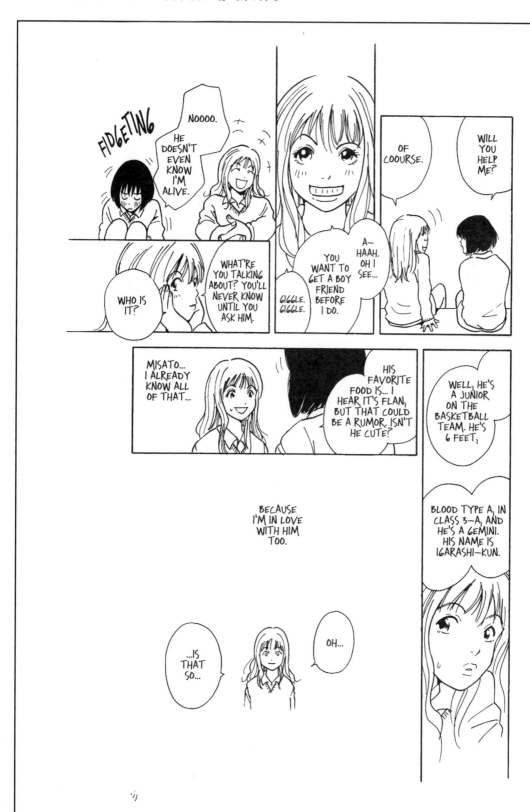

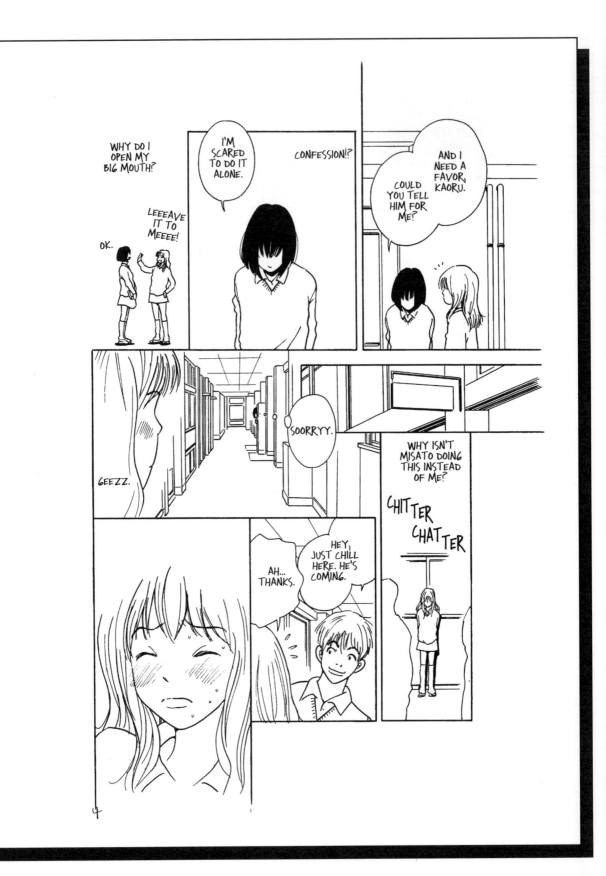

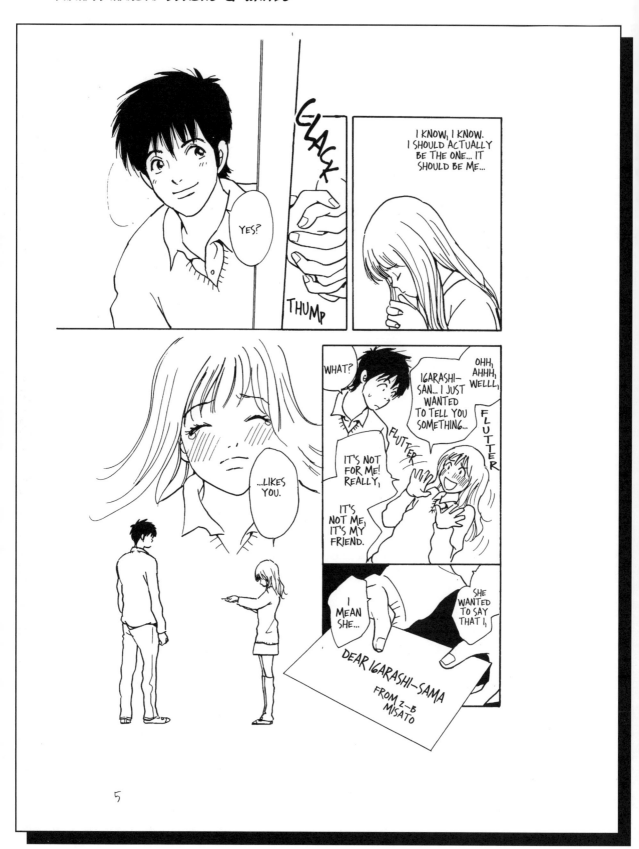

KIDDING KIDDING

H, HE SEEMED NICE.

...

IT SEEMED LIKE YOU WERE THE ONE MAKING THE CONFESSION OUT THERE.

WHY THIS IS HAPPENING?

I GUESS YOU LOVE HIM TOO.

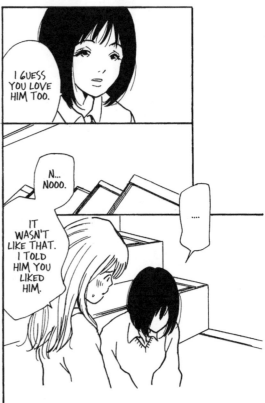

N... NOOO.

IT WASN'T LIKE THAT. I TOLD HIM YOU LIKED HIM.

....

6

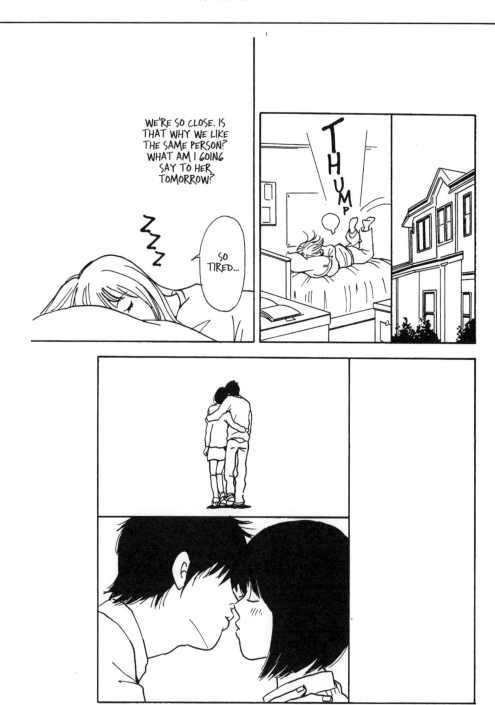

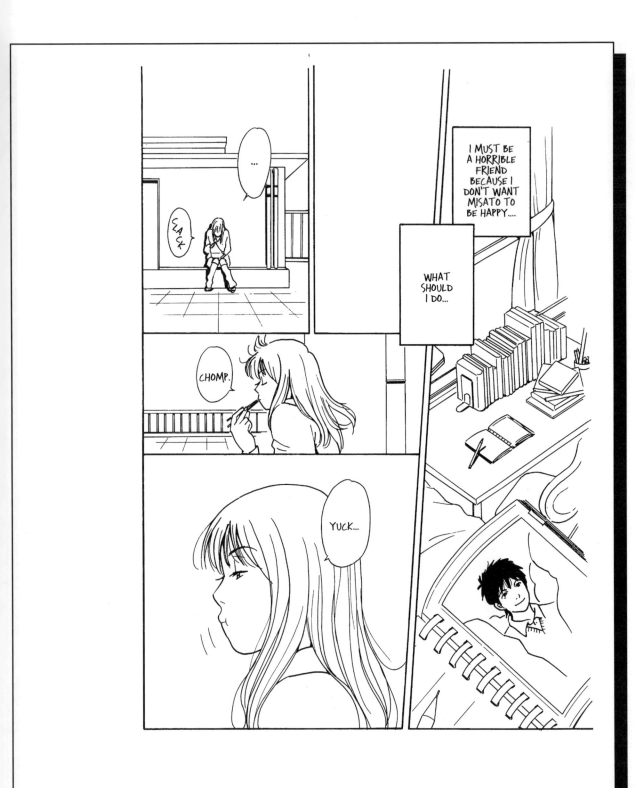

126

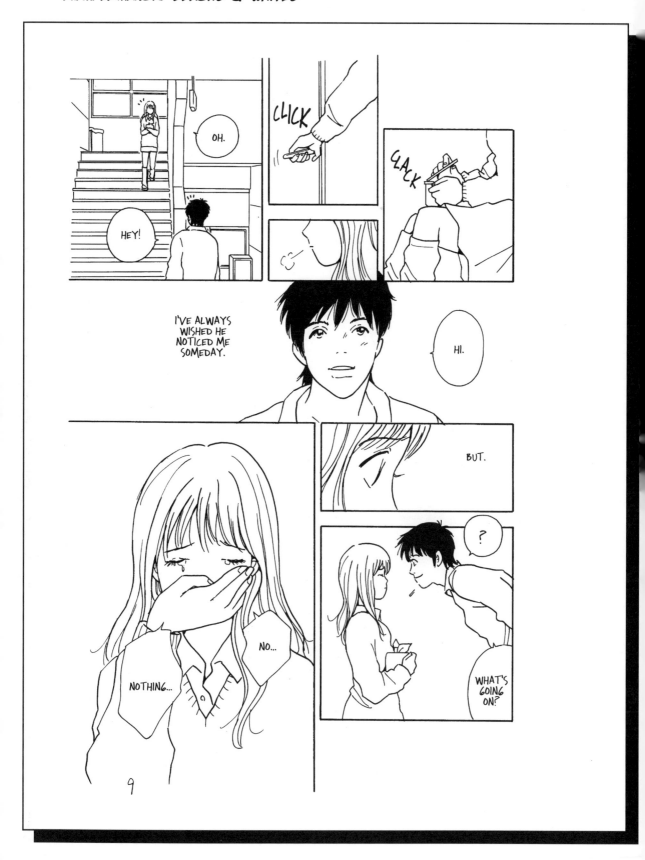

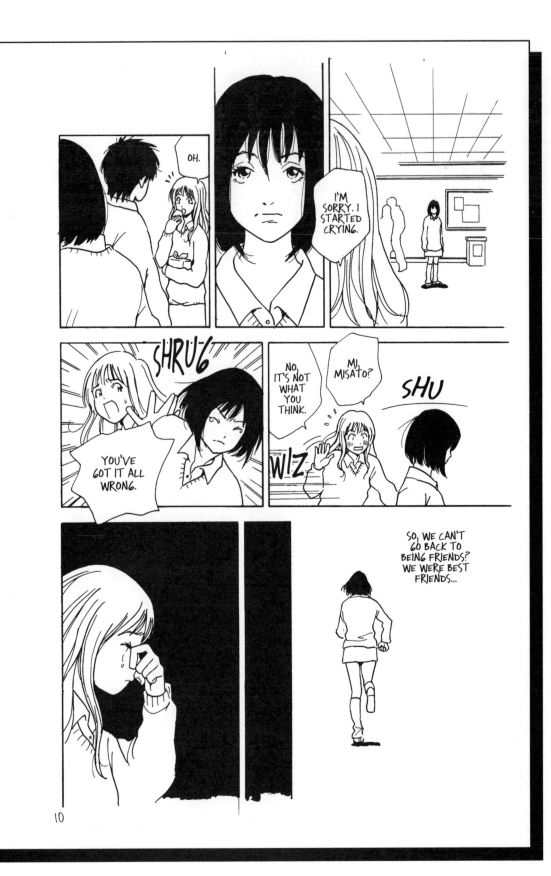

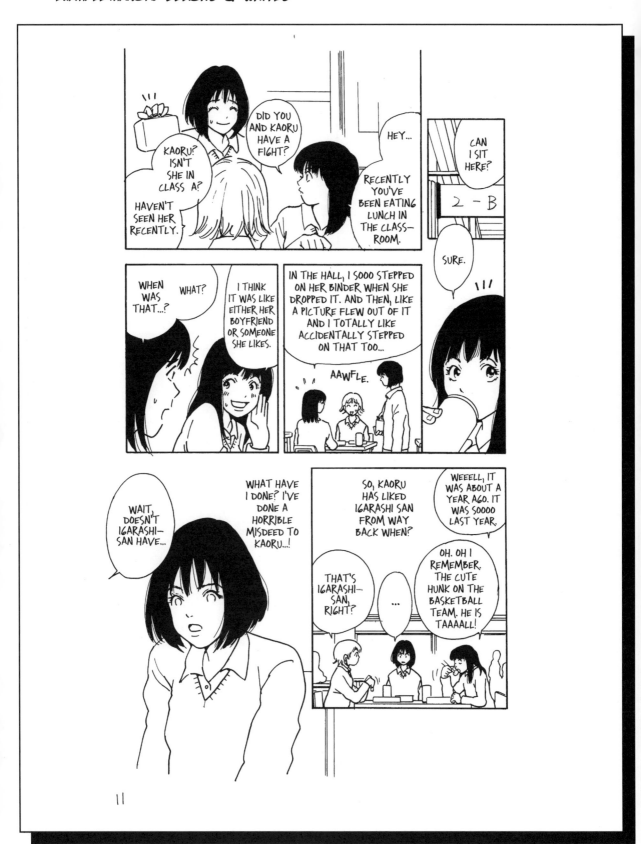

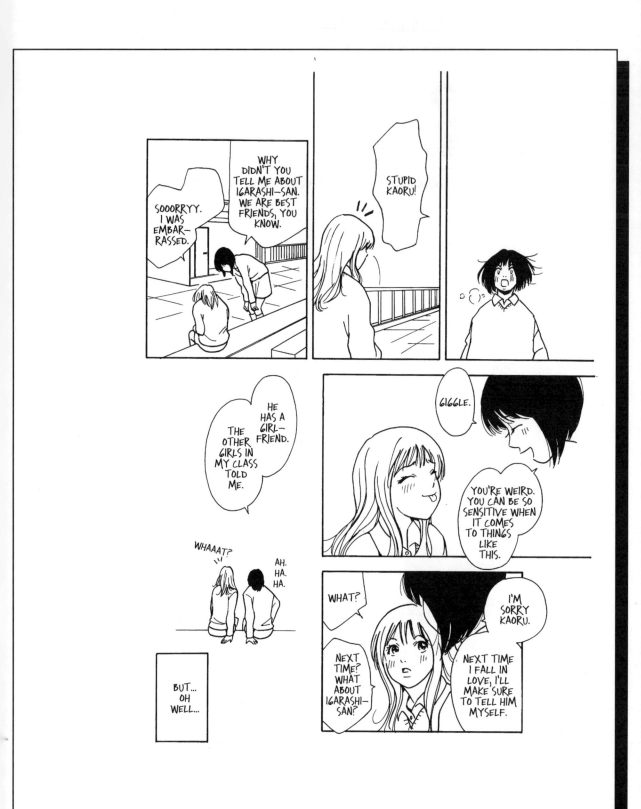

12

⑪ Finishing up with "Screen Tones"

◎ *NECESSARY TOOLS: MANUSCRIPT PAPER, SCREEN TONE, AND AN EXACTO KNIFE*
◎ *USEFUL TOOLS IF YOU HAVE THEM: A DESIGN KNIFE (TONE KNIFE), TONE LANCER, SCOTCH TAPE, A HAIR DRYER, AND A LIGHT BOX.*

EXPLANATION OF THE SCREEN TONE'S PARTS

*THE BRAND NAME AND NUMBERS: ON THE TOP OF EACH SCREEN TONE, THERE IS A BRAND NAME AND A NUMBER, WHICH INDICATES WHAT KIND OF SCREEN TONE IT IS. (DEPENDING ON THE COMPANY; EACH SCREEN TONE IS A LITTLE BIT DIFFERENT.)

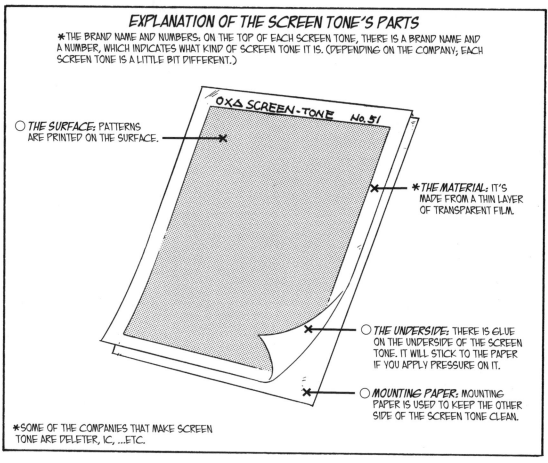

○ *THE SURFACE:* PATTERNS ARE PRINTED ON THE SURFACE.

THE MATERIAL: IT'S MADE FROM A THIN LAYER OF TRANSPARENT FILM.

○ *THE UNDERSIDE:* THERE IS GLUE ON THE UNDERSIDE OF THE SCREEN TONE. IT WILL STICK TO THE PAPER IF YOU APPLY PRESSURE ON IT.

○ *MOUNTING PAPER:* MOUNTING PAPER IS USED TO KEEP THE OTHER SIDE OF THE SCREEN TONE CLEAN.

*SOME OF THE COMPANIES THAT MAKE SCREEN TONE ARE DELETER, IC, ...ETC.

DON'T WORRY. IT'S EASY TO USE.

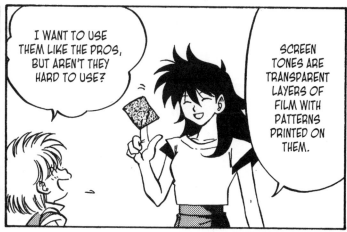

I WANT TO USE THEM LIKE THE PROS, BUT AREN'T THEY HARD TO USE?

SCREEN TONES ARE TRANSPARENT LAYERS OF FILM WITH PATTERNS PRINTED ON THEM.

HOW TO USE SCREEN TONES

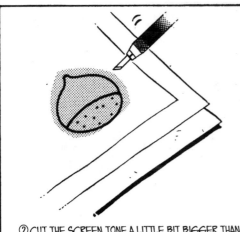

② CUT THE SCREEN TONE A LITTLE BIT BIGGER THAN THE AREA YOU WANTED, BUT BE CAREFUL NOT TO CUT THE MOUNT.

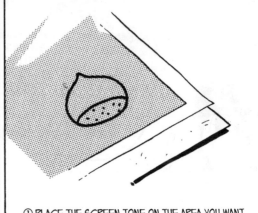

① PLACE THE SCREEN TONE ON THE AREA YOU WANT WITHOUT PEELING THE MOUNT OFF.

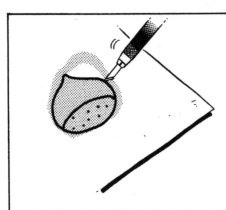

④ USING YOUR EXACTO KNIFE, TRACE THE FIGURE TO CUT IT OUT OF THE SCREEN TONE. IF IT'S HARD TO SEE THE FIGURE OVER THE SCREEN TONE, USE A LIGHT BOX OR WINDOW TO SEE THROUGH. WHEN YOU ARE CUTTING, BE CAREFUL NOT TO CUT YOUR PAGE.

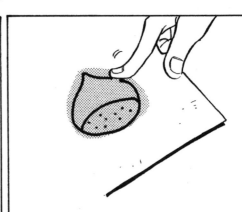

③ PEEL THE SCREEN TONE FROM THE MOUNT AND PLACE IT ON THE AREA YOU WANT IN YOUR MANUSCRIPT. RUB IT A LITTLE SO IT DOESN'T SLIP OFF THE MANUSCRIPT.

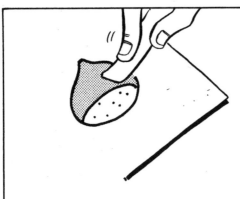

⑥ USE A TONE LANCER OR A SPATULA TO PUT MORE PRESSURE ON THE SCREEN TONE. IN SOME CASES, YOU MIGHT WANT TO PUT A CLEAN PIECE OR PAPER BETWEEN THE TONE LANCER AND THE SCREEN TONE TO KEEP IT CLEAN.

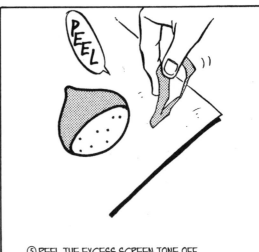

⑤ PEEL THE EXCESS SCREEN TONE OFF.

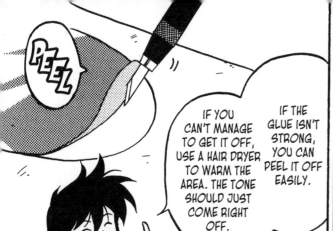

PEEL

IF THE GLUE ISN'T STRONG, YOU CAN PEEL IT OFF EASILY.

IF YOU CAN'T MANAGE TO GET IT OFF, USE A HAIR DRYER TO WARM THE AREA. THE TONE SHOULD JUST COME RIGHT OFF.

WHAT DO I DO IF I ACCIDENTALLY PUT THE SCREEN TONE SOMEWHERE BY MISTAKE.

OR I WANTED TO USE A DARKER TONE...

BUT BE CAREFUL NOT TO WARM THE OTHER AREAS BECAUSE THEY WILL PEEL OFF TOO.

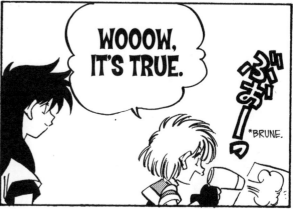

WOOOW, IT'S TRUE.

*BRUNE.

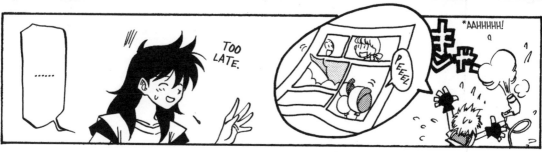

......

TOO LATE.

PEEL

*AAHHHHH!

*USE A CLEAN ERASER.

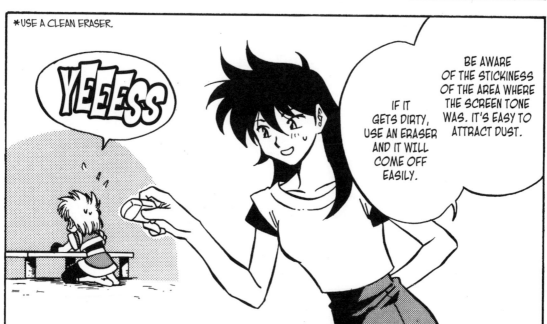

YEEESS

BE AWARE OF THE STICKINESS OF THE AREA WHERE THE SCREEN TONE WAS. IT'S EASY TO ATTRACT DUST.

IF IT GETS DIRTY, USE AN ERASER AND IT WILL COME OFF EASILY.

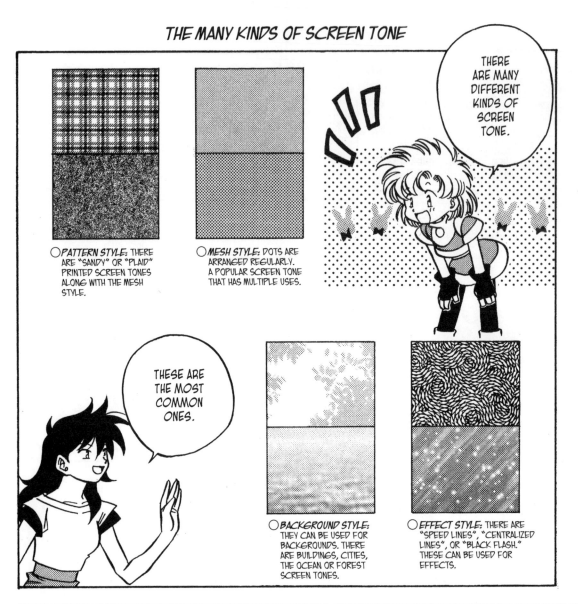

THERE ARE MANY DIFFERENT KINDS OF SCREEN TONE.

○ PATTERN STYLE: THERE ARE "SANDY" OR "PLAID" PRINTED SCREEN TONES ALONG WITH THE MESH STYLE.

○ MESH STYLE: DOTS ARE ARRANGED REGULARLY. A POPULAR SCREEN TONE THAT HAS MULTIPLE USES.

THESE ARE THE MOST COMMON ONES.

○ BACKGROUND STYLE: THEY CAN BE USED FOR BACKGROUNDS. THERE ARE BUILDINGS, CITIES, THE OCEAN OR FOREST SCREEN TONES.

○ EFFECT STYLE: THERE ARE "SPEED LINES", "CENTRALIZED LINES", OR "BLACK FLASH." THESE CAN BE USED FOR EFFECTS.

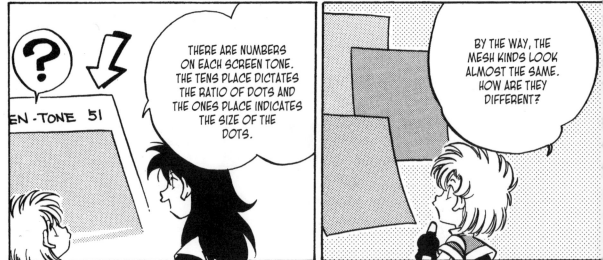

THERE ARE NUMBERS ON EACH SCREEN TONE. THE TENS PLACE DICTATES THE RATIO OF DOTS AND THE ONES PLACE INDICATES THE SIZE OF THE DOTS.

EN-TONE 51

BY THE WAY, THE MESH KINDS LOOK ALMOST THE SAME. HOW ARE THEY DIFFERENT?

THE EXPLANATION OF MESH STYLE SCREEN TONE

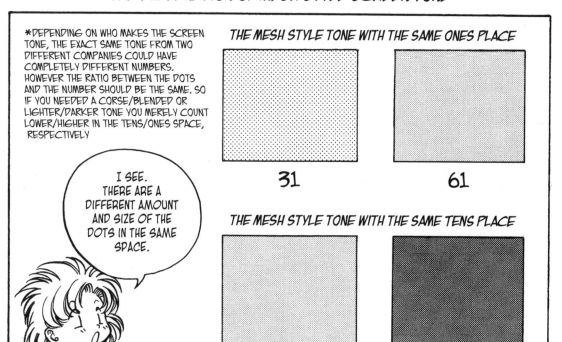

*DEPENDING ON WHO MAKES THE SCREEN TONE, THE EXACT SAME TONE FROM TWO DIFFERENT COMPANIES COULD HAVE COMPLETELY DIFFERENT NUMBERS. HOWEVER THE RATIO BETWEEN THE DOTS AND THE NUMBER SHOULD BE THE SAME. SO IF YOU NEEDED A CORSE/BLENDED OR LIGHTER/DARKER TONE YOU MERELY COUNT LOWER/HIGHER IN THE TENS/ONES SPACE, RESPECTIVELY

I SEE. THERE ARE A DIFFERENT AMOUNT AND SIZE OF THE DOTS IN THE SAME SPACE.

THE MESH STYLE TONE WITH THE SAME ONES PLACE

31

61

THE MESH STYLE TONE WITH THE SAME TENS PLACE

61

63

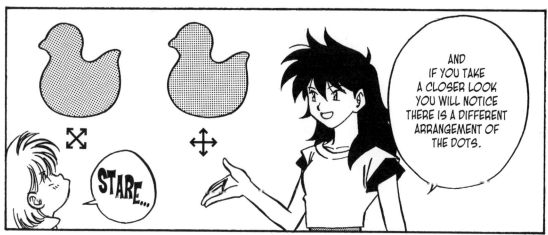

STARE...

AND IF YOU TAKE A CLOSER LOOK YOU WILL NOTICE THERE IS A DIFFERENT ARRANGEMENT OF THE DOTS.

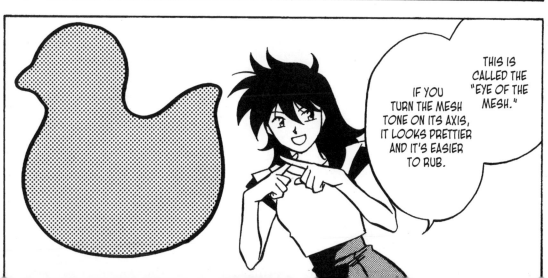

IF YOU TURN THE MESH TONE ON ITS AXIS, IT LOOKS PRETTIER AND IT'S EASIER TO RUB.

THIS IS CALLED THE "EYE OF THE MESH."

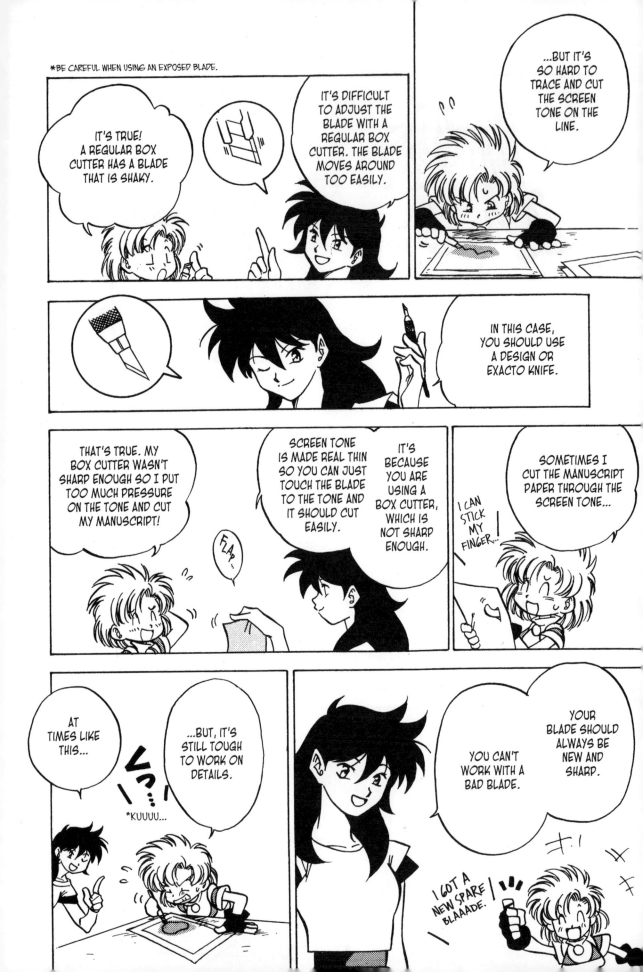

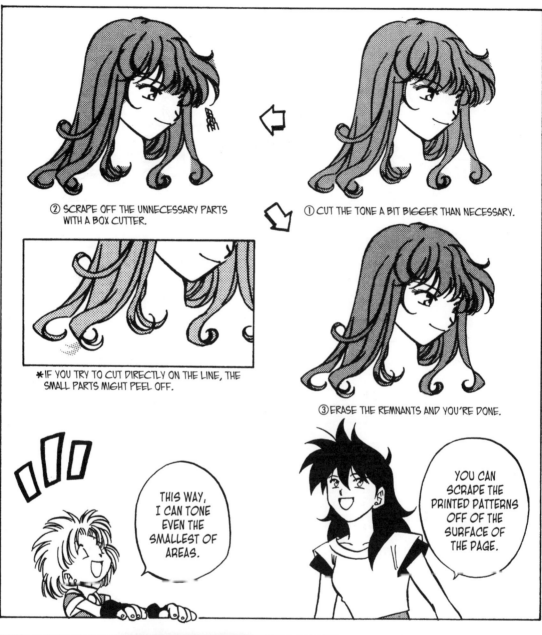

② SCRAPE OFF THE UNNECESSARY PARTS WITH A BOX CUTTER.

① CUT THE TONE A BIT BIGGER THAN NECESSARY.

*IF YOU TRY TO CUT DIRECTLY ON THE LINE, THE SMALL PARTS MIGHT PEEL OFF.

③ ERASE THE REMNANTS AND YOU'RE DONE.

THIS WAY, I CAN TONE EVEN THE SMALLEST OF AREAS.

YOU CAN SCRAPE THE PRINTED PATTERNS OFF OF THE SURFACE OF THE PAGE.

SCREEN TONES ARE VERY THIN SO IF YOU SCRAPE TOO HARD IT WILL CRUMBLE UP. THAT'S WHY YOU SHOULD SCRAPE JUST ON THE TOP OF THE SURFACE.

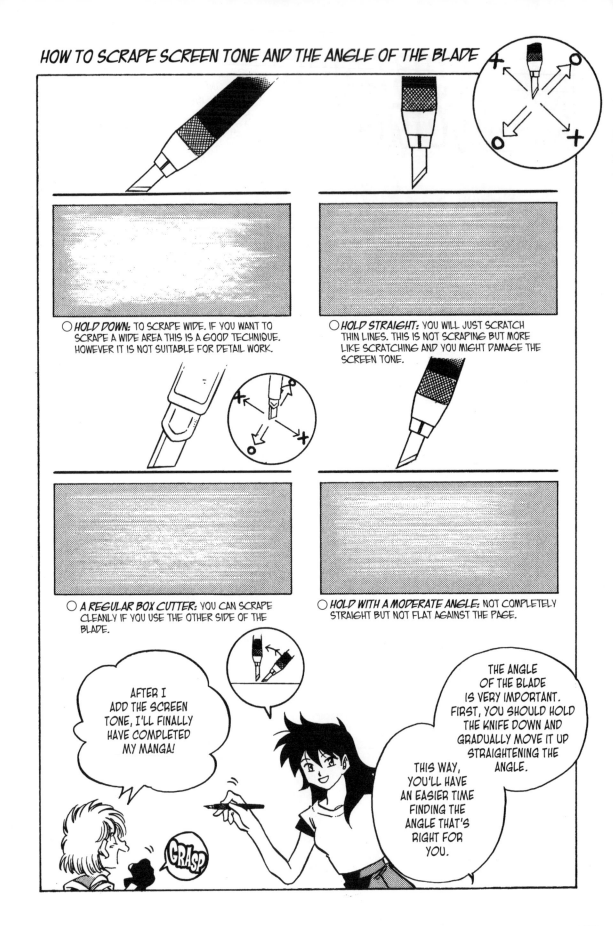

○ **HOLD DOWN:** TO SCRAPE WIDE. IF YOU WANT TO SCRAPE A WIDE AREA THIS IS A GOOD TECHNIQUE. HOWEVER IT IS NOT SUITABLE FOR DETAIL WORK.

○ **HOLD STRAIGHT:** YOU WILL JUST SCRATCH THIN LINES. THIS IS NOT SCRAPING BUT MORE LIKE SCRATCHING AND YOU MIGHT DAMAGE THE SCREEN TONE.

○ **A REGULAR BOX CUTTER:** YOU CAN SCRAPE CLEANLY IF YOU USE THE OTHER SIDE OF THE BLADE.

○ **HOLD WITH A MODERATE ANGLE:** NOT COMPLETELY STRAIGHT BUT NOT FLAT AGAINST THE PAGE.

AFTER I ADD THE SCREEN TONE, I'LL FINALLY HAVE COMPLETED MY MANGA!

GRASP

THE ANGLE OF THE BLADE IS VERY IMPORTANT. FIRST, YOU SHOULD HOLD THE KNIFE DOWN AND GRADUALLY MOVE IT UP STRAIGHTENING THE ANGLE.

THIS WAY, YOU'LL HAVE AN EASIER TIME FINDING THE ANGLE THAT'S RIGHT FOR YOU.

ONE POINT ADVICE

Tone Flash

"TONE FLASH" IS A SCRAPING TECHNIQUE THE PROS USE TO CREATE SHINY THINGS OR TO EXPRESS SPECIAL DIALOG. THERE ARE MANY APPLICATIONS FOR THIS SKILL.

HOW TO CREATE THE TONE FLASH

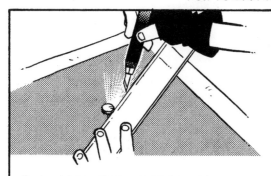

② USING A STAINLESS STEEL RULER, PLACE ONE END AGAINST THE TACK AND SCRAPE OUTWARD, AWAY FROM THE CENTER (TACK) WITH YOUR TONE KNIFE.

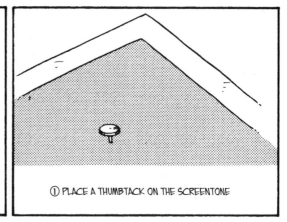

① PLACE A THUMBTACK ON THE SCREENTONE

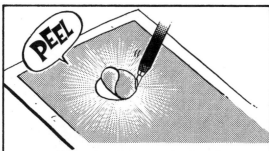

④ SCRAPE AND SHAPE MANY TRIANGLES ALONGSIDE THE RULER LEANING AGAINST THE TACK IN THE CENTER. BE CAREFUL NOT TO MISS THE CENTER AND CONNECT THE LAST TRIANGLE TO THE FIRST ONE CREATING A RADIATE EFFECT. CUT OUT THE CENTER OF THE SCREEN TONE.

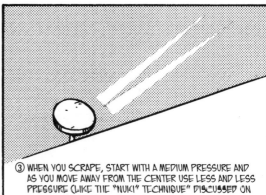

③ WHEN YOU SCRAPE, START WITH A MEDIUM PRESSURE AND AS YOU MOVE AWAY FROM THE CENTER USE LESS AND LESS PRESSURE (LIKE THE "NUKI" TECHNIQUE" DISCUSSED ON PAGE 91 IN CHAPTER 7) CREATING LONG TRIANGLES.

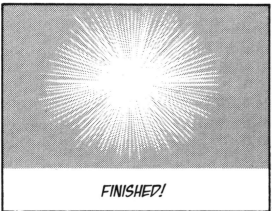

FINISHED!

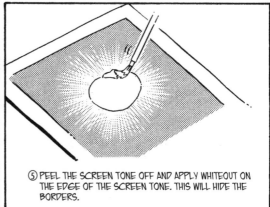

⑤ PEEL THE SCREEN TONE OFF AND APPLY WHITEOUT ON THE EDGE OF THE SCREEN TONE. THIS WILL HIDE THE BORDERS.

ONE POINT ADVICE

Pile Pasting

PILE PASTING IS LITERARY PASTING SCREEN TONE IN A PILE. USUALLY, MESH SCREEN TONE IS PASTED WITH THE SAME MESH TONE OR IT'S MESH TONE WITH A PATTERNED TONE. YOU SHOULD TRY PLAYING AROUND WITH IT.

DIFFERENT WAYS OF PILE PASTING

○ **MESH TONE WITH MESH TONE ②**
IF YOU LAYER TWO MESHES AT DIFFERENT ANGLES YOU WILL CREATE AN EFFECT KNOWN AS THE "MOARE EFFECT". THIS SPECIAL EFFECT CAN BE USED AS A BACKGROUND OR AS JUST A PATTERN.

○ **MESH TONE WITH MESH TONE ①**
IF YOU LAYER TWO MESHES AT THE SAME ANGLE YOU WILL CREATE A CHANGE DENSITY IN YOUR IMAGE. WHEN YOU WANT TO CREATE A SHADOW USING THE SCREEN TONE, THIS TECHNIQUE TO GIVES YOUR IMAGE A THREE DIMENSIONAL EFFECT.

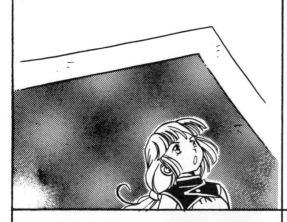

○ **PATTERN TONE WITH PATTERN TONE**
YOU CAN CREATE MANY DIFFERENT KINDS OF "MOARE EFFECT" USING THIS TECHNIQUE. YOU CAN CREATE STRANGE ATMOSPHERES OR NEW CLOTHES PATTERNS.

○ **MESH TONE WITH A PATTERN TONE**
THE MESH TONE WILL MAKE THE IMAGE LOOK MORE THREE DIMENSIONAL. USE A PATTERN TONE FOR THE CLOTHES AND USE THE MESH TONE FOR CREATING SHADOWS.

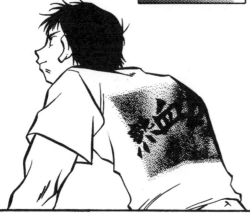

● END ●

SCREEN TONE "MANGA COMPLETE!"

AFTER CORRECTING WITH WHITEOUT AND ADDING IN SCREENTONES, THE MANUSCRIPT IS COMPLETE! STILL, YOU SHOULD DOUBLE CHECK YOUR SPELLING AND ANYTHING YOU MIGHT HAVE ACCIDENTALLY ERASED OR FORGOT TO "INK" OR FILL IN WITH "BLACK."

*IF SOME LETTERS GO OVER THE PICTURE, PLACE TRACING PAPER ON YOUR MANUSCRIPT AND WRITE IT IN.

THE BOY MY FRIEND LIKES

NENE KOTOBUKI

*THIS MANGA WILL BE PUBLISHED AFTER EDITING.

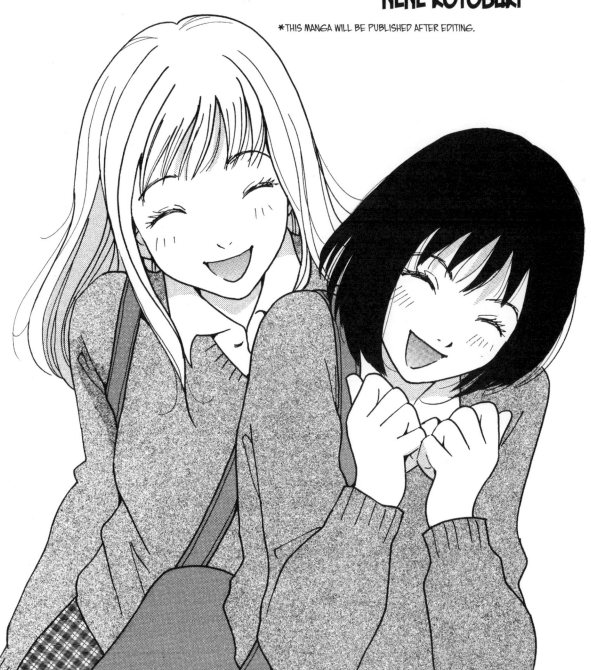

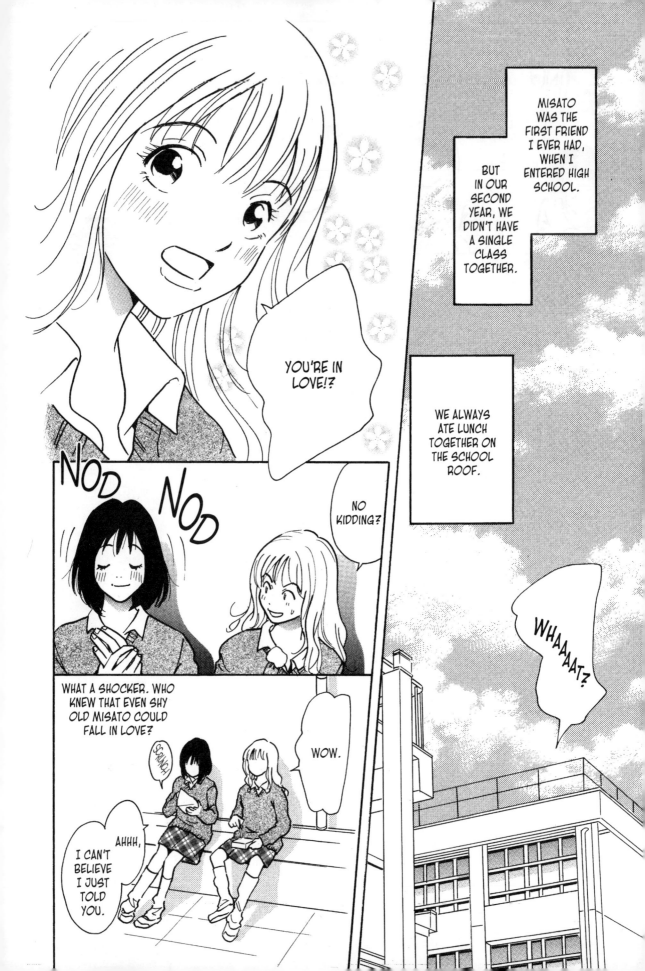

MISATO WAS THE FIRST FRIEND I EVER HAD, WHEN I ENTERED HIGH SCHOOL.

BUT IN OUR SECOND YEAR, WE DIDN'T HAVE A SINGLE CLASS TOGETHER.

WE ALWAYS ATE LUNCH TOGETHER ON THE SCHOOL ROOF.

YOU'RE IN LOVE!?

NO KIDDING?

WHAAAAT?

NOD NOD

WHAT A SHOCKER. WHO KNEW THAT EVEN SHY OLD MISATO COULD FALL IN LOVE?

SCRUNCH.

WOW.

AHHH, I CAN'T BELIEVE I JUST TOLD YOU.

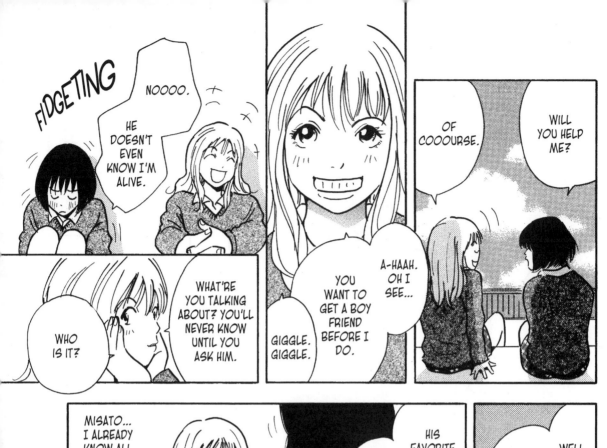

FIDGETING

NOOOO. HE DOESN'T EVEN KNOW I'M ALIVE.

WHAT'RE YOU TALKING ABOUT? YOU'LL NEVER KNOW UNTIL YOU ASK HIM.

WHO IS IT?

A-HAAH. OH I SEE...

YOU WANT TO GET A BOY FRIEND BEFORE I DO.

GIGGLE. GIGGLE.

OF COOOURSE.

WILL YOU HELP ME?

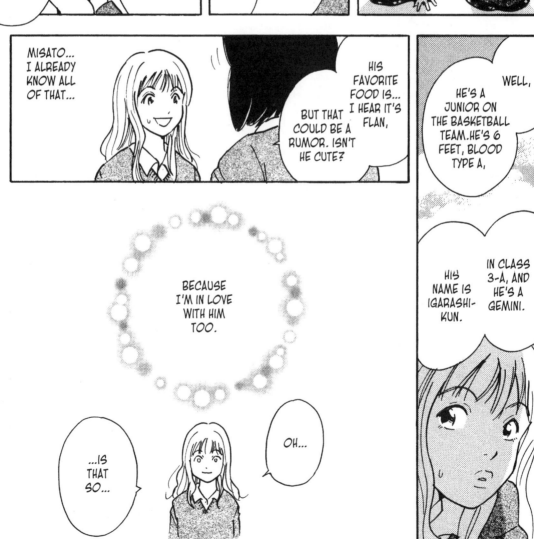

MISATO... I ALREADY KNOW ALL OF THAT...

HIS FAVORITE FOOD IS... I HEAR IT'S FLAN,

BUT THAT COULD BE A RUMOR. ISN'T HE CUTE?

WELL, HE'S A JUNIOR ON THE BASKETBALL TEAM. HE'S 6 FEET, BLOOD TYPE A,

HIS NAME IS IGARASHI-KUN.

IN CLASS 3-A, AND HE'S A GEMINI.

BECAUSE I'M IN LOVE WITH HIM TOO.

...IS THAT SO...

OH...

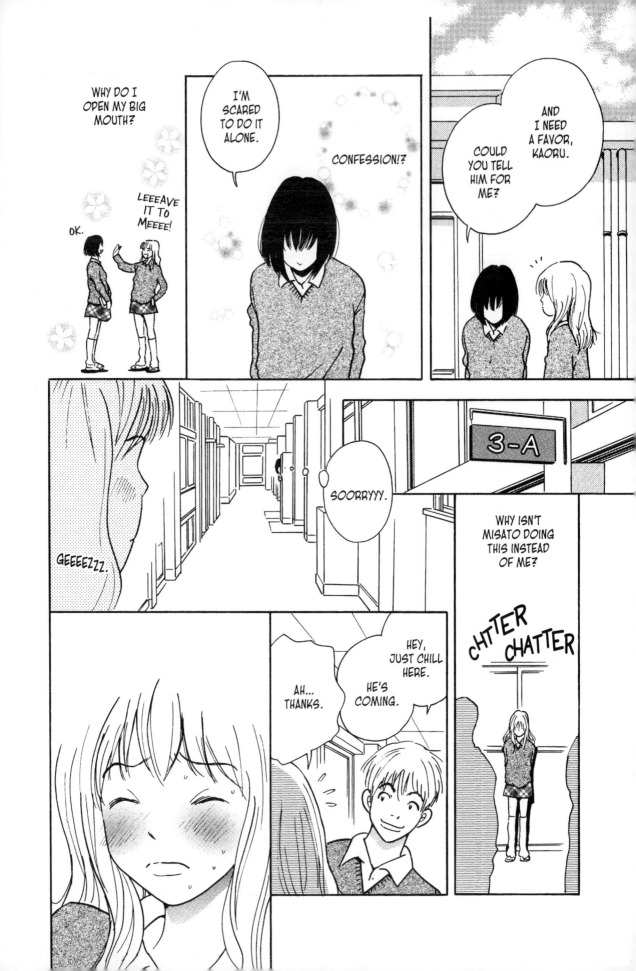

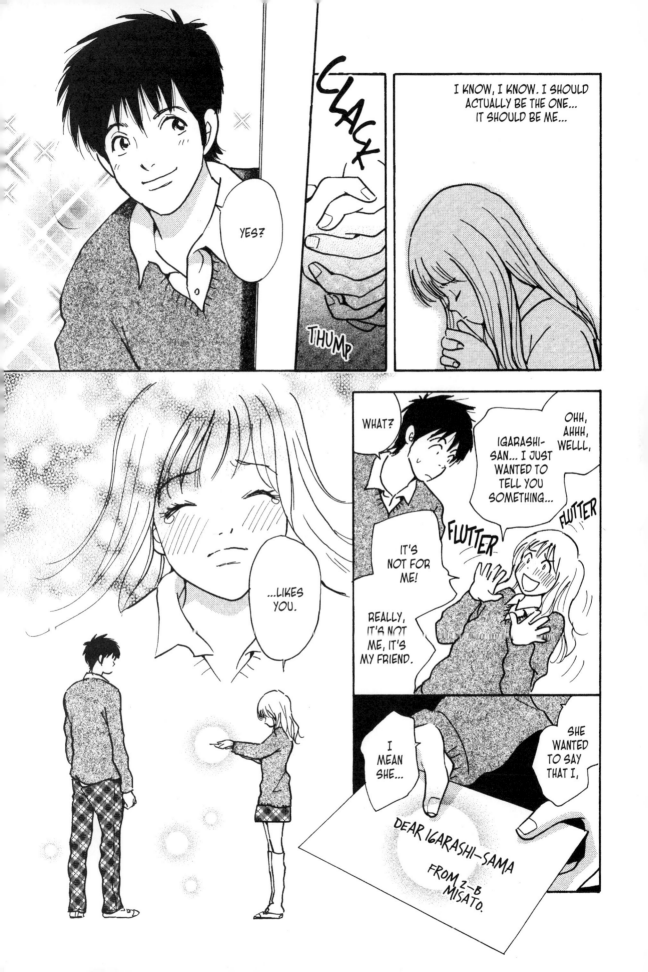

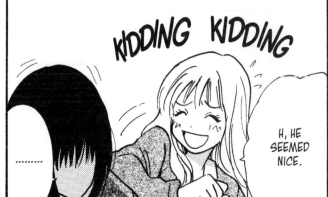

KIDDING KIDDING

H, HE
SEEMED
NICE.

...

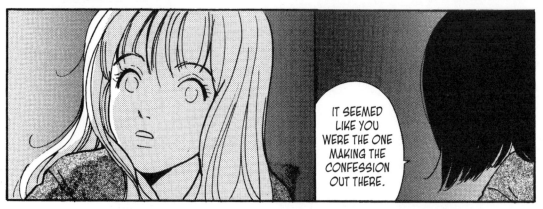

IT SEEMED
LIKE YOU
WERE THE ONE
MAKING THE
CONFESSION
OUT THERE.

I GUESS
YOU LOVE
HIM TOO.

WHY IS THIS
HAPPENING?

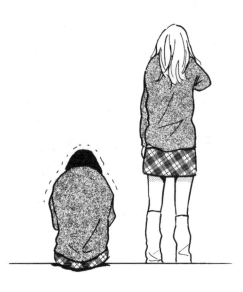

N...
NOOO.

IT WASN'T
LIKE THAT.
I TOLD HIM
YOU LIKED
HIM.

....

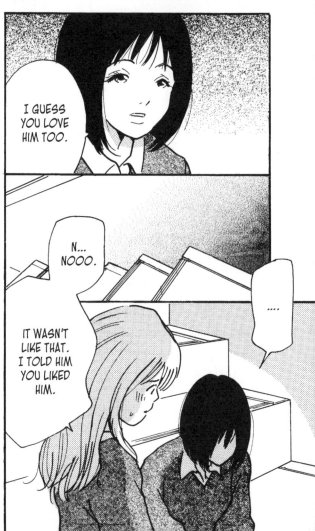

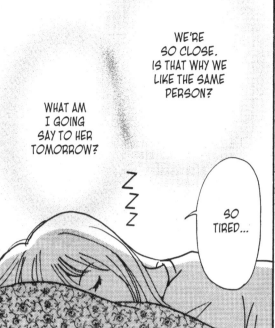

WHAT AM I GOING SAY TO HER TOMORROW?

WE'RE SO CLOSE. IS THAT WHY WE LIKE THE SAME PERSON?

ZZZ

SO TIRED...

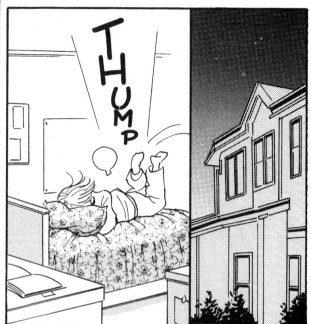

THUMP

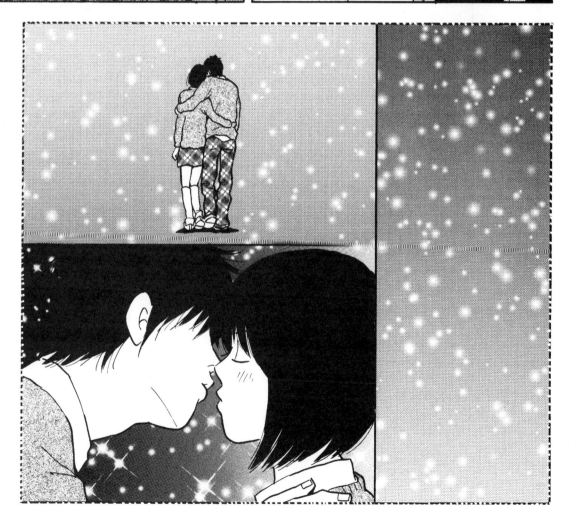

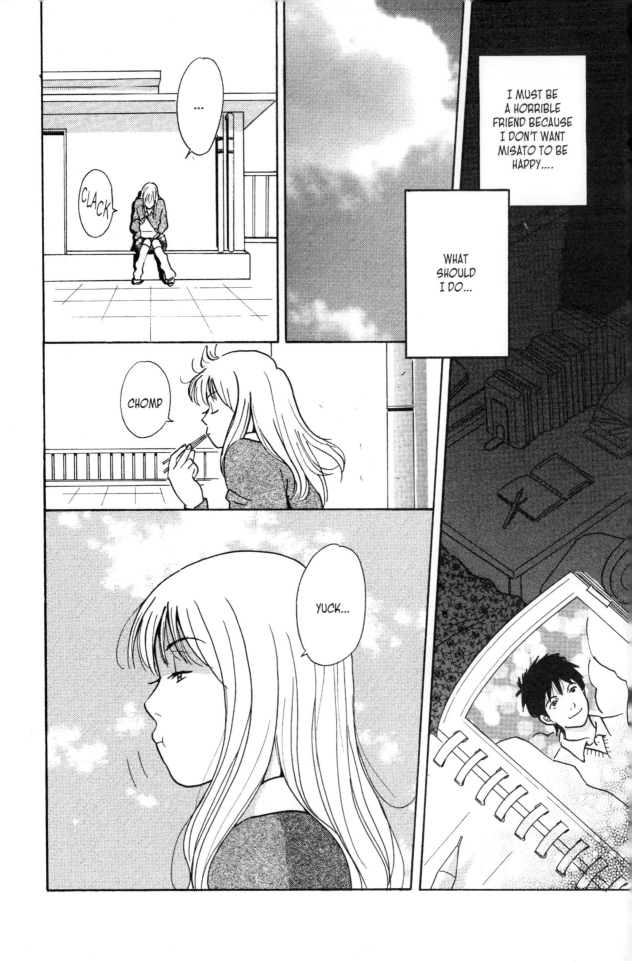

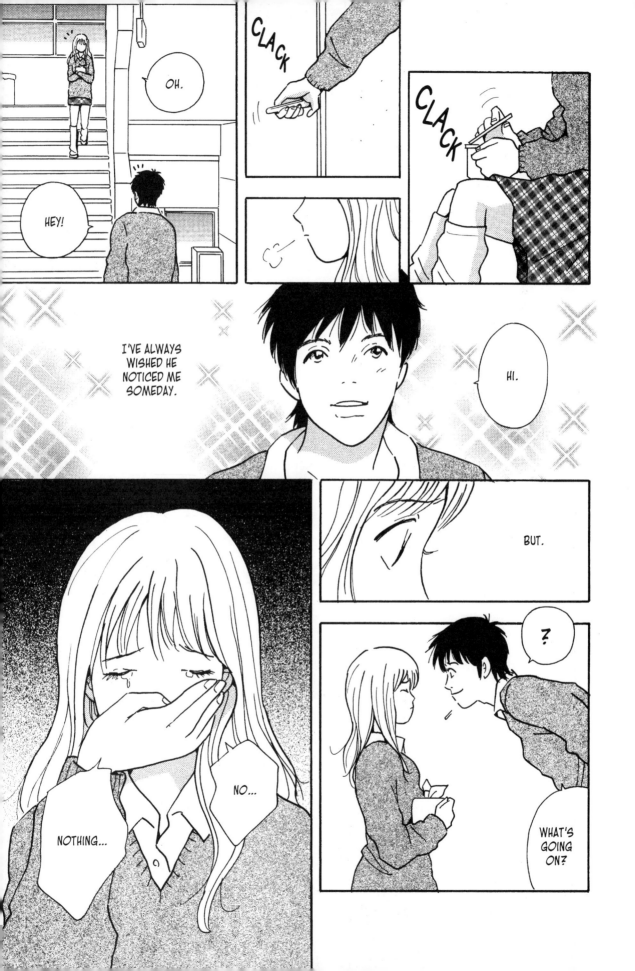

OH.

I'M SORRY. I STARTED CRYING.

SHRUG

YOU'VE GOT IT ALL WRONG.

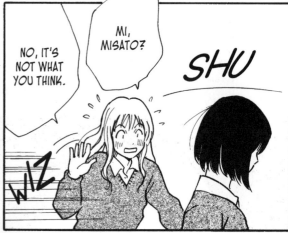

MI, MISATO?

NO, IT'S NOT WHAT YOU THINK.

SHU

WIZ

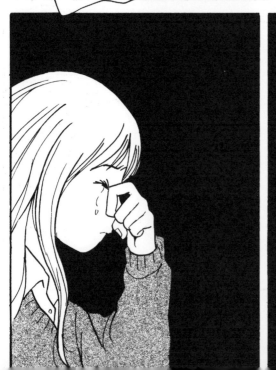

SO, WE CAN'T GO BACK TO BEING FRIENDS? WE WERE BEST FRIENDS...

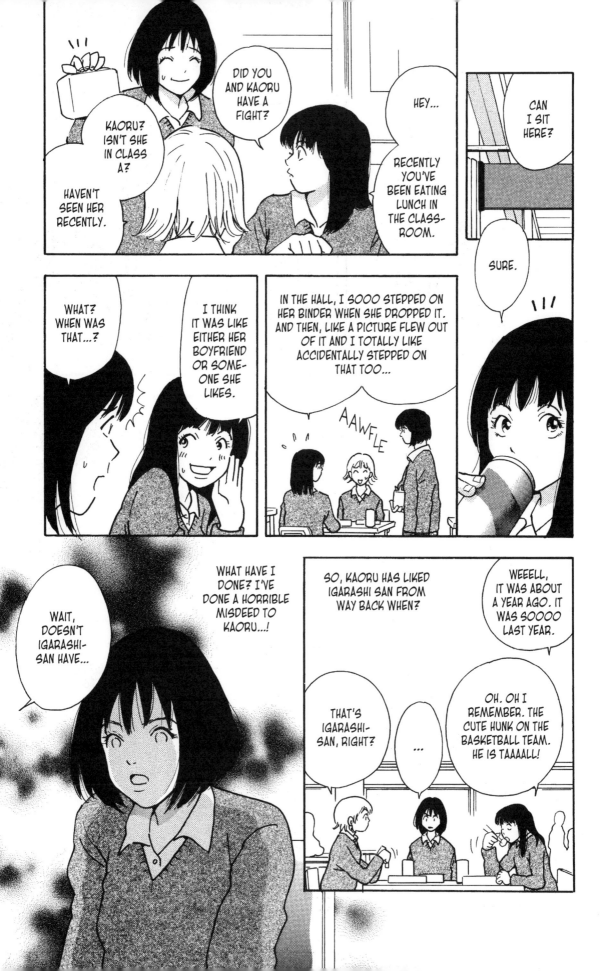

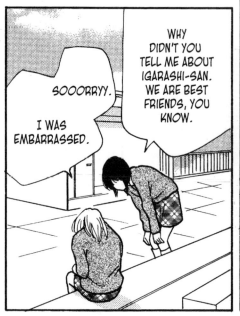

SOOORRYY.

I WAS EMBARRASSED.

WHY DIDN'T YOU TELL ME ABOUT IGARASHI-SAN. WE ARE BEST FRIENDS, YOU KNOW.

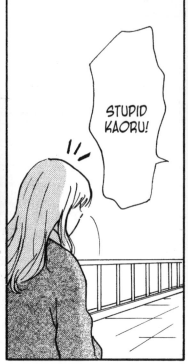

STUPID KAORU!

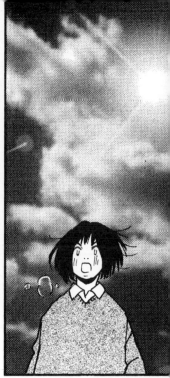

HE HAS A GIRLFRIEND.

THE OTHER GIRLS IN MY CLASS TOLD ME.

GIGGLE.

YOU'RE WEIRD. YOU CAN BE SO SENSITIVE WHEN IT COMES TO THINGS LIKE THIS.

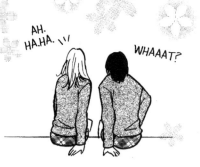

AH. HA.HA.

WHAAAT?

WHAT?

NEXT TIME? WHAT ABOUT IGARASHI-SAN?

I'M SORRY KAORU.

NEXT TIME I FALL IN LOVE, I'LL MAKE SURE TO TELL HIM MYSELF.

BUT... OH WELL...

● END ●

⑫ What Should I Do With My Finished Work?

© NECESSARY TOOLS: A MILI-PEN, FELT TIP MARKER, AN ENVELOPE, TRACING PAPER, SCOTCH TAPE AND A P.C.

BECAUSE OF YOU KYOKO-SAN, I WAS ABLE TO FINISH MY MANGA!

*YAAAYYY!!

OH, NO. IT'S KINDA EMBARRASSING...SO I WASN'T GONNA DO THAT.

WHAT ARE YOU GOING TO DO WITH YOUR MANGA? DO YOU WANT TO SUBMIT IT?

YOUR FRIENDS OR FAMILY.

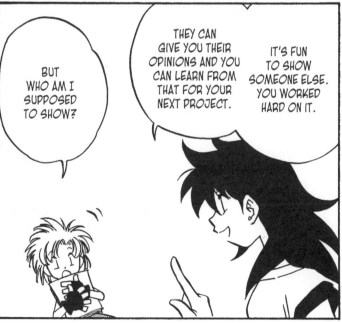

BUT WHO AM I SUPPOSED TO SHOW?

THEY CAN GIVE YOU THEIR OPINIONS AND YOU CAN LEARN FROM THAT FOR YOUR NEXT PROJECT.

IT'S FUN TO SHOW SOMEONE ELSE. YOU WORKED HARD ON IT.

LET'S FILE IT LIKE A BOOK

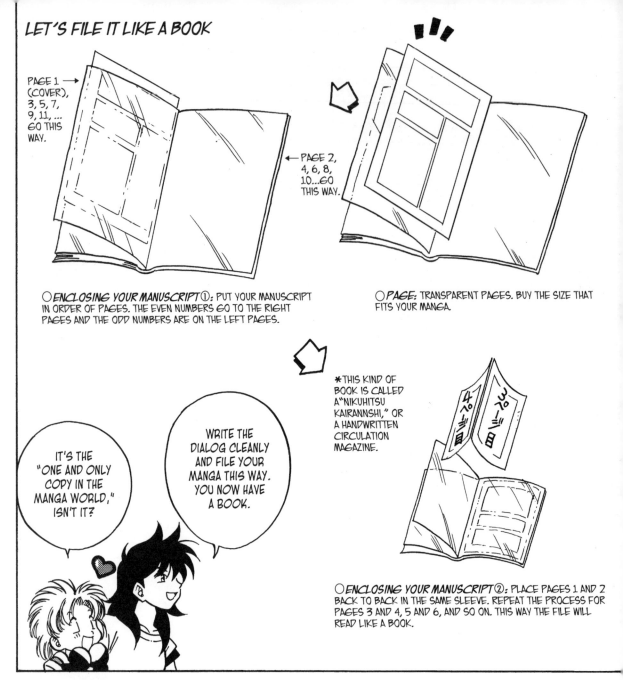

PAGE 1 (COVER), 3, 5, 7, 9, 11, ... GO THIS WAY.

←PAGE 2, 4, 6, 8, 10...GO THIS WAY.

○ *ENCLOSING YOUR MANUSCRIPT* ①: PUT YOUR MANUSCRIPT IN ORDER OF PAGES. THE EVEN NUMBERS GO TO THE RIGHT PAGES AND THE ODD NUMBERS ARE ON THE LEFT PAGES.

○ *PAGE:* TRANSPARENT PAGES. BUY THE SIZE THAT FITS YOUR MANGA.

＊THIS KIND OF BOOK IS CALLED A "NIKUHITSU KAIRANNSHI," OR A HANDWRITTEN CIRCULATION MAGAZINE.

IT'S THE "ONE AND ONLY COPY IN THE MANGA WORLD," ISN'T IT?

WRITE THE DIALOG CLEANLY AND FILE YOUR MANGA THIS WAY. YOU NOW HAVE A BOOK.

○ *ENCLOSING YOUR MANUSCRIPT* ②: PLACE PAGES 1 AND 2 BACK TO BACK IN THE SAME SLEEVE. REPEAT THE PROCESS FOR PAGES 3 AND 4, 5 AND 6, AND SO ON. THIS WAY THE FILE WILL READ LIKE A BOOK.

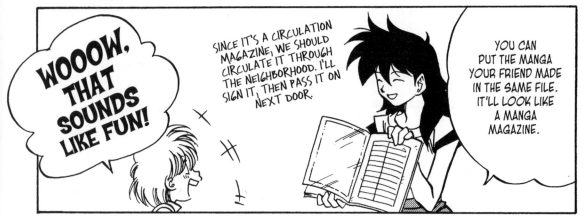

WOOOW, THAT SOUNDS LIKE FUN!

SINCE IT'S A CIRCULATION MAGAZINE, WE SHOULD CIRCULATE IT THROUGH THE NEIGHBORHOOD. I'LL SIGN IT, THEN PASS IT ON NEXT DOOR.

YOU CAN PUT THE MANGA YOUR FRIEND MADE IN THE SAME FILE. IT'LL LOOK LIKE A MANGA MAGAZINE.

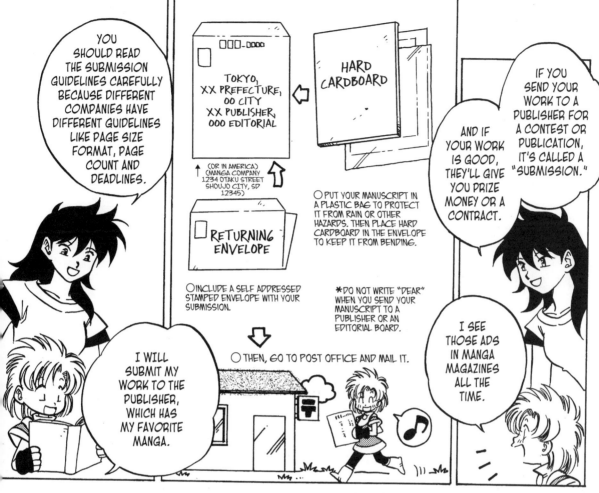

YOU SHOULD READ THE SUBMISSION GUIDELINES CAREFULLY BECAUSE DIFFERENT COMPANIES HAVE DIFFERENT GUIDELINES LIKE PAGE SIZE FORMAT, PAGE COUNT AND DEADLINES.

HARD CARDBOARD

☐☐☐-☐☐☐☐

TOKYO, XX PREFECTURE, OO CITY XX PUBLISHER, OOO EDITORIAL

(OR IN AMERICA) (MANGA COMPANY 1234 OTAKU STREET SHOUJO CITY, SD 12345)

RETURNING ENVELOPE

○ PUT YOUR MANUSCRIPT IN A PLASTIC BAG TO PROTECT IT FROM RAIN OR OTHER HAZARDS. THEN PLACE HARD CARDBOARD IN THE ENVELOPE TO KEEP IT FROM BENDING.

○ INCLUDE A SELF ADDRESSED STAMPED ENVELOPE WITH YOUR SUBMISSION.

* DO NOT WRITE "DEAR" WHEN YOU SEND YOUR MANUSCRIPT TO A PUBLISHER OR AN EDITORIAL BOARD.

AND IF YOUR WORK IS GOOD, THEY'LL GIVE YOU PRIZE MONEY OR A CONTRACT.

IF YOU SEND YOUR WORK TO A PUBLISHER FOR A CONTEST OR PUBLICATION, IT'S CALLED A "SUBMISSION."

I SEE THOSE ADS IN MANGA MAGAZINES ALL THE TIME.

I WILL SUBMIT MY WORK TO THE PUBLISHER, WHICH HAS MY FAVORITE MANGA.

○ THEN, GO TO POST OFFICE AND MAIL IT.

THAT IS A SHORTCUT TO BECOME A PRO.

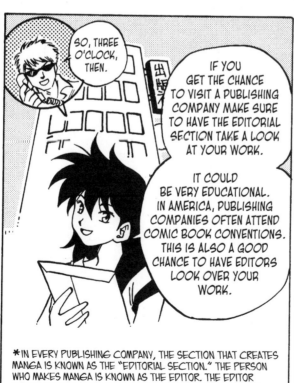

SO, THREE O'CLOCK, THEN.

IF YOU GET THE CHANCE TO VISIT A PUBLISHING COMPANY MAKE SURE TO HAVE THE EDITORIAL SECTION TAKE A LOOK AT YOUR WORK.

IT COULD BE VERY EDUCATIONAL. IN AMERICA, PUBLISHING COMPANIES OFTEN ATTEND COMIC BOOK CONVENTIONS. THIS IS ALSO A GOOD CHANCE TO HAVE EDITORS LOOK OVER YOUR WORK.

* IN EVERY PUBLISHING COMPANY, THE SECTION THAT CREATES MANGA IS KNOWN AS THE "EDITORIAL SECTION." THE PERSON WHO MAKES MANGA IS KNOWN AS THE EDITOR. THE EDITOR WORKS WITH THE AUTHOR TO MAKE MANGA OR CHECKS HER FINISHED MANUSCRIPT BEFORE MAKING THE ACTUAL BOOK.

AND BE AWARE, MOST PUBLISHERS WON'T RETURN YOUR WORK.

SO I SEND THEM A COPY.

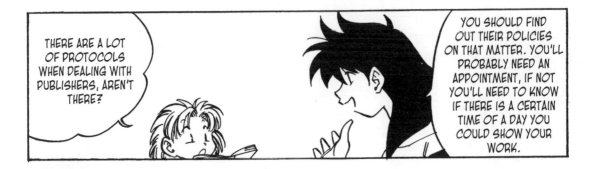

THERE ARE A LOT OF PROTOCOLS WHEN DEALING WITH PUBLISHERS, AREN'T THERE?

YOU SHOULD FIND OUT THEIR POLICIES ON THAT MATTER. YOU'LL PROBABLY NEED AN APPOINTMENT, IF NOT YOU'LL NEED TO KNOW IF THERE IS A CERTAIN TIME OF A DAY YOU COULD SHOW YOUR WORK.

ALISA, YOUR FAVORITE MANGA WASN'T POPULAR OVERNIGHT. MILLIONS OF PEOPLE INCLUDING YOU WERE EXPOSED TO IT. MANGA IS MADE FOR ALL OF THOSE PEOPLE.

I KNOW BUT...

THEIR ADVICE CAN BE SEVERE SOMETIMES BUT THIS IS GOOD FOR YOU. SO BE COURAGEOUS!

SCRATCH SCRATCH

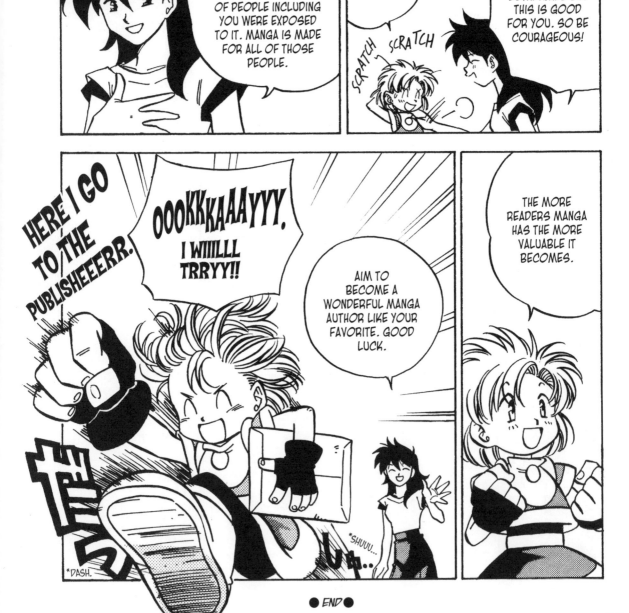

HERE I GO TO THE PUBLISHEEERR.

OOOKKKAAAYYY. I WIIILLL TRRYY!!

AIM TO BECOME A WONDERFUL MANGA AUTHOR LIKE YOUR FAVORITE. GOOD LUCK.

THE MORE READERS MANGA HAS THE MORE VALUABLE IT BECOMES.

*DASH.

*SHUUU...

● END ●

156

Tools The Professionals Use

YOU CAN FIND MOST OF THESE TOOLS IN YOUR LOCAL ART STORE OR ONLINE. SOME OF THEM ARE A BIT EXPENSIVE BUT THEY ARE THE TOOLS THAT THE PROS ARE USING. THE REASON THEY ARE PROS IS BECAUSE THEY UNDERSTAND THE TOOL, THEY'VE USED THE TOOL FOR YEARS, AND SOME OF THEM HAVE EVEN CUSTOMIZED THE TOOL FOR THIER OWN PERSONAL NEEDS. HERE, WE'LL SHOW YOU SOME USEFUL TIPS WHEN USING THESE TOOLS, REGARDING WHITE AND BLACK MANUSCRIPT PAPER.

○ **PENCIL:** IF YOU USE THE HARD LEAD, YOU MIGHT SCRATCH THE PAPER, SO THE PROS TEND TO USE B-B2. YOU CAN FIND THIS LEAD FOR MECHANICAL PENCILS AS WELL.

○ **BLUE PENCIL:** A PENCIL WITH LIGHT BLUE LEAD THAT WON'T SHOW UP MUCH WHEN YOU PHOTOCOPY OR PRINT. IT'S USEFUL AFTER YOU ERASE SO YOU CAN WRITE WHERE YOU WANT THE SCREEN TONES.

○ **ERASER:** THE BEST KIND OF ERASER IS ONE THAT IS SOFT, WHITE, AND ERASES EASILY (AND DOESN'T LEAVE A LOT OF SHAVINGS.) A KNEADED ERASER IS VERY USEFUL FOR MAKING SMALL CORRECTIONS IN THE "PENCILING" PHASE.

○ **NOTEBOOK:** A NOTEBOOK IS GOOD FOR WRITING DOWN ALL OF YOUR IDEAS, DESIGNING CHARACTERS, MAKING STORIES, SCRIPTING, AND THUMBNAILS. CHOOSE ONE THAT YOU FEEL COMFORTABLE WITH. A NOTE PAD IS FINE, TOO.

○ **MANUSCRIPT PAPER:** DIFFERENT COMPANIES MAKE DIFFERENT TEXTURED PAGES. CHOOSE THE PAPER THAT YOU THINK WILL BE MOST EASY TO USE. THIS WILL HELP YOU IMPROVE YOUR MANGA MAKING SKILLS. CHOOSE THE SIZE THAT'S RIGHT FOR YOU. IN AMERICA YOU CAN ALSO USE BRISTOL BOARD OR VELLUM.

○ **TIPS/NIBS:** LIKE MANUSCRIPT PAPER, DIFFERENT COMPANIES MAKE DIFFERENT SHAPED NIBS. NIBS SHOULD ALWAYS BE FRESH AND NEW. OLD NIBS CAN CHANGE THE WAY YOU DRAW. SELECT ONE THAT YOU ARE COMFORTABLE WITH.

○ **PEN AXIS/BODY:** THERE ARE MANY KINDS OF PEN BODIES. ALL OF THEM DIFFER IN THICKNESS, LENGTH, WEIGHT, THE MATERIAL THAT IT'S MADE FROM AND THE SHAPE. CHOOSE ONE THAT IS EASY TO HOLD AND COMFORTABLE TO DRAW WITH. SOME PROS REMODEL THE SHAPE TO FIT IN THEIR HAND BETTER.

○ **INK & SUMI INK:** IT'S SAID THAT BLACK INK BECOMES WATER RESISTANT AFTER IT'S DRY. THERE IS NOT MUCH DIFFERENCE IN THE FEEL WHEN YOU'RE DRAWING, BUT THERE IS A DIFFERENCE IN CONSISTENCY. WHILE YOU'RE DRAWING, THE INK IN THE BOTTLE CHANGES CONSISTENCY BECAUSE THE WATER IN THE INK IS SLOWLY EVAPORATING. REMEMBER YOUR FAVORITE CONSISTENCY AND ADD WATER TO ADJUST WHILE WORKING.

○ **MILI-PEN:** IT'S BEST TO USE A PIGMENT INK BUT ANY BLACK INK WILL DO. MILI-PENS DON'T NEED TO BE DIPPED LIKE A FOUNTAIN PEN. MILI-PENS HAVE AN INK CARTRIDGE BUILT INTO IT, BUT IT'S HARD TO DO TOUCH UP WORK AND SOMETIMES IT SMUDGES WHEN YOU ERASE. MILI-PENS ARE ALSO KNOWN AS RAPIDOGRAPH PENS.

○ **FELT TIP MARKER:** IT IS ALSO BEST TO USE A PIGMENT INK BUT REGULAR BLACK INK WILL DO. USE A WIDE ONE TO FILL IN THE "BLACKS" FOR LARGE AREAS. IF YOU NOTICE ANY SMUDGING, REPLACE IT SO YOU'LL HAVE A CLEAN FINISHED LOOK.

○ **POSTER PAINT OR POSTER COLOR (WHITE):** DIFFERENT BRANDS HAVE DIFFERENT THICKNESSES. LIKE INK, REMEMBER YOUR FAVORITE CONSISTENCY AND ADJUST IT WHILE YOU'RE WORKING. SOMETIMES IT MIGHT EVAPORATE OR PRECIPITATE.

○ **LIQUID WHITEOUT AND WHITEOUT PEN:** IT'S EASIER TO USE ONE THAT'S BOTH OIL AND WATER BASED. DIFFERENT COMPANIES MAKE DIFFERENT KINDS OF WHITEOUT. FIND ONE THAT YOU'RE MOST COMFORTABLE WITH.

○ **BRUSH:** USE THEM WHEN YOU FILL IN THE "BLACKS" OR CREATE "WHITE" EFFECTS. THE BEST BRUSHES FOR THIS ARE THE JAPANESE "MENSOU" OR "HAKKATSU"BRUSH, BUT YOU SHOULD USE ONE THAT YOU'RE MOST COMFORTABLE WITH. THE TRICK IS, CLEAN THEM WELL AFTER EACH USE. THEY WILL LAST LONGER.

○ **FUDE-PEN:** (FUDE-PEN IS A JAPANESE BRUSH THAT THE INK IS BUILT IN THE BODY. IT'S NORMALLY USED FOR WRITING JAPANESE CALLIGRAPHY) THE TIP OF FUDE-PEN IS USUALLY ELASTIC AND IS SUITABLE FOR "BLACK" PAINTING. SOME PROS KEEP IT AFTER THE INK IS GONE AND MERELY USE IT AS A FOUNTAIN PEN FOR ADDING IN "BLACKS."

○ **FACIAL TISSUE PAPER:** ASIDE FROM INKING, TISSUE PAPER IS AN ESSENTIAL TOOL IN THE CREATION OF MANGA. YOU CAN KEEP YOUR MANUSCRIPT FROM GETTING DIRTY BY COVERING YOUR HAND, OR CLEANING THE SHAVINGS OR DUST FROM ERASING. YOU CAN ALSO CLEAN YOUR BRUSH WITH IT.

○ **HAIR DRYER:** USE IT TO DRY YOUR "INKS" OR "BLACKS." DO NOT PUT THE DRYER RIGHT NEXT TO YOUR PAGE. START FROM A DISTANCE AND GRADUALLY BRING IT CLOSE TO THE PAPER. ALSO YOU CAN USE IT FOR PEELING OFF SCREEN TONE THAT IS STUBBORNLY ATTACHED TO THE PAGE.

○ **MASKING TAPE:** YOU CAN PUT AND REMOVE THIS TAPE EASILY WITHOUT DAMAGING YOUR PAGE. PROPERLY USED YOU CAN USE THIS TAPE TO KEEP THE PAGE FROM GETTING DIRTY.

○ **DESIGN KNIFE:** USE IT FOR CUTTING SCREEN TONE. MUCH EASIER TO USE THAN THE BOX CUTTER, THE DESIGN KNIFE IS SHARP, STEADY, AND PERFECT FOR DETAIL WORK. BUT IT WILL BECOME DULL QUICKLY SO REMEMBER TO REPLACE THE TIP OFTEN.

○ **SCOTCH TAPE:** USE IT FOR FIXING YOUR PAGE. YOU CAN ALSO PICK UP ERASER SHAVINGS WITH IT.

○ **LIGHT BOX:** USE IT FOR LOOKING THROUGH THE PAPER FOR TRACING OR REVERSE DRAWING. IF YOU CAN'T SEE THE AREA THROUGH THE SCREEN TONE AND AREN'T CONFIDENT IN CUTTING IT, USE THE LIGHT BOX TO SEE CLEARLY.

○ **BOX CUTTER:** IT'S USED FOR CUTTING SCREEN TONE AND IS IDEAL FOR SCRAPING. IT'S A BIT LESS EXPENSIVE THAN THE DESIGN KNIFE. TRY HARD TO STABILIZE THE TIP OF THE KNIFE.

○ **SCREEN TONE:** THE MOST IMPORTANT THING TO KNOW ABOUT SCREEN TONE IS THE DIFFERENCE IN STICKINESS WHEN YOU APPLY IT TO YOUR MANUSCRIPT. ALSO WHICH FILM YOU ARE MOST COMFORTABLE WITH. IF YOU KNOW YOUR FAVORITE PATTERNS, YOU'RE ONE STEP FURTHER IN IMPROVING YOUR MANGA SKILLS.

○ **TONE LANCER:** TONE LANCERS ARE USED FOR APPLYING PRESSURE ONTO THE SCREEN TONE WITHOUT SCRATCHING IT.

○ **FEATHER BRUSH:** IT'S EXTREMELY USEFUL FOR CLEANING ERASER SHAVINGS OFF OF THE PAGE. TRY TO COLLECT THE REFUSE IN ONE PLACE.

Let's Draw MANGA 漫画

Shoujo Characters

Draw shoujo manga the way you like it!

TEE HEE

"HEE = HEE"

Let's Draw MANGA 漫画
Shoujo Characters

ISBN# 1-56970-966-1 SRP $19.95

Both beginner and intermediate artists can now learn to draw "shoujo" characters in the highly recognizable styles established by celebrated Japanese manga artists. With detailed coverage of classic characteristics and basic features, including signature costumes, hairstyles and accessories, this book is a dream come true for the aspiring "shoujo" manga artist.

Distributed Exclusively by:
Watson-Guptill Publications
770 Broadway
New York, NY 10003
www.watsonguptill.com

DMP
Digital Manga Publishing

www.dmpbooks.com

Let's Draw MANGA 漫画

TOKYO URBAN-HIP HOP CULTURE

BY: MAKOTO NAKAJIMA &
BIG MOUTH FACTORY

ISBN# 1-56970-969-6
$19.95

Distributed Exclusively by:
WATSON-GUPTILL PUBLICATIONS
770 Broadway
New York, NY 10003
www.watsonguptill.com

DMP
Digital Manga
Publishing

DIGITAL MANGA PUBLISHING
www.dmpbooks.com

WHAT IS IT ...HOW MUCH TERROR CAN YOU STAND ?

Let's Draw **MANGA**™ 漫画
MONSTERS

BY:PLEX

ISBN # 1-56970-967-X SRP $19.95

Distributed Exclusively by:
WATSON-GUPTILL PUBLICATIONS
770 Broadway
New York, NY 1003
www.wasonguptill.com

DIGITAL MANGA PUBLISHING
www.dmpbooks.com

DMP
Digital Manga Publishing

Manga Academy

Learn how to create manga from the ground up!

Interactive critiques

Student forums

Let the pros teach you the tricks of the trade!

Drawing, inking, and coloring tips

 enroll at: mangaacademy.com

pop culture sightseeing

exclusive anime studio tours

a one-of-a-kind adventure

For reservations or inquiries, please contact:

Pop Japan Travel at:
Toll Free: (888) 447-6204 Fax: (714) 668-1740
Email: travel@popjapantravel.com

Visit us on the web at:
http://www.popjapantravel.com

DIGITAL MANGA PUBLISHING™

BACK LIST

Let's Draw Manga

Astro Boy
1-56970-992-0 $19.95

All About Fighting
1-56970-987-4 $19.95

Hip hop
1-56970-969-6 $19.95

Monsters
1-56970-967-X $19.95

Ninja & Samurai
1-56970-990-4 $19.95

Sexy Gals
1-56970-989-0 $19.95

Transforming Robots
1-56970-991-2 $19.95

Tezuka School of Animation

Vol 1 Learning the Basics
1-56970-995-5 $13.95

Vol 2 Animals in Motion
1-56970-994-7 $13.95

Berserk *

Vol 1
1-59307-020-9 $13.95

Vol 2
1-59307-021-7 $13.95

Vol 3
1-59307-022-5 $13.95

Desire

Vol 1
1-56970-979-3 $12.95

Hellsing *

Vol 1
1-59307-056-X $13.95

Vol 2
1-59307-057-8 $13.95

Vol 3
1-59307-202-3 $13.95

IWGP

Ikebukuro West Gate Park
Vol 1
1-56970-986-6 $12.95

Vol 2
1-56970-985-8 $12.95

Vol 3
1-56970-984-X $12.95

Only the Ring Finger Knows

Vol 1
1-56970-980-7 $12.95

Passion

Vol 1
1-56970-978-5 $12.95

Vol 2
1-56970-977-7 $12.95

Ring *

Vol 1
1-59307-054-3 $12.95

Vol 2
1-59307-055-1 $12.95

Trigun *

Vol 1
1-59307-052-7 $14.95

Vol 2
1-59307-053-5 $14.95

Trigun Maximum *

Vol 1
1-59307-196-5 $12.95

Worst

Vol 1
1-56970-983-1 $12.95

Vol 2
1-56970-982-3 $12.95

Vol 3
1-56970-981-5 $12.95

Let's Draw Manga *Sexy Gals* is distributed by Digital Manga and can be found online at www.dmd-sales.com.

All titles with an asterisk (*) are co-published titles with Dark Horse Comics.

To find a comic book store in your neighborhood please call the toll free Comic shop locator. (1-888-266-4226)

STOP!

THIS IS THE END OF THE BOOK.

THIS BOOK READS IN ITS ORIGINAL RIGHT TO LEFT MANGA READING FORMAT.
PLEASE START FROM THE OTHER SIDE OF THE BOOK.

THANK YOU.

FINISH ← START

THE READING ORDER:
READ RIGHT TO LEFT.
TOP TO BOTTOM.

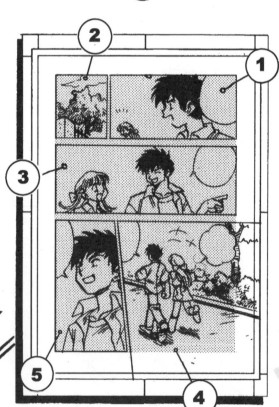

OH

I SEE!